Slate of Hand
Stone for Fine Art & Folk Art

Judy & Ted Buswick

© Copyright 2007 Judy Buswick & Ted Buswick.
All rights reserved. No part of this publication may be reproduced, stored in a retrieval system, or transmitted, in any form or by any means, electronic, mechanical, photocopying, recording, or otherwise, without the written prior permission of the author.

Note for Librarians: A cataloguing record for this book is available from Library and Archives Canada at www.collectionscanada.ca/amicus/index-e.html
ISBN 1-4251-0082-1

Printed in Victoria, BC, Canada. Printed on paper with minimum 30% recycled fibre. Trafford's print shop runs on "green energy" from solar, wind and other environmentally-friendly power sources.

Offices in Canada, USA, Ireland and UK

Book sales for North America and international:
Trafford Publishing, 6E–2333 Government St.,
Victoria, BC V8T 4P4 CANADA
phone 250 383 6864 (toll-free 1 888 232 4444)
fax 250 383 6804; email to orders@trafford.com
Book sales in Europe:
Trafford Publishing (UK) Limited, 9 Park End Street, 2nd Floor
Oxford, UK OX1 1HH UNITED KINGDOM
phone 44 (0)1865 722 113 (local rate 0845 230 9601)
facsimile 44 (0)1865 722 868; info.uk@trafford.com
Order online at:
trafford.com/06-1839

10 9 8 7 6 5 4 3 2

Slate of Hand

Stone for Fine Art & Folk Art

Acknowledgments

Thanks to the artists who so generously shared their time and talent with us. We enjoyed meeting the museum personnel who were friendly and informative: including Suzanne Rappaport and Clare O'Brien at the Slate Valley Museum; Dr. Dafyyd Roberts, Tudur Jones and Julie Williams at the Welsh Slate Museum in Llanberis; Marthe Ray at the Centre de'interprétation de l'ardoise; Amy Hau and Bonnie Rychlak at the Isamu Noguchi Garden Museum; Michael Tooby at the Tate Gallery St Ives; Gerallt D. Nash at the Museum of Welsh Life, St Fagans. We benefited from correspondence with Ruth Ann Robinson at the Old Line Museum, Della Jones at the Slate Belt Historical Museum, Felicia Ferguson at Lumina Gallery (Taos), Michael Freeman at the Ceredigion Museum, Susan Daniel-McElroy at the Tate Gallery St Ives, Oliver Fairclough and Carolyn Charles at the National Museums and Galleries of Wales, David Stilp with the Central States Archaeological Society, and Annette Ratuszniak and Debbie Rigg at Salisbury Cathedral. We were assisted by library staffs in the Chelmsford Public Library, the Boston Public Library, the Fogg Art Museum Library in Boston, the Pember Museum Library in Granville, the Manchester Library, the British Museum Library in London, the Oxford City Library, and the National Library of Wales in Aberystwyth. Thanks also to the Chelmsford Cultural Council for its financial support and the Dorset Colony in Vermont for its hospitality.

We had additional technical support and artist information from: Murray Gregory, Alex McCampbell, Bob Frishman, Bruce Mellin, John and Joan Jones, Janice Edwards and Morris Roberts, Dick Weir, Sara Stanhope, Philip C. Marshall, George Hamilton, John Coles, John Capozzolo, Donald Jones, Laurel Gabel, Jessie Lie Farber, Joel Anderson, Mike Sol Owen, Roger Davis, Ellie Hall, Sir Alan Bowness, Anthony Hopwood, Alun John Richards, Cecil Dorman, John and Peter Tatko, Joshua Andresen, Susan Tufts, Marjorie Eickel, Nancy Macmillan, participants at the 10th Gathering of Cornish Cousins in Pennsylvania, and the Chelmsford Telemedia Corporation. We thank Ashley Drake, Sian Chapman, Cath Filmer-Davies, and Jeff Mellin for production and editorial work on our book.

This project is supported in part, by a grant from the Chelmsford Cultural Council, a local agency supported by the Massachusetts Cultural Council.

Dedicated to Gordon James and the memory of Sally L. James
And the memory of Edward and Virginia Buswick

Contents

Foreword – *by Alun John Richards* ... xi

Introduction ... xiii

Chapter 1: An Adaptable Stone for Artists ... 1
Geology ... 1
A brief industrial overview ... 4
Art resources ... 5
Range of art forms ... 6

Chapter 2: Using the Material at Hand ... 9
Cornwall ... 11
Wales ... 13
Dinosaur carving: *William Roberts* ... 15
Bowls and chalices: *W.J. Rice* ... 16
New York/Vermont ... 18
Marbleizing ... 19
Welsh artifacts: *John Benjamin Evans* ... 20
Slate quarry mural: *Martha Levy* ... 21
Small figure carving: *Don Botsford* ... 21
Maine ... 24
Lamps: *Gordon James and Guy Brown* ... 25
Silhouettes, carved chain, toys: *Emil Carlson* ... 26
Kennedy Memorial ... 27
Pennsylvania ... 27
Game boards: *Roy and Robert Ealey* ... 29
Gothic-design clock: *Humphrey Pritchard* ... 30
Etched decorations: *Joe George* ... 30
Other Slate Areas ... 31
Pictish designs: *James Thompson* ... 32

Chapter 3: Monuments and Lettering ... 33
American carvers ... 33
Documenting gravestones: *Daniel Farber* ... 36
Gravestones in Great Britain ... 38
Modern lettering techniques ... 39
Preparing the slate ... 42

Chapter 4: Jewelry 47
Cumbrian geometry: *John Fletcher* 48
Canadian abstracts: *Louise Desrochers* 49
Kansas elegance: *Susan Ringer Koons* 50
Welsh energy: *Sara Humphreys* 52
Northwest natural: *Sharon Boardway* 54

Chapter 5: Painting 57
Figures in cityscapes: *Brian Gordon* 57
Painting variations 59
Miniatures: *Ken Taylor* 60
Using a square of slate: *Barbara Kulicke* 62
Painting that approaches sculpture: *Merrill Wagner* 64

Chapter 6: Relief Carving 67
Bas-relief: *Frank Eliscu* 67
Murals and beach stones: *Reg Beach* 69
The human figure: *Edmond Laliberté* 71
Illustration carving: *Pam and Jim Martins* 73
Trompe l'oeil: *Ivor Richards* 75

Chapter 7: Sculpture-in-the-Round 79
Pierced, standing forms: *Barbara Hepworth* 79
Biomorphic forms: *Isamu Noguchi* 82
Zen-like forms: *Mack Winholtz* 85

Chapter 8: Stacked Sculpture 89
Dry stone walling: *Joe Smith* 89
Ephemeral art: *Andy Goldsworthy* 91
Figures: *Julie Levesque* 95
Cultural fossils: *Celeste Roberge* 99
Pyramids and urns: *Howard Bowcott* 101

Chapter 9: Contemporary/Abstract Forms 105
Using natural sculpture: *Christopher Curtis* 106
Engraved panels: *Susanna Heron* 107
Total abstraction: *Phillip King* 110
Land Art: *Richard Long* 112

Chapter 10: Mixed Media 117
Music: *Will Menter* 118
Photography and poetry: *Jean Napier* 121
Landscape photography: *Roger Tiley* 124
Art glass: *Bill Swann* 127
Photographs imposed on slate: *Shlomo Shuval* 129

Chapter 11: The Slate Timeline 133
Slate as bedrock 134
Contemporary art 135
Recycling 136
Capturing history 137
Poetry 138

Appendices 141
Glossary of Selected Terms and Places 141
Additional Background on Selected Artists 145
Museums and Organizations for Further Exploration 152
Selected Bibliography 158

Index 164
Photography Credits 174

Foreword

As someone who has had a lifelong involvement with both slate and art, it is an honour and a pleasure to be asked by Judy and Ted Buswick to contribute to this major work.

Slate is a unique substance with noble properties forged over half a million millennia. Whether glistening in the rain, glowing in the sun or glowering in the shadow, its beauty calms the eye. Slate has a tactile serenity that comforts and embraces. It sets a benchmark that no other natural substance can surpass and nothing of man's artifice can match.

Worldwide, the use of slate for buildings has sadly declined; however, one could ask if it is not too precious a material to be squandered on such mundane applications? Slate can only be properly appreciated, not on remote rooftops, but close at hand where its subtleties of colour, tone and texture can be intimately savoured.

Happily concomitant with this decline, the virtues of slate as an artistic material are being increasingly recognised. Not only does it sculpt equally well both in the round and in relief, but unadorned or unworked or even virginal in the parent bedrock, it can make bold and dramatic spatial statements. Additionally it incises more crisply and cleanly than almost any other material, making it a unique vehicle of unmatched durability for depiction and calligraphy.

As this book makes clear, long before art became a discipline, the ancients had an aesthetic appreciation that allowed slate to enrich their savage existences. It also reminds us how, in more recent times, workers in slate crafted it to develop and to demonstrate their skills, and to enhance and beautify their homes.

Without denigrating such vernacular folk art, it is gratifying that artists of international repute are now prizing slate as a rewarding medium. Besides which, in addition to using it, they are expanding the frontiers of its applications for both representational and abstract expression.

The book is most timely; comprehensively drawing together so many aspects of the multifarious ways the material has been and is being used to delight the senses. Taking a global viewpoint, it examines and appreciates of the work of the many artists and craftsmen who are employing this medium. I applaud the inclusion of a mention of slate as a painter's "canvas" and more so, the space devoted to slate as a passive element, when it becomes a challenging subject for the photographer.

Attention is drawn to gravestones on which the skill of the artisan is combined with the inspiration of the artist to a high, often a very high, degree. The "Monumental Sculptors" who pioneered and developed the emotive use of slate must have moved and inspired many of the artists who feature in this book.

Mention is made of the marbleizing or enamelling of slate. Although purists may deplore this as "gilding the lily", the process pleasingly embellished many mundane items and at its nineteenth-century zenith produced numerous objects of undeniable beauty.

The use of slate as a maker of music may seem bizarre, but each fragment of slate has a sound locked within it. It used to be said that a quarry could be identified blindfolded, by the gentle song of the tips as they settled. An exaggeration, no doubt; but in each quarrying district the ring of cascading trimming waste has its own distinctive timbre.

One is left with the question - if this book is so timely and fills such a gap, why has nothing of the sort been previously undertaken? I venture to suggest that it is because until now no one else has had the skill, knowledge or application to do it.

Alun John Richards. Wales 2006

Introduction

At a time when I was learning tole painting, my father brought me a few 8 inch × 12 inch slate roofing shingles. Each had beveled edges and smooth, but not polished, surfaces. I thought they were interesting and could be used with chalk by my children, ages six and eight. When a friend told me she was shopping for a chalkboard to give as a housewarming gift, I realized that a painted design across the top of one slate and a small wooden trough glued to the bottom would turn a roofing shingle into a note board for a kitchen. A great gift idea.

Painting on trays, canisters, and small tins, I had all the oil painting supplies handy. Additionally, I appreciated that slate, unlike trays, would not require seven coats of varnish. I love to paint, but keeping varnish layers smooth and clean was not the fun part of any project.

I painted a cluster of strawberries across the top of the slate, trimmed a wooden molding strip for chalk troughs, cut up foam blocks for erasers, and bought a box of colored chalk. My slate painting business began with the note boards; and two gift shops sold my moderately priced items of slate – including welcome signs, wall decorations, refrigerator magnets, lazy-Susans, and clocks.

Needing a good supply of black slate shingles, I relied on my parents who had moved to a farm in Maine, close to the Monson slate quarries, which have yielded a high quality, black slate since 1870. Mom and Dad purchased slate for me that had been on a shed tumbling over and picked up the broken shingles when an

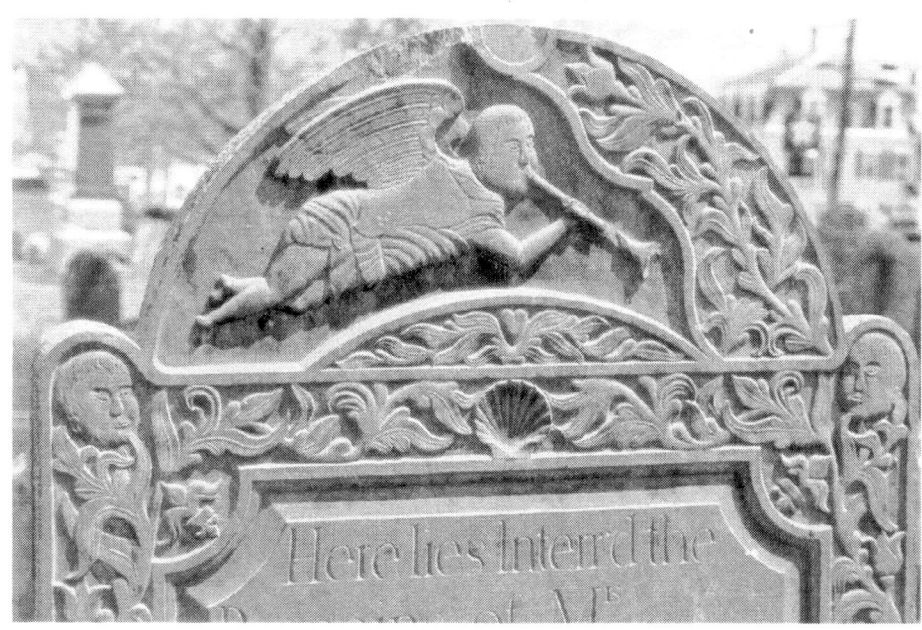

Pic. i.1 Angel blowing horn on the slate gravestone (62" high).

old barn was razed. Because of the six-hour trip between the farm and my home, I didn't get to Maine frequently. My husband, Ted, and I started scrounging locally in burned out buildings that once featured slate roofs. And fortunately, we had friends who were willing to do this for me too.

As my slate supplies came in from several towns and different states, I was surprised at how the shingles varied in size, color, and weight. My interest developed in the stone that seemed to have multiple personalities.

My slate painting career and my work as a freelance writer overlapped when I used my curiosity to research and write about local Massachusetts uses of

Pic. i.2 Map of quarry regions on US East Coast and Canada

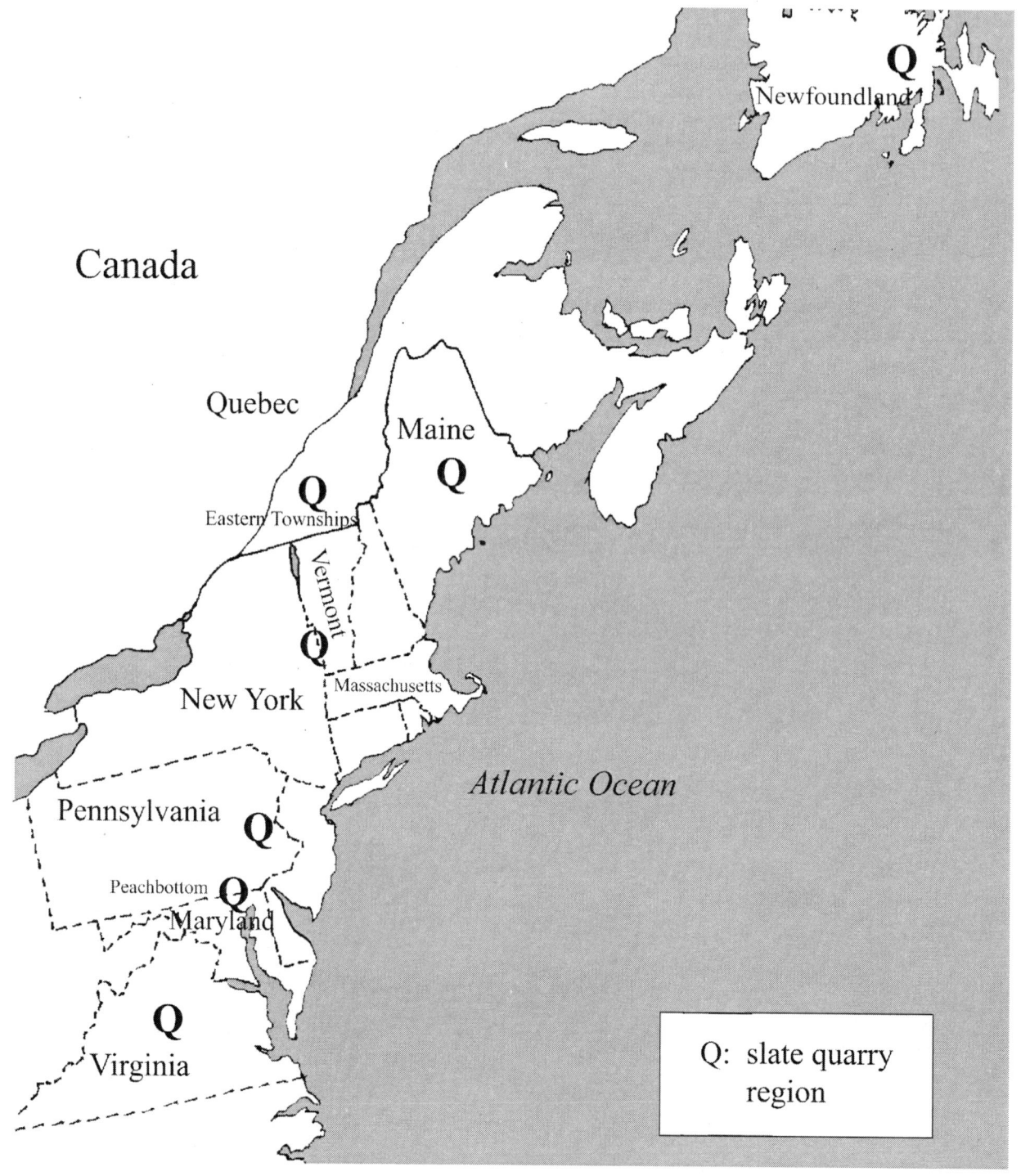

slate. I wrote about slate-roofed turrets on public buildings and colorful scalloped slates on Victorian homes in Lowell, slate tombstones in Chelmsford's Forefathers Burying Ground (1655), and the Park family of colonial tombstone carvers from Groton. The Association for Gravestone Studies led me on tours of old graveyards. My research showed that slate was also used as foundation blocks and stair treads, for sinks in science labs, for electrical switch plates (even in the Empire State Building), for pool tables, as well as for primitive tools now on display in museums. For years *Mycerinus and his Queen*, an ancient Egyptian statue from the Third Pyramid at Giza and now at the Museum of Fine Arts in Boston, was identified as "a slate pair." Originally painted, the work is now recognized as graywacke, a fine-grained stone similar in appearance to slate.

Slate has been quarried around the world. I've been told it can be found on every continent except Antarctica. Early Egyptians carved cosmetic and ceremonial slate palettes for holding make-up. France's northwestern region of Angers produced roofing shingles for castles in the twelfth century. By the seventeenth century, the French exported slate to Quebec and Montreal to cover colonial religious buildings. In the mid-nineteenth century, skilled quarrymen emigrated from the depressed slate areas in North Wales to the American continent and helped develop the newly burgeoning slate industries in Maine, Vermont, New York, Pennsylvania, Virginia, and up into Canada, all along the Appalachian Mountain range.

My knowledge about slate continued to grow, but my book concept was not yet focused. Then for several years, I set aside my painting and research for a job at the Chelmsford Public Library. Yet, I never stopped noticing when slate was the medium – whether in a stone wall or a jewelry maker's booth at a Welsh festival. Upon learning of the opening of the Slate Valley Museum in Granville, New York, Ted and I decided to visit the area and see who shared our fascination with this material so familiar and yet so unnoticed.

We met Suzanne Rappaport, then the Slate Valley Museum Director, who encouraged me to resume my research and narrow my focus to slate used in art. My husband/collaborator and I decided to transform vacation travel into researching quarry regions where we could find slate artists. Months later, Michael Tooby, then Curator at the Tate Gallery St Ives, Cornwall, called us "the slate tourists," and I guess that fits.

We have found slate quarries, slate artists, and slate art through travel and personal contacts, the Internet, museums, and library research. We met folk artists and crafters with small businesses. We saw slate used in hobbies. We had phone interviews or spent time with artists who define art movements and from whom the Guggenheim Museum, the Tate Gallery, or National Gallery of Art in Washington purchase sculptures.

Ted had a chance to visit the Prado in Madrid and see a painting on slate by Titian, the Renaissance master of color. A fellow writer made a special trip to the Getty Museum in Los Angeles to see a sixteenth century portrait painting on slate by Sebastiano del Piombo, a Venetian pupil of Giovanni Bellini. And, most recently, in the National Library of Wales, Aberystwyth, at an exhibition honoring the fifteenth-century Welsh leader Owain Glyn Dwr, we saw a beautifully lettered slate fragment from that century inscribed with a Welsh poem (a cywydd)

from the Cistercian Abbey of Strata Florida, one of the great cultural centers of medieval Wales. The graceful letters seemed drawn with a quill rather than carved with a chisel and mallet.

For us, the search for artists using slate has become an investigation of the creative spirit and a look at self-expression. We learned about ancient art and current trends and realize there is probably much more to uncover. We found there was no common path for our artists, though similarities did occur. Many artists recognize the integrity of slate, its primordial quality, and its beautiful interplay with light.

Ours is a general book about slate used in a wide range of art forms and the many artists who work with it, not an in-depth study of any particular discipline or artist. Early chapters present the historical applications of slate, as well as some recent innovations by regional artisans, thus providing a context for the chapters on modern art. Then, the remaining chapters look at the creation of particular art forms, presenting information on what properties of slate influence the artists and how they approach their work. Dimensions are given as height by width by depth. We include a glossary of terms reflecting regional uses in the slate industry and art disciplines; but we favor our native, American phraseology and spellings in the text, Welsh spelling of place names in Wales, and characteristic word choices by our artists – rather than unifying common terms throughout. Our book seeks to be comprehensive for English-speaking countries, but we know there are many more creative people who have also used slate in similar ways to those included. We hope we have shared with readers an appreciation of slate's artistic merit. If readers come to seek creative applications of their own or to appreciate the variety of slate uses through history and art, we "slate tourists" will feel we have successfully guided others into a relatively unexplored realm of art.

<div style="text-align: right;">
Judy Buswick

Chelmsford, Massachusetts
</div>

An Adaptable Stone for Artists

CHAPTER ONE

SLATE IS MISTAKENLY THOUGHT OF AS ONLY FLAT, BLACK, AND DULL; IT IS NOT A glamorous stone. When sculptors select stone to carve, they more frequently seek colored marble or granite than slate. But artists do use slate in some exciting and creative ways, beyond its utilitarian applications as blackboards, roofing shingles, gravestones, or patio flagstones.

Slate possesses a dignity and a distinctive look. Public buildings with slate roofs are stately and the variety of slate effects and colors complement many architectural styles. Tombstone carvers in the seventeenth century could easily work locally quarried slate with common tools, designing creatively and offering expressive memorials. Artists today who have used slate as their medium find it has wonderful colors, unique textural qualities, and great versatility. It allows for individual expression.

Slate can be evenly black or solidly red, or it can have wavy bands of green blending into a rich purple (see Color Plate 1). It can be a super-smooth surface found in a classroom blackboard or be a rough-textured cemetery tablet with crude lettering. It can be burning hot to bare feet in summer or provide the necessary insulating material for lining an icebox. It can have a razor-sharp edge if broken or can become worn-smooth and gently sloping, as steps on a public building. These "feels" of slate all add to our appreciation of the material.

Color Plate 1
Sara Humphreys
Sunburst (9" × 14½"). The design is cut from mottled purple and green slate from North Wales.

Geology

Geologically, slate is a fine-grained metamorphic rock characterized by its ability to be split into thin sheets or leaves. It is a medium hard stone, noncombustible, and waterproof. Approximately 360–544 million years ago, periods of great pressure and intense heat within the earth's crust transformed beds of pre-existing finely-grained mudstone, or sediment on ocean floors, into new minerals with a platey, flat structure. These and other existing flat crystals aligned due to the pressure field applied. The closely spaced bands of rock in parallel planes would split easily in one direction, not unlike a deck of cards.

The splitting property, or slaty cleavage, is the chief characteristic of slate. The word itself derives from this property, from the Old French verb "esclater," to split. Shale compressed and baked at high temperatures becomes first argillite and then slate. With further heat and pressure, slate transforms to phyllite, as grain size coarsens. Schist is a textural term that describes these metamorphic rocks with their visibly parallel structure.

Geological Periods		
Precambrian Era: (earth's crust formed)		4.5 billion to 544 million years ago (mya)
Paleozoic Era:	*Cambrian Period*	*544 to 505 mya*
	Ordovician Period	*505 to 440 mya*
	Silurian Period	*440 to 410 mya*
	Devonian Period	*410 to 360 mya*
	Carboniferous Period	360 to 286 mya
	Permian Period	286 to 248 mya
Mesozoic Era:	Triassic Period	248 to 213 mya
	Jurassic Period	213 to 145 mya
	Cretaceous Period	145 to 65 mya
Cenozoic Era:	Tertiary Period	65 to 1.8 mya
	Quaternary Period	1.8 mya to today

Table 1 Slate formation periods are in bold in this chart of geologic ages from the United States Geological Survey (USGS) in Reston, Virginia. Other geologic time charts may vary slightly, depending on the techniques used to date rocks.

Drilling a hole in a slate shingle or hand carving a letter for a slate plaque produces a slate powder; this powder illustrates the reversal of the metamorphic process. Slate dust also tangibly demonstrates one of the health risks of working in slate quarries. While the death rate from lung diseases in Britain was 3.67 per 1000 in 1893, the figure for the slate quarrying town of Ffestiniog was 7.63 per 1000, according to a Government Inquiry of the day. Lung diseases, such as tuberculosis or silicosis, are the often fatal result of inhaling slate dust.

The mineral content of the original sedimentary material (volcanic ash and other fine-grained silts) affects the quality and durability of the slate, especially those that are split for roofing shingles. The minerals give the slate shingles their numerous colors and determine a shingle's life expectancy, once its surfaces are exposed to the atmosphere. All slate would be gray except for the various minerals it contains, and thus each slate region is known for the color and quality of slate it produces. Basic slate colors include black, blue-black, gray, blue gray, purple, mottled purple and green, green, and red. Other colors are termed "freaks" by the slate industry, but are interesting combinations that can be used in shingling or sculpting. These opals, bronzes, buffs, and browns may or may not be true slates. Because of varied minerals, some slate shingles do decompose or delaminate, flaking like a piecrust, but the best slates last for hundreds of years.

Slate is quarried in large blocks. Depending on the angle of the slate vein, mineshafts bore deep into a mountain and create a honeycomb of caverns, or else open pits are terraced up a mountainside, forming giant slate steps. Freed by channel cutting or by placing explosives in drill holes, large masses of rock are separated from the vein. These are subdivided into multi-ton blocks and then removed from the quarry. The quarrymen then learn whether or not they can

work with the extracted stone. Getting to the usable material results in a great deal of shattered rock both in the quarry and in the mill or splitting shed. Typically, large areas are required for dumping the waste, and these dump piles remain long after the quarries cease production. A recent report from the Llechwedd Slate Caverns in Wales estimated the ratio to be at least ten tons of waste for every ton of finished slate.

Pic. 1.1 Jean Napier
Slate fence in a remote mountain pasture stands as a vestige of slate applications in North Wales.

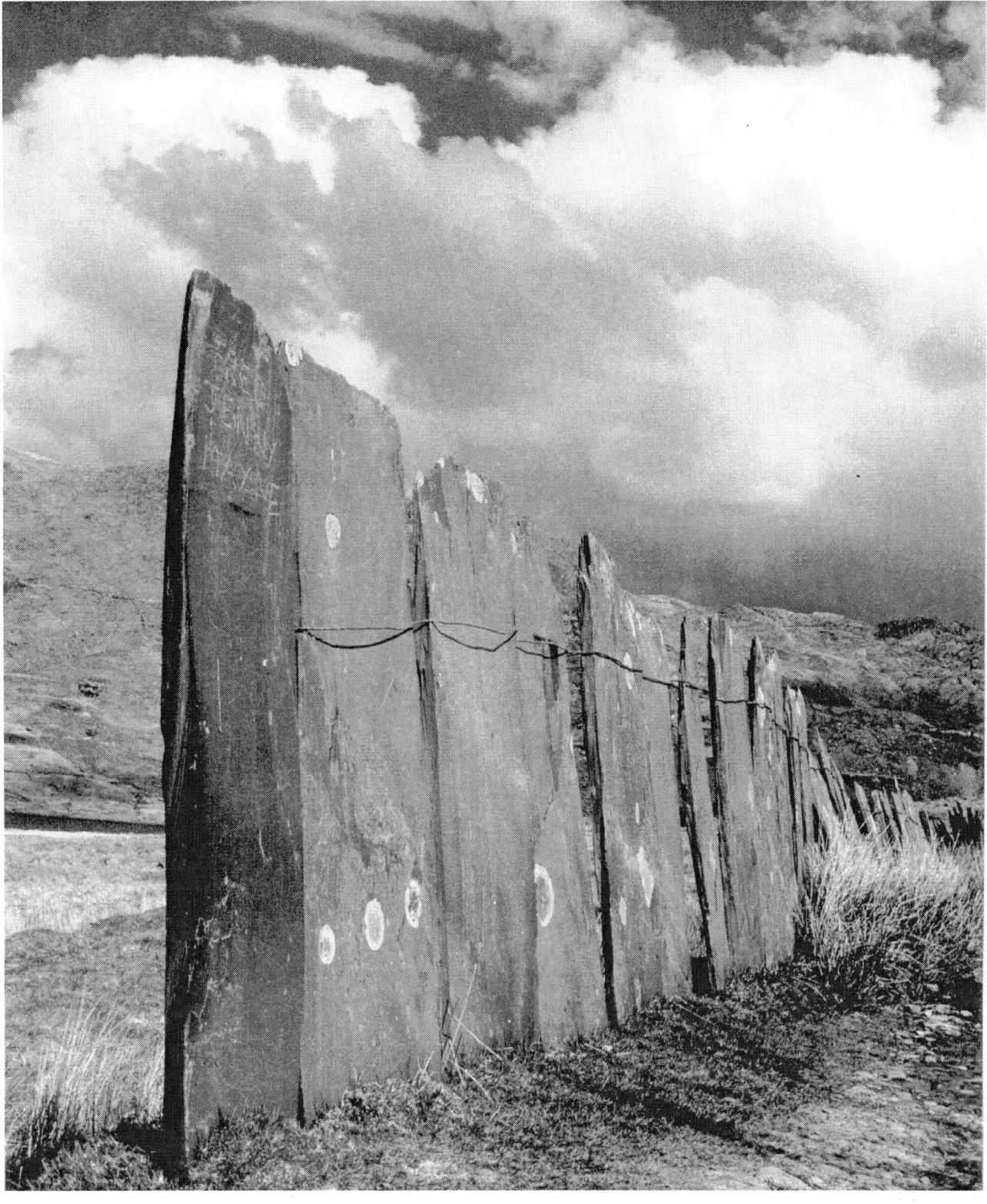

Slate of Hand: Stone for Fine Art & Folk Art

A brief industrial overview

People living near slate deposits have used it for centuries as local needs arose, building fences and walls, hearthstones, and flooring. Depending on slate outcroppings nearby, early gravestone carvers in Massachusetts used whatever grade of slate was available. Most slate gravestones have weathered well and are still sharply lettered and remain beautifully carved hundreds of years later. Others are splitting along cleavage lines or chipping, as weather erodes the carvings.

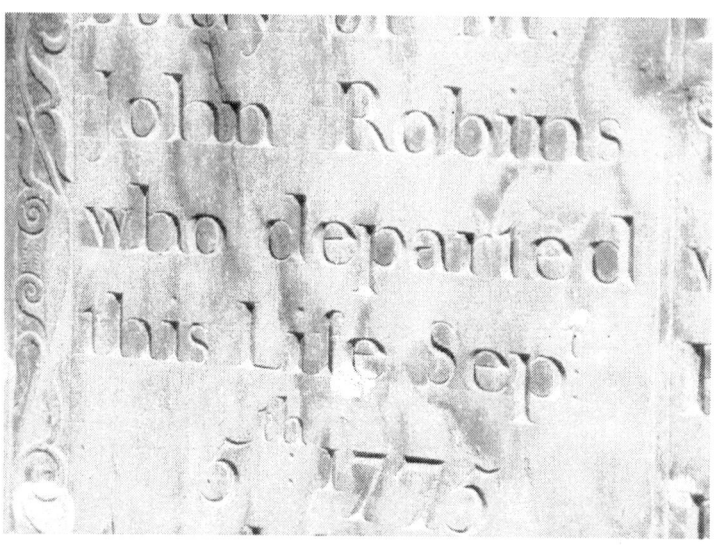

Pic. 1.2 Crisp, elegant lettering remains intact on this Chelmsford, Massachusetts gravestone from 1775.

Slate has been split for roofing shingles in Europe for centuries, as castles in France, England, and Wales testify. Although Conwy Castle in North Wales is open to the air today, it was protected with slate roofs during the thirteenth century. Welsh roofers used primitive methods and paid little attention to the size or thickness of the shingles. Today the shapes are regulated and commercially uniform with two holes for nails, but in earlier times the spaces between the uneven slates were filled with moss to help insulate and keep out the rain. Each "moss slate" hung by one nail.

Wales' slate quarries producing roofing shingles in the pre-Victorian era found it difficult to transport their product out of the mountains and into the market place. Horse-drawn carts carried a limited supply of the split shingles to the nearest port for distribution, until

Pic. 1.3 Moss slate samples rest on pieces of newly cut slate at the Welsh Slate Museum in Llanberis, North Wales.

narrow gauge railroads were introduced to haul the weighty cargo out of the difficult terrain. In the slate regions of Britain, France, the United States, and Canada, a similar history unfolded. In the early to mid-nineteenth century, the industry boomed because rail accessibility provided delivery of stock for the increased demands for building material. The decline in the industry came with the creation of cheaper alternative roofing materials, world wars, and other economic factors, such as labor disputes and deepening quarries. Today it is more expensive to use slate than synthetic roofing shingles, but the characteristics of slate have set the criterion for judging those other materials.

Thus the slate industry has had its ups and downs. In North Wales, and other regions, the mining industry is trying to find ways to reuse and recycle whatever slate waste is quarried. It has made bricks, pulverized slate for cement, and applied it as an abrasive. Slate has been compacted into insulators, used as foundations in highways, as filler for plastics, for glass making, and even for facial powder. Slate crafts are favored items in the tourist market. Modern shearing machines on the rock face and diamond blade saws in the mills have not only reduced slate waste but have also lessened health hazards.

Art resources

Slate for art projects can be purchased from stone yards in almost any region or from roofers or contractors, as well as from regional quarries, though typically not from sculptural material suppliers. Artists working with slate will want to understand the quality and workability of the slate they're considering. As slate dries in the atmosphere above ground, it becomes brittle. Freshly quarried slate is kept wet until the quarrymen are ready to split it for appropriate architectural uses. Abandoned slate tips (piles of discarded slate) have undergone years of weathering and countless cycles of freeze and dry; and so brittleness may be a factor to the artist, depending on the project and tools to be used.

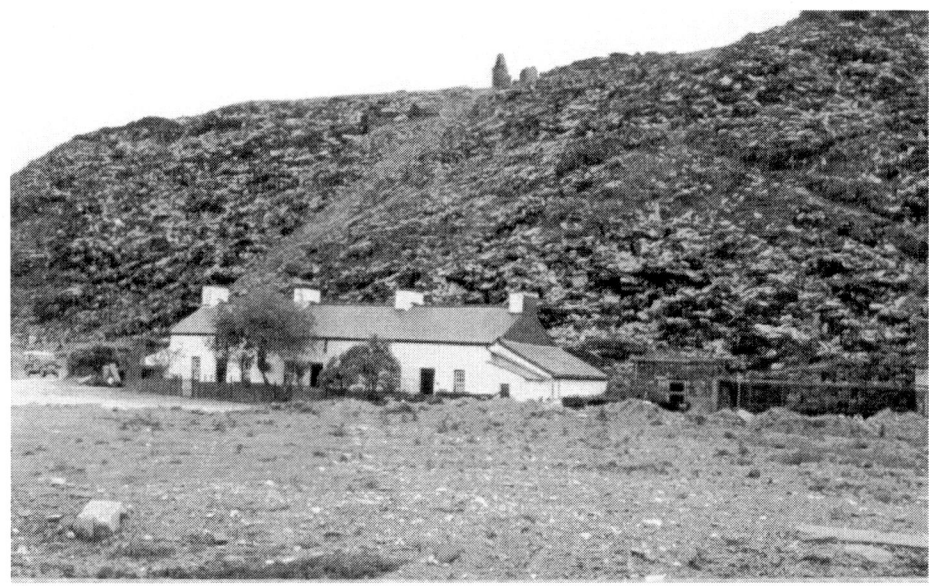

Pic. 1.4 Former quarry workers' cottages nestle beside a tip of discarded slate at the Gloddfa Ganol Slate Mine in Blaenau Ffestiniog.

Hiking in remote regions, artists can pick up and lug home pieces of slate and may feel they are recycling something discarded and unwanted. Abandoned quarries are dangerous places and quarry owners discourage trespassers. It is best to get permission from landowners and to have an experienced guide to show the quarry site, as there are concealed shafts, rotting timbers, and slippery stone paths.

On the other hand, mason shops and working quarries expect to sell their stones (even the discarded off-cuts) to artists wanting either "just a piece" or a ton. Though they have stock for sale, the staff may not have much time to spend with artists selecting the perfect stone for a project. Newly quarried slate may require a wait of several months until the appropriate stock is cut to fill the order. Roofers and contractors may sporadically have used shingles, flagstones, or old blackboards to sell, but they will often need their supply for contract work. So even though slate is readily available, finding adequate supplies may take some negotiating.

But whether found or purchased, slate is the poor artist's stone. It is nowhere near as expensive as marble. Artists have used natural chunks from quarry dumps, special orders and discarded off-cuts from the quarry mill, new and used roofing shingles or floor tiles, blackboards, or shards of slate. Slate panels provide a wonderful working surface for the artisan carving letters or bas-relief and are workable with carpentry or masonry tools. Many of the artists interviewed for this book have adapted machines and tools to suit their needs: to eliminate the risk of inhaling slate dust, to control the speed of power tools, and to devise techniques for their own purposes. They adapted the craftsmanship of quarry workers or tombstone carvers of the past and have also developed new methods of executing art.

Range of art forms

The existence of slate quarries in many parts of the world has led to regional applications of slate in the decorative arts. In each country, artists have carved tombstones or figures in bas-relief. Memorial plaques with hand-carved letters on polished slate grace buildings at colleges and hospitals around the world.

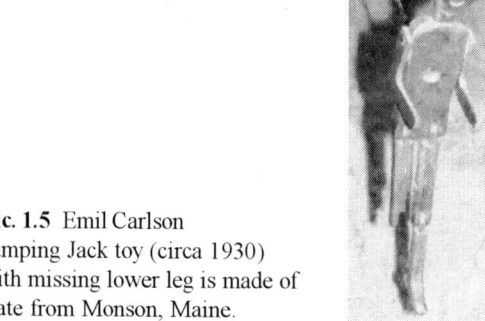

In addition to the standard slate arts, individuals have worked slate for personal pleasure. Probably in any area where slate had an industrial boom, quarrymen have taken home pieces of slate and created household utensils and folk-art decorations. They made breadboards and checkerboards, doorstops, furniture, and toys.

Pic. 1.5 Emil Carlson Jumping Jack toy (circa 1930) with missing lower leg is made of slate from Monson, Maine.

On another level, internationally known artists express environmental concerns and philosophies of art through the medium of slate. This stone and many other natural materials, used in unaltered forms, invite artists to work within the guidelines of nature and observe cycles of change. Slate represents earth's fundamental, layered structure and the endurance of material over time. Something about slate's primal quality has attracted each of the modern artists who have investigated its potential.

For this book, our definition of art embodies aesthetic objects fashioned with skill and imagination, with an intention of being shared to elicit an emotional response. The slate art we discuss ranges from one-of-a-kind decorative objects to massive installations. "Folk art" and "fine art" have melded into one category for us. At the heart of this book is the fact that artists of quality have taken a simple, sturdy stone and used it to create something expressive, intriguing, decorative, or thought provoking.

Using the Material at Hand

CHAPTER TWO

SLATE QUARRIES PROVIDE ARCHITECTURAL SLABS AND FLAGSTONE TILES FOR building materials, but the chief application of slate has been for roofing shingles (see Color Plate 2). Learning from fathers, brothers, and uncles on the job, experienced quarrymen understood the stone with its wood-like grain and characteristic cleavage. They knew how to drill holes for blasting powder that released multi-ton slabs of slate from the quarry face or how to shape and split uniformly thick roofing shingles by tapping precisely with mallet and chisel.

Specialized slate businesses developed, producing everything from mantelpieces to pencils; and those businesses in turn honed various mechanical skills in the workforce. Additionally, quarrymen carried home and experimented with select chunks of freshly cut slate to improve their knowledge of the stone. They used slate when building their homes and created practical household items or decorative objects for their wives and children.

Slate has been used for pastry boards and covers for butter crocks; as chemical and brewing vats, water cisterns, lining for pigsties and cowsheds; and as coffins. Architecturally it is found as flooring tiles, window frames and sills, sinks and counters, lintels, walling, steps, hearths, telephone switch plates, marbleized or painted fireplace mantels and surrounds, and outside cladding of buildings. Slate was extensively used to provide cold storage in dairies and as iceboxes before the days of refrigeration. Wall-covering blackboards, school writing tablets, and slate pencils (instead of chalk) were standard school fare into the 1940s

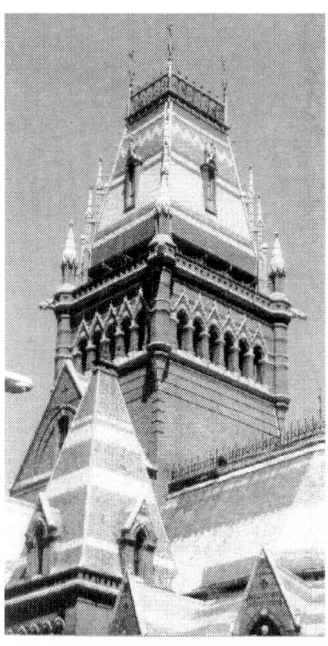

Color Plate 2
For the newly restored and refurbished tower peak on Memorial Hall (built in 1870s) at Harvard University, an effort was made to match colored slates to the originals quarried in New York and Vermont.

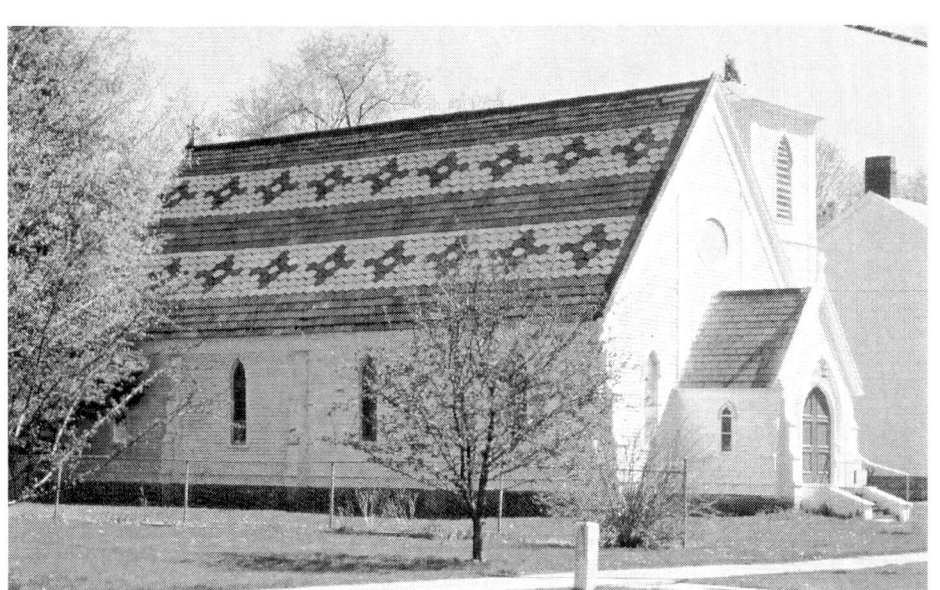

Pic. 2.1 Slate roofing shingles in black, red, and gray form a pattern on this church in Poultney, Vermont. Decorative patterns on homes and barns abound in the area.

Pic. 2.2 Chapman, Pennsylvania home (detail) is clad in local slates shingles.

in some areas. Billiard tabletops were once made from one slab of slate, but today are frequently composed of three one-inch thick slate pieces from Italy or Brazil, with the seams filled with beeswax before green felt is stretched across the surface. Game boards for chess, Chinese checkers, and Parcheesi abound. These early, home and commercial applications establish precedence for today's divergent uses of slate in art.

With both commercial know-how and individual skills, slate workers had an enhanced marketability when they left Cornwall, Scotland, and Wales for quarries in eastern Canada and along the Appalachian range in the eastern United States in the mid- to late-nineteenth century. Once across the Atlantic, some settled into a specific slate belt area and others followed job openings from one location to another, even to Australia. Certain folk arts and commercial artifacts appear in widely separated districts, while others seem, curiously, to have survived in isolation, probably thanks to one or two practitioners.

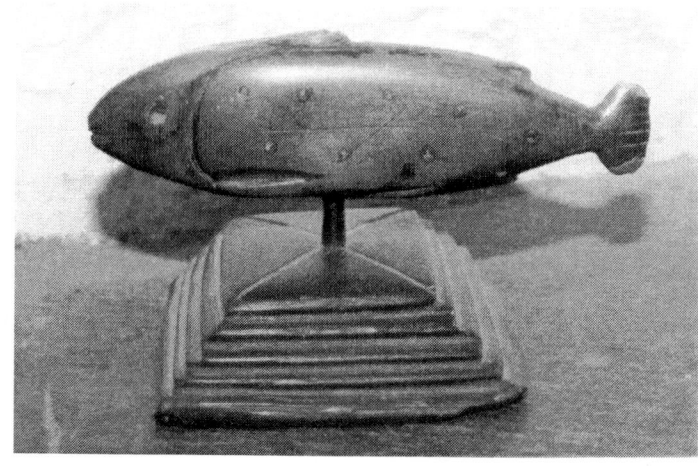

Pic. 2.3 Ornamental slate fish on carved base is displayed in Llainfadyn Cottage, the home of a slate quarryman from northwest Wales now at the Museum of Welsh Life, St Fagans, near Cardiff.

CORNWALL

The Delabole Quarry in North Cornwall is the oldest slate quarry in England and said to be the biggest man-made hole in Britain. It is almost 500 feet deep and 1.5 miles in circumference, though those numbers change as the pit is filled in and reconfigured to open new wall faces of slate. In Cornish "delyou" means flakes or leaves, and "bol" or "pol" means pit. From the late middle ages Delyoubol, or Delabole, was known as the pit of flaky stone. The "blue" or soft-gray slate of Delabole has been used as a building material for over 600 years and continually quarried since the early seventeenth century.

The quarry of non-homogenous deposits continues to produce slates in a range of qualities for monumental, architectural, and roofing applications today. Delabole slate shingles have iron deposits in some veins which turn a shade of soft orange, explains the quarry's General Manager George Hamilton. As much as 98 percent of the slate quarried was wasted 100 years ago, in the process of looking for usable stock for roofing shingles and floor tiles. Today 20 percent recovery has been accomplished by producing a wider range of products: counters, shower bases, walls, bath surrounds, fireplaces, and paving. Slate is also now crushed into granules or filler and used in paint. It is mixed with polyester resins and then pressed into hot, high-pressure molds to produce reconstituted roofing shingles, which look remarkably like the "real thing" but are lighter weight.

Delabole was a pioneer in making slate powders and granules, says Hamilton. An early use was to mix slate powder in Polygram records. The grinding was done by hand, to be sure there was no quartz in the powder. Hamilton suggests that anyone with old 78 rpm records made in the

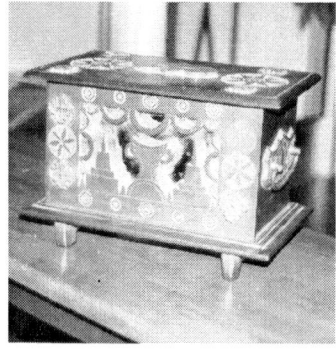

Pic. 2.4 Alms box is displayed at the Slate Valley Museum in Granville, New York. A very similar box exhibited in the Museum of Welsh Life, St Fagans, is identified as a nineteenth century collecting box from Colwyn Bay, North Wales.

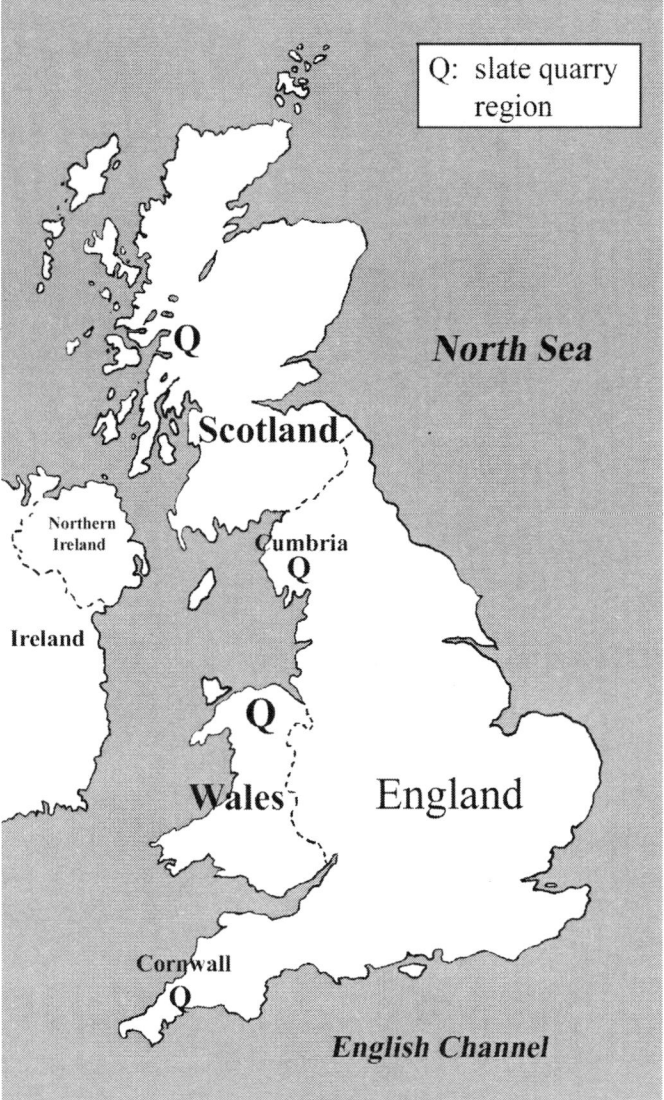

Pic. 2.5 Map of United Kingdom slate quarry regions referenced in this book.

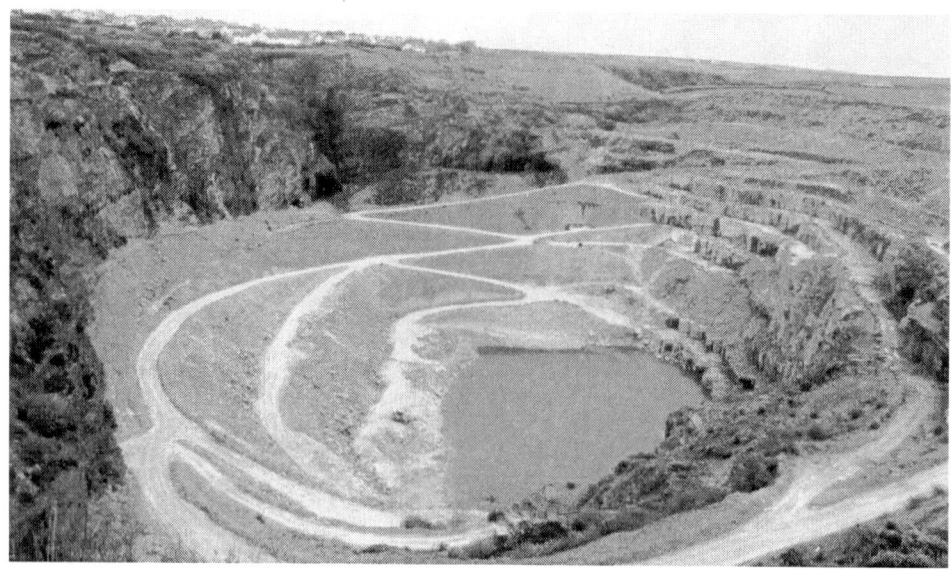

Pic. 2.6 Delabole quarry in Cornwall, with town of Delabole perched on the rim.

United Kingdom probably has some music with Delabole slate in it.

In North Cornwall the stone walls, called hedgerows, are distinctive. Surface stones, geologically of Upper Devonian slate, cleared from surrounding areas were stacked and slanted into patterns of angled slates reminiscent of a herring-bone fabric. Built to be windbreaks, these hedgerows border narrow paths which are now often country roads. Others separate neighbors. Many of the hedgerows are filled with soil and so wild flowers thrive. The work of hedgerow builders from hundreds of years ago still decorates village gardens and sheep pastures.

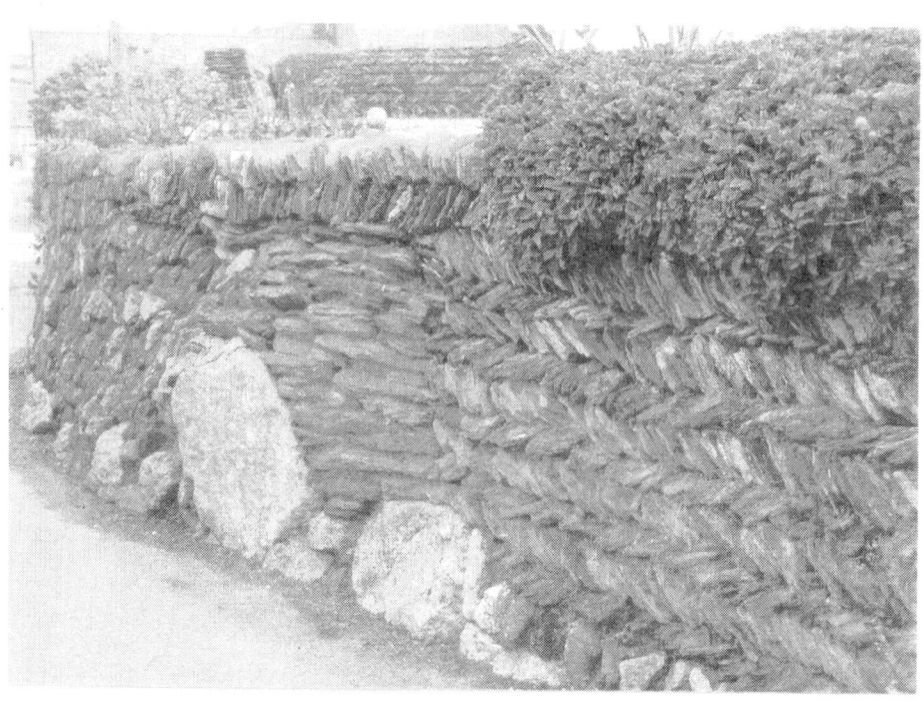

Pic. 2.7 Cornish hedgerow in village of Trevone Bay.

Generations ago, most Cornish homes had a twenty-inch circle of flat slate, known as a bakeboard or pasty board. The traditional Cornish pasty is a meat and vegetable-filled pastry crescent formed by rolling dough into a circle on the board, filling it, and then folding and sealing the edges. Most pasty boards are plain with a pierced knob for hanging the board, but a few have engraved designs on the reverse, or heart-shaped holes. The boards are seen in Cornwall and areas of Pennsylvania where quarrymen settled.

WALES

In northern Wales slate is still quarried in the Cambrian Mountains, the range running north and south through the country on the western coast of the United Kingdom. Abandoned quarries along the coast of mid-Wales and in the Preseli Hills in the southwest provide hikers with some interesting sites to explore and show other historical sources for Welsh slate, though the predominant industry has always been in the north (see Color Plate 2). Welsh slate varies in color from gray to blue and green, purple and dull red, and black. Locals had used slate for centuries, but quarrying developed into a major industry during Queen Victoria's reign (1837–1901), when railroads made the mountain resources accessible and British gentry saw an opportunity to develop a worldwide market.

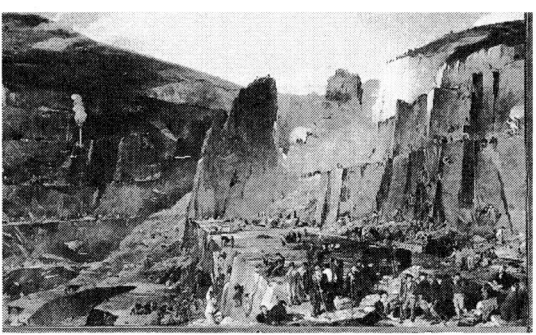

Color Plate 3: Henry Hawkins *Penrhyn Quarry*, 1832 (4'4" x 6'2") This vast quarry overlooking the Ogwen Valley in North Wales covered 560 acres. (Photo courtesy of The Douglas Pennant Collection (The National Trust/NPTL/John Hammond))

Welsh historian Alun John Richards says, "The industry brought prosperity to Bangor and Caernarfon, it created towns such as Bethesda, Blaenau Ffestiniog, Llanberis and Porthmadog. ... Above all, it created a whole new and proud way of life." Local farmers and fishermen turned to slate for their livelihoods and learned quarry techniques. The Welsh slate industry in the middle of the nineteenth century "accounted for almost half the [country's] total revenues from trade, industry and the professions," reports Richards.

Enhancing their homes with slate, the one material on hand, pre-Victorian Welsh craftsmen created both functional items and the purely decorative. They and the Victorians adapted wood carving techniques and fashioned the necessary chisel bits and tools, sometimes with the help of the quarry blacksmith, so they could ornament their homes. They made novelty items, like miniature bureaus, figured bookends, or game boards. They carved the edges of slate plinths (thin platforms) used to keep their best furniture off the earthen floors in their cottages and made doorstops of slate, frequently decorated with spirals or concentric circles (known as cup-and-ring marks), motifs copied from stone carvings by ancient people all over the world.

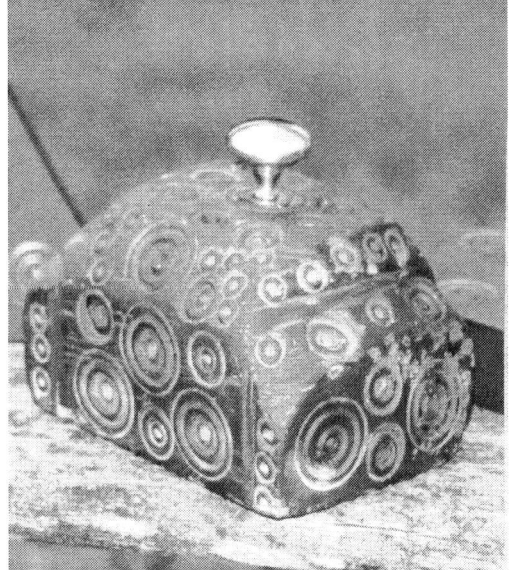

Pic. 2.8 Antique doorstop of Welsh slate has concentric circles probably incised with a scribe and compass.

Pic. 2.9 W.J. Rice A generations-old household decoration, this modern doorstop updates an ancient design.

In the early 1800s large slabs of slate produced as a cheap industrial material were individually carved for mantels and fireplace surrounds in hundreds of homes in the slate valleys, especially near Bangor, where "quarrying started earlier than elsewhere and where more men were employed" at that time. In a publication from The National Museum of Wales in Cardiff, archaeologist Gwenno Caffell explains that between 1823 and 1843 the quarrymen could afford these large slate planks and created decorative mantels for their own homes. This was a "boom period in the valley" when new houses were built and older ones refurbished.

This "form of Welsh folk art not previously recorded" has been researched since 1977, revealing "a mass of cheerful, confident, imaginative carvings" that

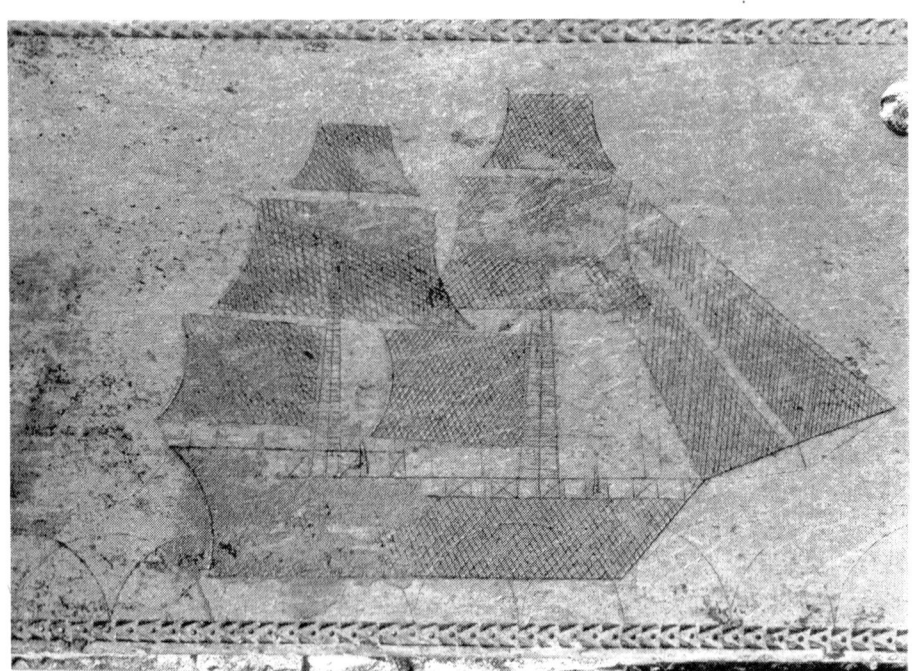

Pic. 2.10 *Sailing ship* (mantel detail) A quarryman who had previously been a sailor on such a ship carved this decoration for his cottage mantel.

range from "extremely accomplished ... to simple, rather crude." Carved names, initials, and simple traditional patterns of lines, concentric circles, and whorls have been found on slate mantels and fireplace surrounds, many still in place and others discarded and used as garden benches or walkways. Freehand, the quarrymen carved plants, birds, buildings, lines of music, and more – including one notable astronomical explanation of the planets, eclipses, and the Zodiac. One sailor turned quarryman carved a likeness of the ship he had sailed on. Sailors, experienced with climbing a ship's riggings, left the sea to work in the quarries and were comfortable hanging from ropes to pry loose large slabs of slate.

These mantel carvers were folk artists who frequently remain nameless, and much of their work has been discarded over the years. The Bangor Museum and Art Gallery has some carved mantels, as does the Museum of Welsh Life in St Fagans. Caffell organized a traveling exhibit of reproductions of the carved mantels from the Bangor area.

Delicate slate fans were another Welsh folk art; fancifully produced and strictly decorative, the fans demonstrated the quarryman's skill of splitting slate. Fans were a specialty of the Ffestiniog area where the quality of slate is high. Each fan started as one oblong block of slate, which was then split in half. Each blade of the fan was then repeatedly halved again and again until a razorblade might be

used to split the last sections. As many as thirty-two blades could be cut from a one-inch thick slate.

The fan blades were tightly tied together while the carver used files or saws to notch out a pattern on the edges of the split block and to drill a hole just short of midway along the blades for a pivot screw. Splayed open in a swirl and attached to a pedestal on a base, the fan would sit on a windowsill or shelf, acknowledging the craftsmanship of the carver. Delicate and detailed fans are made today as one of the slate-working demonstrations for visitors at the Welsh Slate Museum in Llanberis.

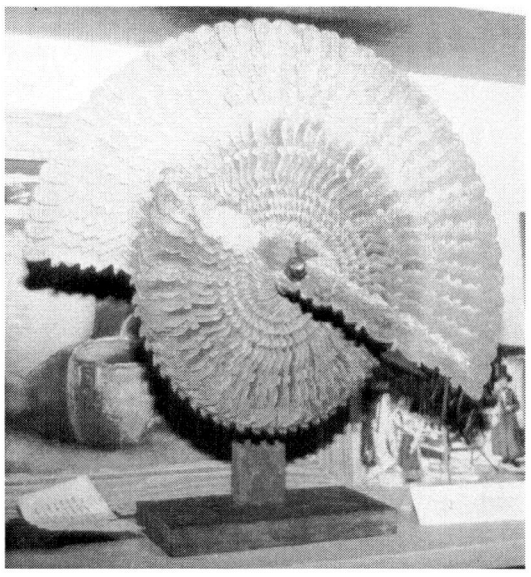

Pic. 2.11 John Benjamin Evans *Slate fan* (12" blades, 14½" diameter) Quarrymen split and carved decorative slate fans from one block of Welsh slate. (Donated to Green Mountain College by Morris Roberts)

Dinosaur carving: *William Roberts*

Some slate craftsmen are known by name and their works are inspiration to others. William Roberts, known locally as "Gwilym" Roberts, is a semiretired stone engraver who freelances his artistic skills to a number of monumental mason shops, commonly called "slate yards," near his Pwllheli home in North Wales. He had studied art at the Chelsea Art School in its "old location" on Kings Road in South Kensington in the late 1950's and today does oil paintings, in addition to work in the slate yards.

In his freelance work Roberts paints slate house plaques, filling commissions for a common home decoration in North Wales. After drawing a design that illustrates name of the house (a mountain scene, a tree, a sheepdog or a flower), he transfers the design to vinyl and it is sandblasted onto the slate at the slate yard. Roberts then uses acrylic paints to decorate the incised slate, as the final step in creating the house plaque.

Since about 1980 he has also painted decorations on tombstones which may be of granite or slate. He uses his quick-drying acrylic paints on the stones and finishes the painting with a spray varnish. Again, his contribution is the concluding step before the stone is delivered from the mason's yard.

Working for monumental masons, Roberts has also had experience carving subjects in relief in granite, marble, and slate. He once carved a marble bas-relief of

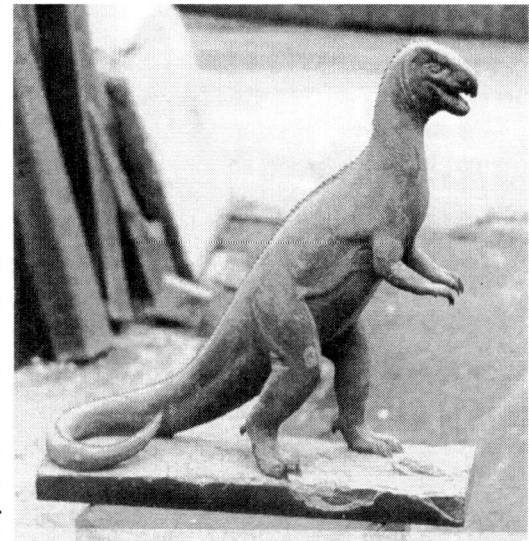

Pic. 2.12 William Roberts Dinosaur (20" × 15" × 4") Welsh slate captures the stance and features of dinosaurs as understood in the 1960s.

Romulus and Remus for an Italian restaurant in Pwllheli. He repaired a broken nose on a Victorian granite statue, the bust of a lovely woman. Mike Sol Owen, proprietor of the J. Williams & Co. slate works in Pwllheli, carved out a piece of stone from beneath the base of the bust; he and Roberts glued this piece to the face of the statue. Roberts then carved a new nose for the lady.

The most unusual work in the J. Williams & Co. slate showroom, which features slate plaques, house signs, and fireplace surrounds, is a dinosaur 20-inches high, carved from slate. When Sol Owen was a university student, he brought zoology books home as a guide and asked Roberts to carve a Tyrannosaurus Rex. Sol Owen thought that slate, being mudstone millions of years old, called for "a subject of similar antiquity." Roberts acknowledges that today scientists believe the dinosaur really didn't stand the way he carved it so many years ago. He says he should have carved "a buffalo or a deer. It would have been better."

The sculpture has features that seem textbook accurate, though. To carve it, Roberts took a 20 by 15 by 4 inches block of slate with the cleavage plane going up and down and drilled out big chunks. He removed others with a chisel and hammer and, in standard sculpting technique, continually refined the removal process. He kept filing the shapes, using a variety of tools. "You try everything," he said. He used "a riffler with a tungsten tip (or maybe it was diamond)" and a "scabbling tool," a toothed chisel which looks like a truncated fork.

When one of the dinosaur claws broke, he reattached it. In a few spots on a leg, the slate chipped and Roberts used glue and fine slate dust to repair these breakage points, just as he'd done with the granite nose.

A common misconception is that slate cannot be carved, but this dinosaur disproves the "truism." The fact is slate can be carved very slowly and patiently.

Bowls and chalices: *W.J. Rice*

Pic. 2.13 W.J. Rice *Octagon Bowl* (16" × 4") A hand-worked bowl was bored from Ffestiniog slate.

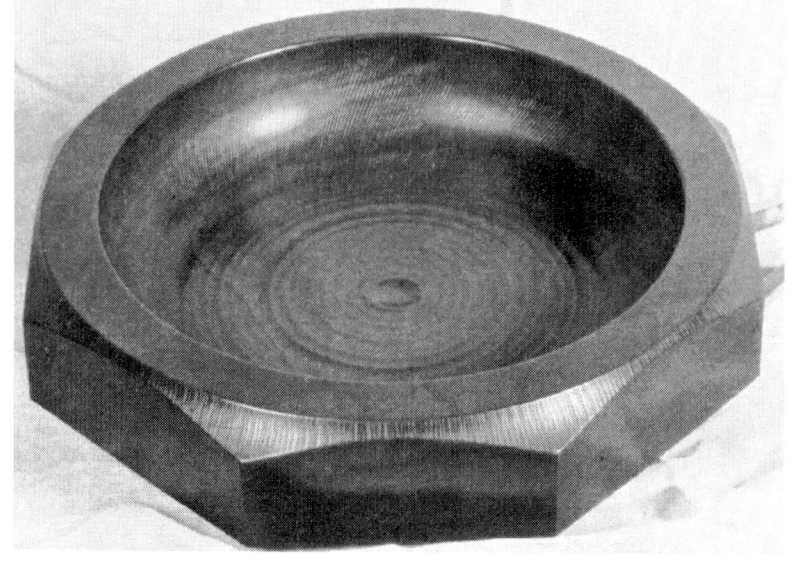

Another Welsh craftsman of exceptional skills is W.J. (Bill) Rice, born and brought up in Blaenau Ffestiniog in a family of quarrymen. During his military service he was stationed in Cyprus and explored castles and ancient monasteries there. His quarry heritage helped him see "that these native Cyprus builders had adapted and innovated their skills in stone carving" to produce "permanent, useful, and beautiful buildings."

With training and experience as an engineering fitter, Rice returned to Blaenau for a job in a local engineering factory in 1967 and met David Lewis, then the owner of the Craft Centre Cymru, which sells only Welsh-made items in shops across Wales. Lewis said he didn't like "trinkets in slate" but wanted well-designed slate ashtrays, and he encouraged Rice "to design and

Using the Material at Hand 17

make small ashtrays with circular centers and cropped corners." For a short time, making these became an after-work "apprenticeship" for Rice, following the tradition of generations of quarrymen, who often used what little leisure time they had to design and carve slate for decorative home items.

Many years passed before Rice decided to challenge himself with slate, deciding "it was time to create and make something truly worthy of this beautiful material." In 1990 he turned full time to producing slate objects that are useful and beautifully handcrafted, such as bowls of various sizes and plates or platters up to 18 inches in diameter. He makes urns, vases, sundials, bookends, and small clocks. His doorstops (Pic. 2.9) and candlesticks are most reminiscent of the folk art tradition, as he often incorporates the historical spiral patterns and concentric circles on them.

At the quarries, circular cores are cut from blocks of slate. The parallel slaty cleavage allows these cylinders then to be split into various thicknesses. While the quarries often split slate coasters only ¼-inch thick, Rice uses the cores for bowls two to four inches deep. The width of these would be determined by the width of the core. He also uses unworked blocks of slate and others cut into geometric shapes.

Slate is better if newly cut, Rice advises; though sometimes old pieces that have been sheltered out of the wind can be used. He makes an analogy to wood, saying slate is "like newly cut wood that will crack if it dries out." He seeks the best quality slate, selecting "the harder, denser rock" from the quarries he knows and the men who work there. He checks each piece with water to see if there are obvious cracks. By putting water on the side and waiting for it to dry, he can spot a crack on the smooth surface of the slate. Many pieces have had to be discarded when hidden flaws were revealed.

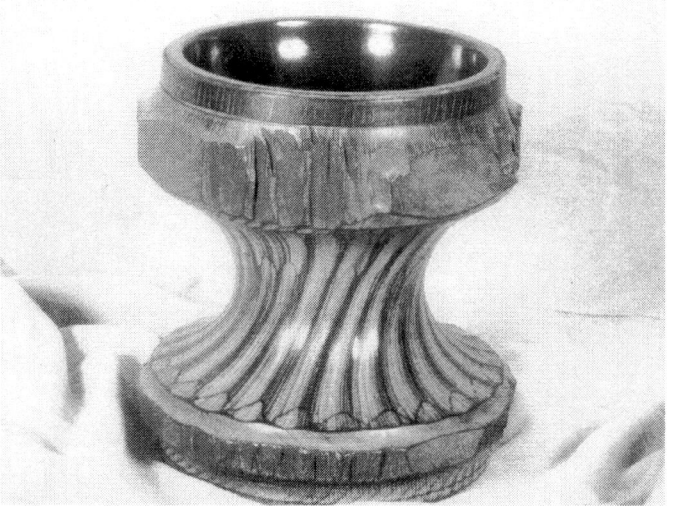

Pic. 2.14 W.J. Rice
Elevated Bowl (10" ×10")
Ffestiniog slate and a steel band adorn this intricately cut stemmed bowl.

The challenge for Rice has been "to gouge and carve a deep cavity in the slate without shattering or splitting the rock." Creating a beautiful, deep chalice, he used a block of purple slate that was worked differently from a bowl. He had to protect the stem and not let it crack as he carved the cup, stem, and base. His work is often simple and elegant, with distinctive spiraling marks. He seeks out various colors of slate from the quarries and uses mineral streaks or natural bands of color to enhance his designs.

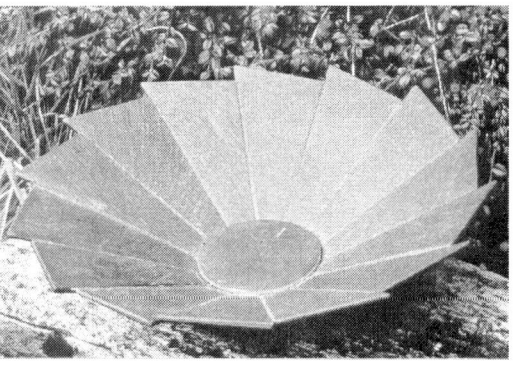

Color Plate 4 W.J. Rice
Segmented dish (17")
A practical and decorative dish was created from alternating slate colors from Ffestiniog and Dyffryn Nantlle.

Rice explains that sometimes layers of white quartz intrusions are found in slate. "Pyrites (Fool's Gold) or small spots of a contrasting colour" and bands of slate colours may all appear in the stone he selects to work (see Color Plate 4). Each quarry has its own distinctive quality and "colour, which is quite remarkable

considering these quarries all lie within a mere twenty-mile radius," he says of the North Wales quarries. But Rice points out that the slate beds range from 350–600 million years old and "so great variations in both quality and colour are only natural." The "Ffestiniog and Aberllefeni slate beds date from the Ordovician period. Bethesda, Llanberis, and Dyffryn Nantlle slate beds date from the Cambrian and Pre-Cambrian periods."

For Rice, slate is "a fascinating material, because of the different colours and the hardness of veins," as well as the technical challenges it poses him. He has designed for himself, made, and continually adjusts the machine he uses to bore out his slate bowls. For a while he rented workshop space in Blaenau Ffestiniog in Capel Rhiw, the home studio of internationally known artist David Nash who creates with wood. Rice then found a small workshop of his own a mile away from his home, where he works trying not to disturb neighbors with the grinding noise and slate dust.

Once the slate is turned to the required shape, it is either left in this raw state showing the mechanical marks or Rice uses a diamond sandpaper and "elbow grease" to polish the surface to a mirror-like smoothness. In the final step he adds a green padding to the base and rubs on a pure Welsh beeswax to seal the surface, as it adds shine and enhances the colors of his stone. He includes provenance information to each piece.

Rice likes "to make things that are relatively useful," thus uniting the practical with "a thing of beauty." As an example, he explains that "the low ambient temperature of this stone means fruit keeps far better in a slate bowl than anywhere else."

Rice continues to refine his slate carving machine and produce "new goods hitherto never seen in slate." He is attempting to bring "aestheticism to a basic natural raw material which has for too long been chained to the constraints of traditions and archaic industrial conditions." Once perfected, his slate-boring machine will hopefully "satisfy new commercial markets and introduce new appreciation to a public, which has been ignorant of the beautiful qualities of slate and its potentialities."

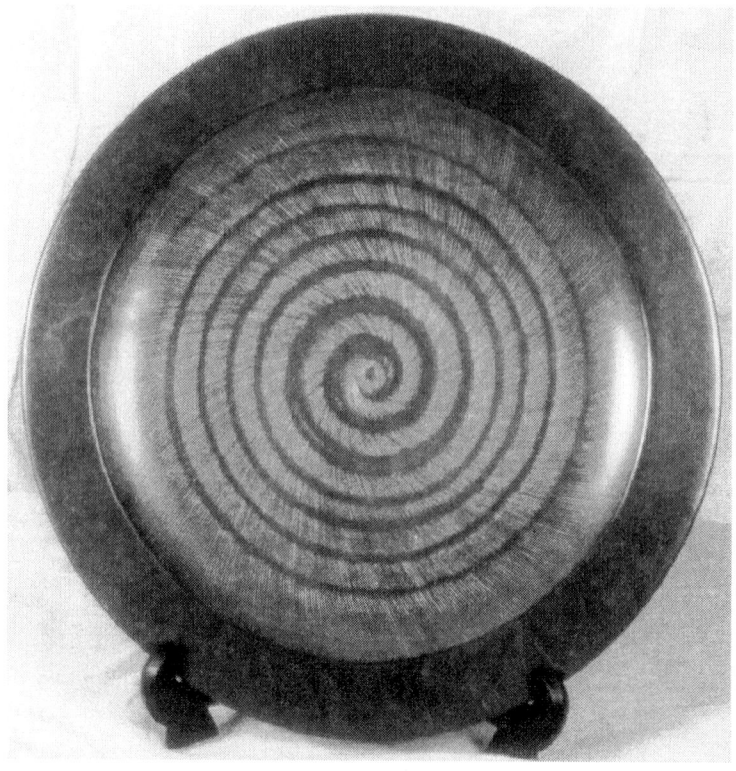

Pic. 2.15 W. J. Rice
Spiral Plate (12" diameter)
The spiral pattern of antiquity is carved here in a plate honed to a high polish on the border.

NEW YORK/VERMONT

Spanning the shared border of New York and southern Vermont, this "Slate Belt" is about thirty-two miles long and six miles wide running north to south. This unique region, considered as one continuous geologic unit, produces both black and colored slates, including greens, grays, purples, and mottled varia-

tions. The most unusual color is the New York red slate, a rich raspberry red resulting from abundant hematite (see color plate 5). The area is thought of as the "colored slate capital of the world" and has wide, comparatively shallow quarries.

When the Welsh started arriving in Washington County, New York, and Rutland County, Vermont, in the 1850s and 1860s, they found a wider range of tones in a smaller area than they'd known at home. Welsh quarries had distinctive slate colors, impurities in some veins, and varying degrees of hardness which prepared the immigrants for evaluating and working the slate in America.

Throughout the region, sidewalks of huge slate slabs still line many neighborhoods. School blackboards and tablets, slate pencils, and flagstone were produced, though roofing slate was the chief product. At its peak in 1905, there were two hundred working quarries in New York/Vermont slate belt.

Quite common in this region are slate roofs of colored patterns or with legible dates. In 1953 it was pointed out that "any house not slate covered in this area would stand out like a blackberry in a pan of milk." Mansard roofs and Victorian turrets across the United States were decorated with scalloped shingles in green, red, or purple from this area. Red slate, though the hardest to split, was used on local barns and the stately homes of quarry owners. Red slate on any roof can usually be traced to the quarries in Granville, Middle Granville, Hampton, or Hebron, New York. (Though a red-toned slate has been worked in Arkansas, USA, and Acton Vale, Canada.)

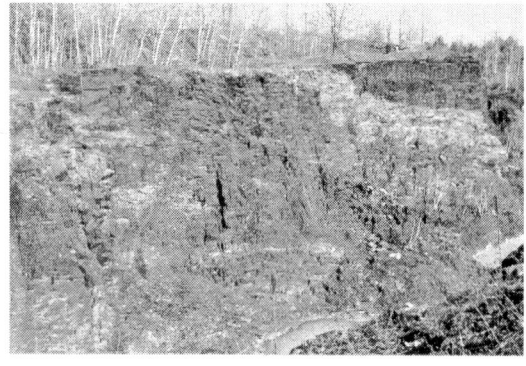

Color Plate 5 This red slate quarry has been worked by Sheldon Slate Products in Middle Granville, New York.

Marbleizing

One of the slate trades probably carried from Britain was marbleizing, or enameling, of slate. In order to develop a marbleizing mill, one Vermont slate company hired Ryland Hanger, a man from Plymouth, England, who was later dubbed by a Poultney newspaper as "the father of the marbelized [sic] slate business" in the United States. This was a Victorian business that turned inexpensive slate into simulated marble for fireplace mantels and bureau tops, to name only two uses. A marble mantel that might have cost $40 to $500 could be purchased in slate in the $12 to $125 range, as reported by slate industry scholar Gwilym R. Roberts. By the turn of the century several churches in this slate belt had marbleized slate pulpits, including the Welsh Jerusalem Congregational Church in Granville, New York. This black marbleized pulpit with gold-leaf engraving is now on display at the Slate Val-

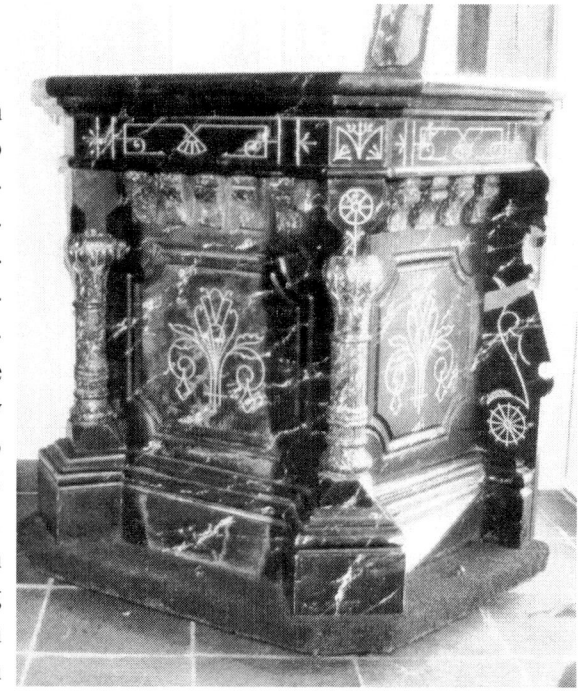

Pic. 2.16 Marbleized slate pulpit with gold-filled engraving, now in the Slate Valley Museum in Granville, New York.

20 **Slate of Hand:** Stone for Fine Art & Folk Art

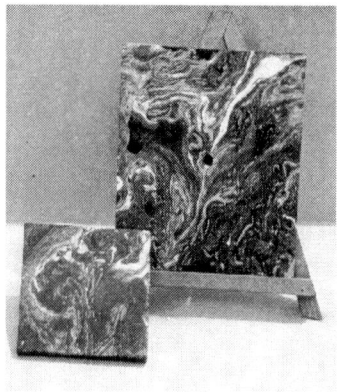

Pic. 2.17 Michael Ball Marbleized slate tiles (5½" square and 3⅛" square) with white and gold swirls were produced from a reinvented recipe.

ley Museum in Granville, along with chess boards and other marbleized artifacts created by Welsh immigrants.

Suzanne Rappaport, former Director of the Slate Valley Museum, explains that the process for making slate look like marble involved repeated painting and baking. A coat of black Japan paint was first applied to the surface and baked. The slate was then either hand-brushed or else dipped and pulled through a floating oil pigment swirled to the desired veining, in a process similar to marbleizing paper. The patterned slate was then baked, varnished, and baked again. Polishing with a pumice stone and felt block was done before one more baking. All this hardened the coatings and produced a finish nearly as smooth and heat resistant as real marble. One company in 1888 advertised that it could imitate at least sixty marble veins and wood grains. The marbleizing process was common enough, though guarded, between 1880 and 1915; then it went out of vogue.

Michael Ball, a modern-day marbleizer and art teacher in Fair Haven, Vermont, creates trivets, clocks, and chessboards of marbleized slate. He had queried local slate men but found them puzzled about the process for marbleizing; and he found he could not recreate the process with "old recipes," many of which used turpentine and ox gall as the floater (liquid). Since nothing seemed to work exactly as written, he experimented until he created his own technique. He uses a special jig to inscribe lines or has a commercial engraver score his slate chessboards. Ball masks off the section of slate he wants to protect from the flow of paint and uses a kiln to dry his marbleized surface, being careful not to use excessive heat that would dry out and explode the slate. Like the Welsh marbleizers who worked "at night behind locked doors" over one hundred years ago, Ball too keeps his exact process a secret.

Welsh artifacts: *John Benjamin Evans*

John Benjamin Evans (1875–1920), a slate craftsman from a village near Caernarfon, North Wales, came to Poultney, Vermont, in 1911, bringing with him samples of his slate handwork. Now on display at the Welsh Room at Green

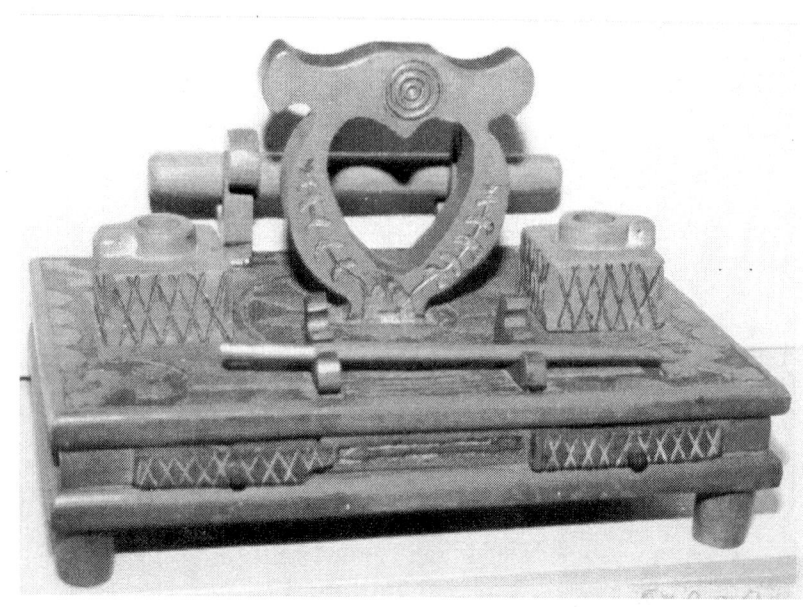

Pic. 2.18 John Benjamin Evans Slate inkstand (9" × 12" × 7½") motifs include simple cross hatching, concentric circles, a sunburst, and embellished crosses in each corner. (Donated to Green Mountain College by Morris Roberts)

Mountain College in Poultney is a slate fan of two-tone gray and purplish color and another broken, unfinished fan. The second might have broken in passage or while Evans, known as "John the Stone Cutter," continued to work it upon arrival. The intricacy of the opened fan attests to his skill (Pic. 2.11).

Another of Evans' creations in the Welsh Room is a complex inkstand of black Welsh slate, highlighted with gold in the decorative scribed lines of various patterns. A slate pen with a metal tip for a pen nib, two slate inkbottles, and a round slate rod to roll over blotting paper are all moveable parts on the base. Holding the rolling rod and pen, carved slate cradles flank a more intricate harp-shaped piece in the center, seemingly a handle for lifting the unit. Two small slate drawers slide in and out from the slate base.

Color Plate 6 Martha Levy *Men Working in Slate Quarry* (24' long)
This mural depicts Depression-era quarry workers. (From the collection of the Slate Valley Museum, Granville, New York)

Slate quarry mural: *Martha Levy*

A more recent art project than carved fans or marbleized slate on display at the Slate Valley Museum is a twenty-four foot long oil painting titled *Men Working in Slate Quarry* which was created as a 1939 Works Progress (later Projects) Administration's Federal Art Project (WPA). Landscape artist Martha Levy of Woodstock, New York, painted the quarrymen of her day hard at work at the various jobs within a slate quarry. Depicting local history, the large mural hung in Granville High School for many years and was eventually restored by artist Dean Fausett of Dorset, Vermont, in 1976. Now displayed in three parts, the mural artistically presents the "new world" view of slate quarrying (see Color Plate 6).

Small figure carving: *Don Botsford*

Don Botsford considered himself a "Vermonter," though he has lived in New York and then Massachusetts for many years. He was born in Granville, New York, and grew up just across the border in Poultney, Vermont. As a boy, he had made two items of slate, a turtle and an ashtray, acknowledging that he tried slate those first times, "probably because it was available." As an adult, he seemed to whittle slate, with detailed results similar to the dinosaur carved by Gwilym Roberts in Pwllheli. Many of Botsford's three-dimensional slate figures derived from patterns in wood-carving craft books, and yet he developed a method all his own for working slate. He carved slate in fulfillment of a personal challenge to see how far he could advance his skill.

Pic. 2.19 Don Botsford *Hound dogs* (4" high) Howling hounds were carved from mottled green (left) and red slate from the New York/Vermont slate belt.

Botsford's skills were developed in industry where he was an engineer working with ferrous and nonferrous materials, from brass and copper to ceramic and Teflon. He learned both handcrafting skills and patience, he explains, and came to understand the value of proper magnification in detailed work. He routinely cut .0015-inch diameter holes into pure silver parts for Vidicon vacuum tubes (the eyes of a television camera). The methods were so precise that it is possible to drill holes through human hair, which averages .0035-inch thick. He asserted, "You can manipulate muscles in your fingers to do wonderful things."

With early retirement, Botsford expanded woodworking as his hobby, making end tables, clocks, and chairs. He whittled a hound dog for fun, and turned to more complicated patterns after receiving a woodcarving kit for Christmas in 1996. He soon complained of wanting more of a challenge than he had in carving and painting wood.

Wondering about slate as a carving medium, he reduced by half an eight-inch pattern of a howling hound to carve it from a piece of gray slate. The carving looks almost like clay. The caricature has a big mouth and big feet, the ears are curvy, and the tail goes straight up. Next, he carved the same dog from a purple slate mottled with green that appears as a streak on the dog's back.

Returning to Poultney for a high school class reunion, Botsford visited the Sheldon Slate Products Company in Middle Granville, New York, to get more colored slate. At the office he requested permission to salvage something from their "junk pile of slate." The receptionist told him their insurance company did not allow this but that she would call Peter Tatko, the plant manager whose family owns the company with quarries in New York, Vermont, and Maine.

Tatko arrived in the office and was surprised by Botsford's carving. "Nobody carves slate!" he exclaimed, then carried the carved dog back to the plant to show others. When he returned, he brought Botsford samples of slate from the company inventory of both local and out-of-state varieties. Tatko explained that Pennsylvania slate was softer than the black slate from Maine and would be easier to work, but warned that local red slate would be "very hard and brittle." In the months ahead, Botsford found Tatko was absolutely correct about both stones. "The Pennsylvania slate was easy," but the red slate took him about sixty hours to carve, instead of the forty hours he'd needed for the earlier hounds. "The red polishes up nicely," he said, "probably because it is hard. I ran into hard spots too, which are usually flint." He learned from Tatko that red slate is "twice as much work to (quarry) as other colors; diamond blades are ruined faster," in the mill. And because it is so brittle, 99 percent of red stone quarried ends up on the dump tip!

Botsford continued using woodworking patterns on slate to make several Ozark Mountain characters on mules or swayback horses. For his wife he designed and carved a small black cat curled up on a red slate pillow and a detailed pair of nesting geese. He made companion turtles in black to accompany his earlier rendition and turned out nuts and bolts of slate, with moveable parts. He almost succeeded in carving a slate marble rolling freely inside a cube of black slate, but one

Pic. 2.20 Don Botsford *Ozark Mountain characters* (4" high) Figures were carved in slate from woodcarving patterns.

side of the cube split before he was done. The casual viewer not noticing the hairline crack is amazed at the clean proportions of this little feat of craftsmanship.

Botsford's basement workshop was well organized and exceptionally clean. He has created his own dust collector by building a plywood box housing three furnace-filters and a blower motor to draw the dust. He wears a mask when cutting both wood and slate, yet he has found that with his dust collector running, his mask is dust-free.

Using a photocopy machine, Botsford started most projects by reducing a pattern to four inches high – "the limit of my patience," he said. He then glued his pattern to the side of the block of slate. Strategically placed holes were drilled with a drill press, using a ⅛-inch high-speed drill bit. He worked carefully because the drill bits could break or bind up in the slate and cause it to split. The holes allowed him to navigate his manually powered saw when turning corners. Next, with the coping saw he used a rocking motion to cut away the unnecessary slate and thus produced a profile of his design. "This is a time consuming and dusty procedure," he said.

Botsford found he preferred to use the coping saw with the teeth on the blade attached reversed from the typical installation. His action was "to push on the blade, rather than pull it." With pressure from each rocking stroke of the inverted blade, stock is removed and "there's more cutting and less rubbing. The job gets done faster with this method used on long turns and straight cuts. It's a tedious process to cut out the profile and so any shortcuts are a big help."

Botsford experimented with a number of wood- and metal-working tools to grind the slate in the process of defining his figures. Grinding produces the most dust and made his dust collector especially necessary. Tatko sent him

Pic. 2.21 Don Botsford *Nesting Canadian geese* (4" high) A three-dimensional figurine pair was carved over forty hours from black slate.

Pic. 2.22 Don Botsford
Native American on horseback
(4" high)
Details and proportions were improvised from a drawing in a coloring book.

some drill bits, known as diamond quills, but Botsford of their bonding material didn't last well against the friction from slate. He saved these for fine details and hard-to-reach areas where little pressure is required. His dentist donated some carbide drills, and these he used mostly for facial details and for engraving the date, information about the slate's origin, and his name on the bottom of the finished pieces.

The best tools for refining figures Botsford has found were Norton grinding quills, called mounted carborundum points. They come in a number of shapes and vary from $1/8$" to $3/4$" inch diameter on a $1/8$" inch diameter shaft. A Dumore motor connected with a flexible shaft and hand-piece holding his grinding quills was used to do the carving.

Another indispensable tool Botsford relied on is his lighted magnifying glass. "This gets the light right where you're working," he said. "The fingers can be taught if only the eyes can see. Good lighting and good magnification are a must," he advised.

"I get a great deal of pleasure from making something nice to look at out of a piece of rock." Although many people work with wood and metal he felt "the challenge isn't there. Anybody can do it. But with slate, practically nobody else does it."

His most ambitious slate carving came from chiding by Everette, his brother and fellow wood carver. After requesting a pattern that would provide him with "more of a challenge," Don opened his mail to find a page torn from a child's coloring book. The detailed drawing depicted a Native American on a rearing horse. Everette had sent it with no message; but, "I knew what it was for and I was just stubborn enough that I kept looking at it," Botsford recalled, until he decided he could carve it.

He had to create his own side views for each of the carving's dimensions other than that drawn in the coloring book. Slate feathers, markings on the saddle blanket, and the horse's flowing tail required attention. He made the bow of wood and string, and the spear is copper wire painted black. "The Indian was harder to do than the caricatures, because the proportions couldn't be faked," Botsford said of the figure that required over sixty hours work.

To smooth the rough areas, Botsford used an emery cloth and an open grit sandpaper that dry wall masons use to sand patching material. He also used a grinding quill by hand to smooth curves, an atypical application of the tool. With dental bits, he carved facial features.

Botsford's biggest investment in his slate craft was his time, an analysis shared by other slate artists. He chose not to sell his work, because he "felt quite possessive about the figures." Few people had seen his carvings, few even knew he carved in slate, until he exhibited his figures in 1999 at the Slate Valley Museum in Granville.

Pic. 2.23 *Hebron Pond quarry, Monson, Maine*
Though the pit is now filled with water, the retaining walls of slate blocks remain and shore up the slate tip where trees are now taking root.

MAINE

Maine's slate region is near Monson, Blanchard, and Brownville in southern Piscataquis County, in the central part of the state. The slate belt is 15 to 20 miles wide and the beds are very steep, quarried in both open pits and later in deep shafts with lateral underground tunnels. "Monson slate," as this fine-grained slate is known, is a uniform, blue-black slate with an ebony-like surface.

Slate was discovered in Brownville in 1814 and Welsh immigrants worked there in the 1840s, but this slate region developed rapidly only after 1870 when William Griffith Jones, a Welsh miner, discovered an outcropping of slate in Monson and opened a quarry. Numerous quarries soon developed and immigrant workers came from Canada, to be followed by Swedish and Finnish people recruited to work the mines. With so few metallic elements and being easily cut and drilled, Monson slate is a nonconducting material used for electrical panels, switchboards, and insulators. The industry peaked and dwindled until only one quarry is in production today. The Tatko family's Sheldon Slate Products produces countertops, floor tiles, flagstones, and the occasional special order gravestone.

Lamps: *Gordon James and Guy Brown*

Being a nonconductor of electricity, slate chunks in freeform shapes lend themselves to the production of lamps. A simple column or solid upright slate-chunk, cored for the wire and crowned with a light bulb socket, decorates many homes. Another example, a more complicated water-pump lamp, was fashioned in the 1940s by Monson-native Guy Brown (circa 1900–1950) and visiting hunter Gordon James from Massachusetts. Probably using a woodworking design, the two men created a lamp with a working pump handle that produces not water but light, with the pull of a chain.

Brown supervised the planing of a slate stem and flat base, which were later etched and filled with gold leaf. Bored holes through the base and inside the post hide the wiring. A wooden dowel across the bottom of the post allows two screws

Pic. 2.24 Guy Brown and Gordon James
Pump style lamp (base and pedestal 7 7/8" high) has wires concealed in the pedestal and octagonal base, and the pump handle (broken) originally controlled the on-off pull chain.

Slate of Hand: Stone for Fine Art & Folk Art

Pic. 2.25 Emil Carlson
Silhouette and carved slate collection
Many silhouette pieces here are ³⁄₁₆" thick, fashioned from shiny black Monson slate.

from beneath the base to bite into the wooden dowel and secure the upright post, on which a waterspout is notched, supposedly to hang the bucket. A miniature bucket was secured to the base with screws, and a wire threaded through a seed-shaped bit of slate provided a grip on the bucket handle. James recalls this project was taken on when conditions were too inclement for deer hunting.

Silhouettes, carved chain, toys: *Emil Carlson*

At the quarry mill in Monson, Emil Carlson (1881–1950) worked at the rubbing beds finishing electrical switchboards and eventually as foreman. At home he continued working with slate, making household items like shelves, tabletops, and towel-hanging rings. He made a wide array of purely decorative and sometimes fanciful items. Many of his slate gifts, created over half a century ago for his wife and children, have been preserved by his daughter Lurene Carlson Houston.

Carlson often crafted five versions of the same slate items, one for each of his children. Houston reports that many of these have been lost or broken. Her collection of around forty slate pieces may be the largest in her family, even though she has given items to her own children and grandchildren, as have her siblings.

Houston's two older sisters were proud of their dad's work and in the 1920s took to school a one-of-a-kind chain he had carved from slate. Linked chains carved from a single stick of wood are common in Maine, but this slate chain was worth showing off. Carlson had carved the chain from a single length of slate over an entire winter. To keep from splitting the slate, he had patiently worked a

Pic. 2.26 Emil Carlson
Slate chain (broken) (2' originally)
Freely moving links of this slate chain are metallic and smooth to the touch.

small file to grind away the unwanted stone. It was probably two and half feet long and had at least eleven links, plus a hook and ring. When it broke at school, the sisters were heartbroken. Houston keeps the "smooth and satiny" pieces in a tin. They have the feel of polished metal.

The other slate creations by her dad fill a curio cabinet in her living room, not far from a slate hearth and Monson slate mantel over the fireplace. Using a handsaw, a coping saw, and in later years the electric jigsaw his children gave him, Carlson created a number of silhouette figures framed in circles and squares, based on designs traced from magazines of the day. He copied a youthful Dutch couple, a Southern belle in a hoop skirt, and a number of moose, deer, and hunters. Houston drew some of the designs or added branches to help round out a moose silhouette within a circular border of slate. Carlson drew some figures himself, including a man carrying a canoe with a dog trailing behind and another of a hunter with a hound. Additionally, he made ornamental shelves decorated with silhouette figure backdrops and graceful curving supports. Other pieces include three dimensional miniature animals, pairs of dice, a six-inch slate bolt with a nut that unscrews (much like those of Botsford), a doll's chair, and a Jumping Jack on a stick (Pic. 1.5). Carlson carved an inkwell, stemmed cups, and a candlestick – each so it might actually be used. Though smaller, these vessels are similar in concept and execution to works by Rice. Houston's favorite piece is a toy piano her dad made around 1920. The miniature instrument has a slate top and sides, as well as sixteen slate keys that plink out notes.

Houston does not recall how her dad got started with his slate crafts, because "it seemed like he had always done it." He and other quarrymen produced game boards of slate. One long-time resident reports that "almost every house in the Monson area" has a cribbage board, chessboard, or other slate game board. Even the cribbage pegs would have been slate, until replaced with maple.

Carlson may be only one of many quarrymen who experimented with slate silhouettes and toys, though he is certainly one of the most prolific. He died of silicosis in 1950, leaving his family a legacy of slate crafts.

Pic. 2.27 Emil Carlson Ornamental shelf (8" high) with flowing scroll work and detailed characters stands above a dog silhouette, laying flat.

The Kennedy Memorial

Thousands of visitors to the Arlington National Cemetery near Washington, D.C., stop by The Kennedy Memorial, designed by John C. Warneke. Here Monson slate with a naturally cleaved face marks the graves of President John F. Kennedy, his wife Jacqueline, and two children who predeceased them. The most recent addition, the headstone for Jacqueline Kennedy Onassis, was fashioned from slate quarried in Maine, milled in New York, and carved in Newport, Rhode Island, at the John Stevens Shop by John "Fud" Benson, master of letter cutting (Chapter 3).

PENNSYLVANIA

The Pennsylvania slate bed runs forty miles long and five miles deep, from north New Jersey through seven counties of Pennsylvania, and is said to be the biggest slate deposit in the United States. In the Lehigh-Northampton counties, the five-

Pic. 2.28 *Doney Quarry, Pen Argyl, Pennsylvania,* 1993 Slate slab on right is being lifted out of the pit by pulleys and cables.

mile wide Slate Belt region runs south of and parallel with the Blue Mountains. Some sections of the vein are very hard, others are soft, and each quarry has its own reputation for quality and applied uses. Different quarrying methods are used, depending on the configuration of the slate beds. Wide, shallow pits are used around Bangor, Pennsylvania, where the slate beds are relatively flat and the slate is soft and characteristically black with few ribbons. The Pen Argyl, Pennsylvania, quarries are narrow and deep, because the slate veins lie nearly vertical. Pen Argyl slate is usually black and often develops a light, golden brown surface color due to iron in the stone, much like the Delabole slate. Pen Argyl is where many Cornish came to work; nearby Bangor was the center for the Welsh.

During the first four decades of the twentieth century, Pennsylvania produced on average 40–50 percent of the national output of slate, making blackboards, plumbing fixtures, mantel pieces, sidewalks, electrical panels, kitchen sinks, and billiard tables. Marbleizing was done on checkerboards, bookends, tabletops, and clocks.

The earliest slate quarried in Pennsylvania was in the Peach Bottom district on the Pennsylvania-Maryland border. Discovered by Welsh brothers in 1734, Peach Bottom slate was very hard and lasted hundreds of years as both roofing slate and tombstones. It is not quarried today, though slate roofs, various architectural features, sidewalks, and slate dumps now overgrown with trees remain clearly visible in Delta, Pennsylvania.

Pic. 2.29 Roy Ealey Blue Boy comb-rack (approximately 15"×10"×3") of carved and painted slate from Pennsylvania provides a decorative household item.

Game boards: *Roy and Robert Ealey*

Pennsylvanian quarrymen used slate for household items and architectural purposes. Robert James Ealey (known as Jim Bob) recalls his quarryman father, Roy Ealey (1892–1976) who was the son of a Cornish immigrant, erecting slabs of slate as supports for bridges on their farm. When he came home from the Dally Slate quarry in Pen Argyl, Roy took pleasure in marbleizing game boards, carving dog figures and cartoon characters, and fashioning shelves of slate. In 1911 Roy created a comb-rack of slate, with a carved and painted youth on horseback (referred to as "The Blue Boy") on the back panel, above a three-inch deep tray with "Ealey" carved on its front. The combrack hung by a sink where the family used it for many years.

At age ten, Jim Bob started making checkerboards and today continues the family tradition of creating various game boards of slate. He engraves and then paints a checkerboard on one side and a Parcheesi board on the reverse of a square, slate board. "I have enough appreciation for slate not to cover it up with paint completely," he says, while admitting that he has not mastered the marbleizing process used by his dad. Jim Bob also makes slate clocks and heart-shaped earrings split with a razor blade.

A marbleized game board and some other items by Roy Ealey are on display in Mt. Bethel, Pennsylvania, at the Slate Belt Museum. Here also is a small slate Bible carved and gilded by John F. Gilbert and trivets, a sword, and a carved friendship plaque in slate, demonstrating a variety of local creations.

Gothic-design clock: *Humphrey Pritchard*

A polychromatic slate clock on display in the Old Line Museum on the Mason-Dixon Line in Delta, Pennsylvania, in the heart of the Peach Bottom slate region, is the prized possession of this small, local history museum. The eight-day floor clock of Gothic design stands seven foot, two inches tall and was hand-carved from dark gray Peach Bottom slate, red slate from New York, and black slate probably from Vermont. Humphrey Pritchard (born 1875), the clock's designer and creator, was the son of Welsh immigrants who settled in Arvonia, Virginia, where he was born and where his father owned slate quarries. His family moved to the Peach Bottom area and he became a slate splitter.

Pritchard's nephew, a man in his nineties, recalled that Pritchard had a speech problem and so elected to use his leisure time alone in his workshop behind his house. He labored a year and a half to complete the clock in 1906, though he'd built and dismantled one earlier after being unhappy with its proportions. The clock, now in a vault but available for viewing, has columns, spires, and six levels of grillwork. It includes carvings of deer, a rabbit, a dog, an eagle, pinecones, and oak leaves. The clock is held together by 1300 tiny screws and was once illuminated by interior light bulbs, though the wiring today is fragile and damaged.

Etched decorations: *Joe George*

Joe George, a retired foundry manufacturing supervisor and former "slater" at the quarry in Chapman, Pennsylvania, has created a kit he uses to instruct children and adults in the craft of slate etching. Working slate with hand tools is becoming a lost art, he explains, though he continues to produce decorative items using this simple technique.

For each of his workshops, he uses a hacksaw to cut and shape blocks of slate into pieces three or four inches thick. These he splits into 1/8-inch thick slates. He then sands the best side to a fairly smooth finish, bevels the edges, and seals the finished side and edges with a coat of clear polyurethane, which is immediately wiped clean. His kits for beginners contain one thin slate, a small line drawing to be used as a pattern, a pencil and carbon paper, a plastic straight edge, and two improvised chiseling tools. His directions explain how to scribe a pair of heavy lines near the perimeter of the slate, creating a border with one of the tools, and to then transfer the pattern with the pencil and carbon paper. The traced lines on the slate are scribed with his tool that looks like a dental bit (or thin, slightly blunted nail) on a small wooden stick. The scribing strokes are done heavily and drawn toward the artist, not away from him.

Pic. 2.30 Humphrey Pritchard *Slate Clock*, 1906 (7' 2" high) Designed and created by a quarryman, this hand-carved polychromatic slate clock was formerly illuminated. (In the collection of the Old Line Museum, Delta, Pennsylvania.)

Using the Material at Hand 31

Next, the area between the pattern and the border is roughed out with a sharp, flat screwdriver-type tool he calls "a backgrounder." George advises using a short twisting motion and to work away from the etched pattern and border lines. When the background tool is too big for detailed areas, the pointed scribing tool is used to continue the surface texture. A final clear coat of polyurethane on the border darkens the space outside the worked area and adds "another texture and color to the piece." The decorative pieces may be hung by a hanger affixed with epoxy, fitted into trivets, or mounted on wood for napkin or mail holders.

George maintains that, "Etching on slate is 10 percent skill and 90 percent patience!" His basic art kit allows the beginner to experience the challenge of working on slate with a high rate of satisfaction, while limiting the outlay of time and strength. Using thicker pieces of slate, the artist can carve deeper and get into relief carving (see Chapter 6); but the etching process is quicker than carving.

Pic. 2.31 Joe George
Slate etching kit includes a pattern and carbon paper, two scribing tools, and a thin slate piece (5"×3").

Pic. 2.32 Joe George
Decorative etched items include a letter holder, wood framed slate plaque, and salt and pepper shakers.

OTHER SLATE AREAS

The Eastern Townships of Canada, Newfoundland, Australia, Ireland, Italy, France, and England's Lake District all have slate quarries. The Buckingham slate from Arvonia in Central Virginia is widely known to be an extremely hard slate. The Hunsrück slate of western Germany is famous for its fossil deposits recording life in the Devonian seas. The slate islands along the west coast of Scotland thrived in the eighteenth and nineteenth centuries, producing blue-black roofing slate shining with iron pyrites. From slate quarries on the Scottish mainland comes one last local artisan to help show the range of locally wrought art.

Pictish designs: *James Thompson*

James Thompson, a self-taught artist with an interest in the prehistoric cultures of Scotland, recreates Pictish designs on slate plaques, pendants, and paperweights. He uses roofing slate from ruined buildings and bases his designs on the stone carvings left throughout Britain and Europe by Neolithic and Iron Age tribes. Though the true meanings are not known, the Pictish motifs include animals (boar, wolf, and stag), geometric designs (crescents, spirals, and concentric circles), both z-shaped and u-shaped rods, and figures of people with spears.

Thompson began working his designs with a nail, trying to replicate the originals and "capture some of the mystery that surrounds them." With a scribing tool from metal work, he now lightly scores in an outline and then "goes back to really gouge out the design and get a white line by creating a small canyon." Most Scottish slate is gray and gives a white line when scraped, but there is also a red slate he uses that goes to a soft pinkish hue. Done completely freehand, Thompson's circles are not perfect; just as the stone carvings of spirals and "cup-and-ring marks" from about 4000 years ago frequently have a flat side and are not perfectly round.

Pic. 2.33 James Thompson Three Pictish designs (approximately 1-2" wide) include a serpent and double disc with a z-rod from Aberlemno Tayside on gray slate (top left), the Knocknagael Boar from Inverness on red slate, (top right), and the Andross deer from Ross-shire on gray slate.

Creative crafts people continue to find applications for slate. Decorated wall plaques and magnets, sandblasted trivets, and silk-screened items of slate are common in gift shops and craft shows today in many regions. Artists use oil paint or acrylics to hand-paint designs onto reclaimed shingles, and at least one company mass-produces painted plaques on new, imitation-slate shingles processed from slate granules. The New Age interest in indoor fountains has resulted in water cascading down pieces of slate piled in tabletop urns. A California man selects slate from a nearby Mariposa quarry in the Yosemite Valley to create tabletop fountains and bases for Asian-style floral arrangements. Hunters seek out the most realistic sounding turkey-calls made by the Capozzolo Brothers of Bangor, Pennsylvania, from slate scraped with a wooden or acrylic peg. And in Montreal, Janine De Cacqueray includes bits of slate in the handmade paper she produces. Thus, the number of ways to be creative with slate continues to grow, especially in the slate quarry regions.

CHAPTER THREE

Monuments and Lettering

OVER TIME, SOME FOLK ART HAS BECOME FINE ART. THE GRAVESTONE CARVERS and letter cutters of the seventeenth and eighteenth centuries in Massachusetts provide a solid body of craftsmanship, now commonly regarded as among America's first sculpture. Frequently isolated from the trends of Europe and using locally available material, these individual carvers produced what they thought was expressive and what their skills and tools could accommodate. Local slate was available to these carvers in a number of outcroppings in several towns, though the early colonists first used simple wood markers or fieldstone. Slate was reportedly extracted from Slate Island in Boston Harbor for private use beginning in the 1630s. From the 1660s a fine Massachusetts slate was carved for gravestones and remained popular into the late eighteenth century.

The initial impression one gets scanning the oldest burial grounds in eastern Massachusetts is an overriding tone of gray. The white marble monuments of the nineteenth century are in a more recent section of such cemeteries. On closer inspection the older, slate stones do show a range of color – now generally dulled from the hundreds of years of weathering and pollution. Besides the standard gray slate color, there are purplish slates striped with light bands, light-colored slate with whitish bands, and shaly slate of rose and green. A few stones from an area southwest of Boston were cut so the letters appear in an orange tone against the dull green slate. The slate from the Pin Hill quarry in Harvard, Massachusetts, is generally a blue-gray. It was once thought that slate for gravestones was imported from England, perhaps as ballast on ships, but scholars find no supporting documentation. Researchers and geologists have determined that eastern Massachusetts had sufficient slate for the early carvers, though few quarries are extant today.

The quality of these slates has weathered the test of time – though some better than others. But after three hundred years, the carvings and inscriptions in the better slates of Massachusetts show crisp and clear designs and letters. Gravestone rubbing on slate surfaces using rice paper and special wax crayons, called heel balls, produces images with sharp lines, while sandstone rubbing produces a coarser tracing.

American carvers

Discovering who carved these stones has required serious research, started by Mrs. Harriette Merrifield Forbes in the late 1870s. She had recently been introduced to photography when she began a pioneering effort to record

gravestone information. She devoted herself with a scholar's zeal to photographing gravestones and researching court records, wills, and bills of sale to learn about the carvers and their beautiful memorials to ordinary citizens and dignitaries alike.

Her daughter Esther Forbes used much of her mother's colonial research in writing a Pulitzer Prize winning book, *Paul Revere and the World He Lived In*. Esther eventually submitted her mother's manuscript and photographs of gravestones to Houghton Mifflin, which published the landmark book in 1927, *The Gravestones of Early New England and the Men Who Made Them: 1653–1800*. By the time the book came out, Mrs. Forbes had moved on to photographing old houses, but her gravestone book remains a sound resource for students of New England history. She identified more than 100 carvers in New England who worked in the seventeenth and eighteenth centuries and documented their output, described their preferences in design, and analyzed their symbolism.

Like the Welsh quarrymen of later years, the American colonists who carved embellished stones frequently earned their livelihood at other jobs, supplementing incomes by carving upon request. They used the tools of their trades and were probably masons, bricklayers, roof slaters, leather workers, surveyors, or wood workers. One was even a "gentleman," records Forbes. They used various chisels, hammers, and mallets; and many relied on emblem books, pattern books, or woodcut broadside illustrations from Europe for their inspiration.

Two of the best early carvers are not known by name – one referred to by Forbes as "The Stone Cutter of Boston" and another known only by his initials, J.N. But then during this same period, records document the work of Quaker William Mumford, Charlestown's Joseph Lamson, the Forsters of Dorchester, and many more who carved in locally available slate and other stones.

Scholar Allan I. Ludwig credits Joseph Lamson (1658–1722) with being "the first carver who actually created what can be called a 'localism' or a true provincial variant of the English manner." Lamson was born in Ipswich, Massachusetts, and was "a mariner, a cordwainer, a surveyor, and finally a prolific stonecarver," writes Ludwig. Lamson's two sons and then their sons carried on the stone carving business that Joseph possibly learned from the Stone Cutter of Boston, whom Ludwig prefers to identify as the "Charlestown carver" and whom researchers today most often refer to simply as "The Old Stone Cutter." No matter the name, the skills were passed along.

The senior Lamson seems not to have signed his work, which was prolific, but there are examples of his style initialed C.L. or N.L., by his sons Caleb or Nathaniel. Gravestone scholar Laurel Gabel has found stones carved by the Lamsons in old burial grounds all over New England and along the Eastern seaboard from Nova Scotia to the Carolinas, as well as in Bermuda and Barbados. Gabel points out that Lamson stones went to the places where the ships from New England traded.

Like "The Old Stone Cutter," Lamson often included "memento mori" or "fugit hora," or he added a line from the Bible. Other characteristics of his work include "drapery at the top of the stone; the little [winged] men carrying the pall; …

Pic. 3.1 Joseph Lamson, carver The Timothy Cutler (died 1694) slate gravestone (27" high) in Charlestown, a part of Boston, Massachusetts, is carved with Latin phrases, imps of death, heads on the side columns, and his typical death's head symbol. (Photograph in the collection of the American Antiquarian Society, Worcester, Massachusetts)

heads at the top of the fruit columns; the use of small letters as well as capitals, and the narrower border of a different design across the bottom on the stone," according to Forbes. Lamson's characteristic death-head symbol had a broad top skull and highly curved eyebrows ending in hooks.

Lamson and his family often used a purplish, diagonally striped slate which might have been local or perhaps have come from Braintree (Massachusetts) where the slate was known to be stripy and reddish. The colored stones have a similarity to the reddish slate from Wales' Nantlle Valley, but slates from different areas can share common properties. It is not known where Lamson got his slate, but he did have a dock of his own and could have easily sailed to Braintree. He and his family used this characteristic slate for at least twenty-five years, reports Gabel.

In 1691 Joseph Lamson experimented with naked imps of death, or little winged men at work. His were more "boldly cut," according to Ludwig, than earlier examples and based on Lamson's own vision, not copied from illustrations of the day. Gabel has recently compared the imps to the "boxer" figures of English needlework samplers and suggests these may be the source for his death imp figures.

Ludwig says Lamson was the "first to codify the use of soul effigies [stylized heads] in foliated and floral border panels." At the top of a side column, Lamson

Pic. 3.2 Portrait stone (oval 10"×6") of the Reverend Ebenezer Bridge (died 1792) is similar to several portraits of Boston-area pastors from this era with round faces, almond eyes, and clerical collars.

used sculptural skills to carve human faces more realistic than abstract. Eyes fit into almond-shaped sockets, lips were more natural looking, and noses were no longer pendants.

Ludwig believes Lamson carved the first portrait effigies in New England on slate tombstones in Cambridge and Boston in 1709. Portrait stones frequently have unique, layered, wavy hairstyles and wear individually textured wardrobes. (Pic. 3.3 Elizabeth Goldthwaite) We have no way of knowing whether the stones looked liked their subjects or were merely carved to represent them stylistically. Jessie Lie Farber, gravestone researcher, finds too many repeated "portrait stones," as she calls them, to believe they are truly images of the deceased.

Documenting gravestones: *Daniel Farber*

Daniel Farber (1906–1998) and his second wife, Jessie, shared a mutual interest in old tombstones. She had worked on a book about a transplanted cemetery in South Hadley, Massachusetts, and they met at the American Antiquarian Society in Worcester, Massachusetts, where she had come to study his collection of gravestone photographs.

Farber was already a businessman and world-renowned photographer when, one winter day in 1958, he wandered into an eighteenth-century graveyard in rural Massachusetts and found a subject that would fascinate him for the next forty years. "The old slate stones were brightly illuminated by sunlight slanting across their handsome, aged carvings," he wrote. He had encountered "a magnificent new subject – early American gravestone art. These old stones are America's earliest sculpture." Recognizing that many of the stones were "fast weathering away and disappearing," Farber began a crusade to provide a photographic record that has become invaluable to art historians, genealogists, archaeologists, and students of American history.

Pic. 3.3 James New, carver The Elizabeth Goldthwaite gravestone (detail) (34" high) shows the slate carver's attention to hairstyle and clothing, as well as his use of background texturing on this 1796 stone from Northbridge, Massachusetts. (Photograph in the collection of the American Antiquarian Society, Worcester, Massachusetts)

As newlyweds, the Farbers began a twenty-year project, travelling "the length and breadth of New England and along the Atlantic seaboard from Nova Scotia to Savannah, photographing 7,500 different stones and creating a collection of 15,000 black-and-white photographs." They usually took two pictures of each stone – a detail of the ornamental carving and the whole stone in its setting.

The Yale University Art Gallery and the American Antiquarian Society make available to scholars duplicate sets of the American gravestone photographs. The Winterthur Museum in Delaware,

the Museum of American Folk Art in New York City, the Smithsonian Institution and the Library of Congress in Washington, D.C., and the Museum of Fine Arts, Boston all include Farber's gravestone photographs, either in archives or on display. Farber felt these images would provide information "long after the stones themselves have been destroyed by erosion, vandalism, and the careless use of mowing machines – all truly grim reapers." The stones and the photographs themselves have artistic, religious, and historical values.

As a team, the Farbers engulfed themselves in the study of early American gravestones, becoming experts in the field. Jessie and five others were the founding members of the Association for Gravestone Studies (AGS), a nonprofit organization now based in Greenfield, Massachusetts, with a membership of 1,200 worldwide. Dan was a leading member, a financial backer to the early Association, and President for a term. The Farbers helped with the 1989 revised edition of Forbes' gravestone book, and Dan provided sixteen new photographs to replace missing negatives from the original 1927 manuscript.

In the last years of his life, he and Jessie (with help from her son, Henry Lie) devoted thousands of hours to creating eleven CD-ROMs of photographs and detailed information about carvers and gravestones. Assisted with details by researcher Gabel, the Farbers provided computer access to their own photography collection, 1,259 photographs made by Mrs. Forbes in the early 1920s, and 486 photographs made by Dr. Ernest Caulfield in the 1950s.

Dan offered tips to other photographers who would attempt to capture the details of the dark, early slates and other tombstones. Bright sunlight, he specified, is needed to record the inscribed surfaces. "The sun should rake across the face of the stone from the side or top at an angle to the stone of no more than thirty degrees." It's not enough to have sunlight squarely strike the face of the slate, because "the details of the stone's design will not be as well defined and legible" without cast shadows. Also, snow reflects light and diminishes the contrast needed to define the carved surfaces; thus tombstone photographers should avoid snow and overcast days.

The fronts of stones in New England burying grounds generally face west and so "light up" for about one hour in the early afternoon. But frequently stones face other directions or may never by lighted by the sun, for one reason or another. A camera's flash might illuminate the surface but it wouldn't accentuate the three-dimensional effect in the carvings.

Alternatively, it is possible "to light the entire face of most stones" with an inexpensive door mirror, Farber was pleased to discover. He used a 15 inch × 50 inch mirror fitted to a tripod to direct sunlight as needed. All grades of mirrors can be used, but plate glass "produces the sharpest, brightest light with the least distortion." A mirror can be placed to reflect light from as far away as 100 feet, even to the stone permanently shaded by trees or buildings. Jessie acknowledged that even though "it sounds so obvious," it was a "huge contribution" Dan made in devising the reflecting mirror that extended "the length of time per day one can make an excellent photographic document." She points out that "you can move your mirror or wait for God to move the sun."

Stones to be photographed "should be cleaned with a soft bristle brush and water to remove dirt, lichen, and bird dung. Chemicals, detergents, and stiff

brushes may damage the stone and should not be used," Dan advised AGS members. If grass close to the stone is trimmed with hand clippers, the camera may capture lower lines or border designs. Clipping may also bring to light "signatures, prices carved into the stone, and other significant markings which should be recorded when the marker is photographed."

Daniel Farber found eighteenth-century gravestones to be works of art "exhibited in outdoor museums." He was especially interested in the decorative carvings on the tympanums, seeing them as pure folk art. Daniel and Jessie Lie Farber appreciated that American gravestones are unique historical artifacts – all dated, in many cases signed, and usually in their original locations. These hand-carved stones, commonly of slate, are art treasures, as well.

Gravestones in Great Britain

Scholars in both England and New England continue to study gravestones as both works of art and recorded history. On both sides of the Atlantic, early grave markers of perishable wood may have been erected, before stone was carved. Rough-hewn slabs of slate carved only with the date of death and initials were used to mark some graves in Wales before the eighteenth century. Then "carved and epitaphed headstones began to sprout in their serried ranks," explains Welsh historian Alun John Richards.

In Great Britain the long history of marking graves with stone sculpture – from Roman times, through medieval, to Victorian days – has been researched by a number of people honoring English craftsmanship. Foremost among the researchers is Frederick Burgess who wrote in great detail about the many materials and periods of gravestone carving in *English Churchyard Memorials* and frequently references American counterparts. Burgess points out that "impervious slate" for English grave markers came from two areas, the Midland counties and Cornwall.

Cornwall's most noted slate carver was Neville Northey Burnard (1818–1878) who left school at ten years old to work with his stone mason father in the building trade. The youth's natural talent for inscribing slate with flattened six-inch nails was quickly recognized and he carved many headstones, as well as busts and statues. In the churchyard at Altarnun he carved an eagle in flight against the sun's rays and signed it "N.N. Burnard Sculp aged 14." Burnard went on to study sculpture in London and develop his skills and reputation to the extent of taking commissions from the most illustrious men of the nineteenth century.

Slate monuments in Cornwall provided Mrs. Alice C. Bizley, a woman working alone much as Mrs. Forbes did, with a regional focus for a small volume of gravestone research in 1965. Bizley's research traced the development of making monuments in slate from the fifteenth to the eighteenth centuries. She was able in many cases to identify the craftsmen using their local slate, which was sometimes called "Cornish marble." The slate was plentiful, "very durable" and "widely used throughout Cornwall for more than four centuries," she writes.

Using simple line drawings in her book instead of photographs, Bizley made "careful record ... of every slate carved with the figures of deceased men and

their families." In 1965 sixty-four of the aged stones still remained in "forty-seven of the parish churches of Cornwall; and one in the churchyard at St. Enodoc" near Padstow.

She explains that the gentry and merchants of Elizabethan Cornwall found slate "the ideal material, at a moderate cost, for putting up family monuments," and later yeoman families copied the style of the gentry. Peaking about 1575–1650, figures of men and women were cut in high relief on slate panels and tomb-chests with backplates. She believed professional carvers executed these bold relief carvings until the end of the sixteenth century. Some early carvings were fully painted over, though this practice lessened as styles changed and the deeply carved lines became more and more shallow.

Since the high relief was difficult and time consuming to produce, carvers turned to "low or shallow relief and finally to use the incised line" which more easily incorporated details and was not as likely to flake the slate. Also, some carvers found human anatomy difficult to draw and so they leaned toward producing decorative lettering, as on the wall panel commemorating Honour Webber (1601) in the Church of St. James in St. Kew. Elaborate lettering and bas-relief carving are frequently found side by side, but each has its merits and notable practitioners.

Modern lettering techniques

Modern, hand-cut lettering embellishes war memorials, dedication plaques, donor tablets, foundation stones, office signs, nameplates, cemetery monuments, and garden inscriptions. These hand-cut letters will last as long as the buildings or monuments they adorn.

Today's power tools have modified the art of hand lettering on slate. Modern letter carvers are technology based and computer driven, most generally using air compressors and pneumatic adapters to carve or sandblast letters into stone in an effort to keep up with the demands of business. They may create a reusable pattern by cutting a rubber or Mylar® stencil or rely on commercial pantograph letters and cut about a dozen stones in a day, compared to the hand-carver who may do one per month. Even more recent technology produces photo-exact etchings done with a laser. Scanned or digitally-produced text and graphics can be burned into the stone without the need for masks, stencils or chemicals.

A calligrapher like Vermont's Tari Swenson who customizes designs of a word, phrase, or plaque pays special attention to the form of each letter. She transfers

Pic. 3.4 Cornish figure of Honour Weber (died 1601) in low relief stands upright about six feet high, with ornate lettering bordering the stone.

Pic. 3.5 Tari Swenson *Good Day, 1999* Calligraphy was designed and then cut through a layer of green slate into red.

her finely drawn calligraphy to a rubber resist and sandblasts her design onto slate which "offers an extremely crisp edge – facilitating fine lines and flourishes." Having the polychromatic quarries of New York and Vermont within an easy drive, she often selects slate with layers of color. She might incise her lettering through a top band of green to expose red slate beneath it.

Still, when it comes to letter cutting by hand, a few modern carvers – the elite and usually most highly paid – retain the age-old skill of carving with mallet and chisel, taking weeks and even months to complete a project. Calligraphy remains the basis of this slate art form that is as rare today as it is beautiful.

Pic. 3.6 Tari Swenson *Growing Wisdom Plaque "Four Seasons,"* 1999 Free-form lettering and nature motifs are incised into a slate plaque and darkened with a coloring agent.

Burgess, Britain's gravestone scholar and author, explains that handwriting styles influenced stone cutters from the seventeenth to nineteenth centuries in England. The masons sometimes emulated the penmanship taught by writing-masters of the day and at other times incorporated display types from posters and handbills. Imitations of calligraphic forms on stone abound and this "urge to imitate writing and printing was probably the reason for the monumental mason mainly restricting himself to incised inscriptions" – or the traditional V-cut.

Letter cutting by hand on slate can be accomplished several ways. In addition to the incised V-cut, another lettering style of recessed imprints is attained by outlining a letter with a square-cut channel and then splitting away the inside, thus producing a flat-bottomed, cleave-textured letter that is often augmented by gilding. Raised letters are achieved by laboriously chipping away background material to leave words exposed.

Having an integrity and beauty of its own, the classical V-cut letter is crisp and can only be produced with the chisel and mallet. Today's sandblasted letter has a clean external look, though its subsurface groove is rounded and may be irregular and pocked. These pockets in the stone will hold water that could freeze, expand, and break a letter apart. Additionally, letters with "islands," such as

Pic. 3.7 Diagram of letter cuts The angle of the traditional V-cut stays the same but widens as letters are more deeply cut. (Adapted from Harold Crossley)

V-cut sandblast cut square cut raised letter

A,B,D,O, or P, and those with juncture strokes, such as K,M,N,V,W,X,Y and Z, are vulnerable to ice. Because the V-cut does not entrap ice, it will outlast the sandblasted letter. Thus, the old way is the best way to create the longest-lasting memorial in lettered stone.

The elegance of letters hand-cut into slate shows to best advantage for viewing or photographing, as previously noted, when angled light enhances the strokes and varying depths of the grooves. Every chisel stroke leaves a white cut that contrasts with the slate's dark surface, allowing hairline swirls and delicately tapered serifs to stand out. Carved letters can be left raw-cut, painted, or gilded in 23K gold, palladium, or platinum leaf.

Britain's outstanding master of letter cutting and designer of letterforms, David Kindersley (1915–1995) suggested that both Classical Roman and Renaissance lettering provide good models for carvers to study. He believed the "art [of lettering] probably reached its zenith in the scriptoriums just before the advent of printing with movable type." Kindersley learned the art as an apprentice in the mid-1930s with sculptor, engraver, letter cutter, and typeface designer Eric Gill (1882–1940). Known for his elegant lettering and typefaces, Gill was involved with the revivals of both hand-cut lettering and later with direct carving of stone sculpture. Gill studied with Edward Johnston (1872–1944), who has been called the father of the modern revival of lettering, and both broke from the nineteenth century typographic tradition to rediscover beautiful, old letterforms of carving. Gill reconceived and implemented a sculptural power in his letters.

David Kindersley, and then his son Richard, took a slightly different tack with their design, experts attest, producing a lyric quality in their work. The senior Kindersley's workshop continues today as The Cardozo Kindersley Workshop, under the direction of his second wife and calligrapher-partner Lida Lopes Cardozo Kindersley. Since 1966 Richard Kindersley has had his own studio, designing and carving title-lettering schemes for businesses, cathedrals, and universities in England, following in his father's tradition. He has also responded to ancient standing stones, which he sees as giving expression to the inner spirit.

Pic. 3.8 David Kindersley Workshop
Alphabet
The importance of spacing is emphasized on this Welsh slate plaque.

Pic. 3.9 Richard Kindersley
Riven Welsh Slate Standing Stone
($8^{1}/_{5}' \times 1' \times 2"$)
This stele explores the pure geometric form of early Greek letterforms. Translation of the Greek: *Yet a little while is the light with you, walk while ye have the light.* St. John

In a series of standing slate slabs, Richard has hand-lettered poetry and philosophy. Elegantly formed letters are the basis for the work of these renowned carvers.

Preparing the slate

Modern letter cutters typically have the quarry's milling machine shape the stone plaque or monument and rub the slate smooth before shipping it to the carver's shop. Then, after further rubbing the surface with fine emery cloths, sand, or powder, the carver may either set the slate upright on a sturdy easel or place it flat on a tabletop to work comfortably from any side. Other times the letter cutter is commissioned to work an existing stone in situ, usually upright. The benefits of working a stone upright, instead of laying it flat, are that the carver sees it visually the same way viewers will and the slate dust falls away instead of pooling in the grooves. Working with light from over the left shoulder, a right-handed carver starts at the bottom and cuts each letter "from serif to serif, without ever adding serifs later," explained David Kindersley.

Tilting the appropriate tungsten-tipped or carbide chisel at two angles into the stone and tapping with a mallet of either wood or metal produces hand-cut letters of V-cuts. The cutting angles in a letter remain constant, which means a deep cut will produce a wider letter. Delicate lines and flourishes may be added by "chasing with a graver [a fine-pointed tool] rather than cutting with a chisel," suggests Burgess. Boston letter-carver and Past President of The Lettering Arts Guild of Boston, Frances "Frankie" Bunyard (1926–1993) explained that letter-carving techniques, similar to other art methods, can be learned in twenty minutes, but it takes twenty years to execute them correctly.

Pic. 3.10 Cardozo Kindersley Workshop
Flourish ABC
Calligraphic embellishments disguise the fact that a chisel, not a pen, was applied.

Pic. 3.11 Houmann Oshidari
2719 Pacific (8" × 11½" × ¼")
The artist used sandpaper and water to polish the surface of an oblong green slate; then with rasps and files he shaped the central arch and lined the border, before carving lettering of his own design with chisel and mallet.

Monuments and Lettering 43

Self-taught letter cutter John Williams of St. David's in West Wales cuts deep letters into his sundials, house signs, and commemorative plaques. The ³/₈-inch tungsten-tipped chisel he uses for most of his work – from marking out the design on the slate to smoothing the line of the V-cuts – has an added length on the handle for a better grip, which helps him control the evenness of his lines. He goes deep by pressing hard and using upper body muscles, then he goes back and takes out any rough bits. He now prefers a wooden moulder (mallet) to his metal one, since it is lighter and "has more kickback swing" than the heavy metal mallet.

Some early letter carvers took a direct approach and merely scored the widths of lines before starting to carve their text. These faint trace lines can still be seen today in many cases. Miscalculations abound on older stones, as there is no satisfactory method of repairing mistakes carved into slate, beyond rubbing out (or sanding down) the whole area and starting anew at a deeper level. Abbreviations and caret inserts were frequently used to correct errors in eighteenth-century lettering cut in slate. Williams tells of one old marker where the letter carver simply continued his word around the corner, onto the side of the stone.

Quite common today, and more accurate than "eye-balling" the space needed for a line of words, is the method of designing on paper before transferring the letters to stone. Houmann Oshidari of Lexington, Massachusetts, whose interest in stone lettering began with pen and ink on paper, apprenticed with Bunyard for two years before her death and learned that the carving process starts with "writing first on paper – ten to twenty times, again and again." The letters' outlines are commonly transferred to the surface of the stone with white, black, or yellow transfer paper or by pouncing. When pouncing is done, the letters are outlined with little holes applied by a notched roller, and then a fine powder is sprinkled which leaves the design on the slate. David Kindersley preferred pouncing only when a full-scale drawing or logo was provided; otherwise he typically offered a small sketch to clients and drew his design directly onto the slate with white watercolor pencil.

Lida Kindersley explains that "at the moment of drawing on the stone, our attention

Pic. 3.12 John Williams *Caersalem* (7" × 24")
This house plaque for Caersalem (Jerusalem in Welsh) includes the Celtic cross of Bishop Abraham and the carver's logo, JW intertwined lower right, all embellished with gold leaf.

Pic. 3.13 The Chelmsford stone of Benjam(i)n Spaulding (died 1737) displays block lettering with caret inserts, visible score lines, and spiral motifs.

Pic. 3.14 Houmann Oshidari *Genius is...* (11½" × 11½" × ¼") Oshidari is interested in history and carving quotations of long-lasting significance, i.e., *Genius is one percent inspiration and ninety-nine percent perspiration,* by Thomas Alva Edison.

Pic. 3.15 Cardozo Kindersley Workshop *Alphabet Box* (top view), 1971 (8" × 8" × 2") This blue-black Welsh slate has carved letters painted off-white.

is completely focused on making the design work. We draw from a scale sketch, not from a full-size drawing." Of vital importance is the awareness of space within and around each letter. Like the sculptor aware of negative space, the letter carver calculates the area untouched by the chisel. "Bad letterforms well spaced are infinitely preferable to good letterforms badly spaced," was the truism Kindersley offered his students. It takes an artist's eye and a calligrapher's design skills to justify the labor and time-intensive work of today's letter cutters working with chisels.

For more than ten years, Newport, Rhode Island carver, John "Fud" Benson has applied twenty-first century tools to his centuries-old techniques of hand-cutting letters. He acquired his first Mac® computer in 1987 and found Adobe® Photoshop® a "tremendously worthwhile tool for performing a rapid and exhaustive investigation of potential designs in a way you couldn't even do by hand," he reports on-line. He feels this is a legitimate use of modern technology but continues to carve in the traditional manner for most jobs, since "the stamp of the hand of the maker is part and parcel of the value of the artifact – and has been, time out of reckoning." Benson also uses his computer to help design fonts, based on his own handwriting and classic lettering.

Benson represents a long line of letter cutters to work from his Newport shop. The stone cutting business has passed from one generation to the next through three generations of Benson family artists who took up letter-cutting work in The John Stevens Shop, founded in 1705. The first John Stevens (1646–1736) was a mason and cordwainer (cobbler) who apparently learned carving from William Mumford in Boston and then moved to Newport and established a gravestone-carving business. Researchers see an improvement over the years in Stevens' lettering techniques. Frequently carving on black slate, he surrounded his script with simple borders and placed an unusual head with hanging teeth in the tympanum. His son John Stevens II (1702–1778) carved beautiful lower-case letterforms, though he is rarely acclaimed today. John Stevens III is noted for his decorative carvings, but his blocky lettering style sadly mimics typeface. The Stevens family passed the shop and slate carving techniques through several generations of carvers until the last Stevens stonecutter died in 1900.

John Howard Benson (1901–1956) picked up the basics of stone cutting from Stevens' family in-laws who did little letter-carving in slate but worked mostly in white marble producing Italianate decoration. Then Benson revived the hand-lettering tradition practiced by generations of Stevens family letter cutters

and distinguished himself as one of America's best designers of carved-stone lettering, on a par with Gill in Britain. Benson carved with steel chisels and used Monson black, Vermont green, and sometimes Vermont red slate, though the consistent texture of the black Maine slate was his preference for his bold letterforms and creative imagery.

After the senior Benson's death in 1956, his wife, Esther Fisher Benson, carried on the work of The John Stevens Shop with two assistants, until her son John (Fud) took tenure at the shop around 1961. Tungsten carbide tools had come into existence by then; and using these, the younger Benson switched to ordering the extremely hard slate from Buckingham, Virginia, which the old steel chisels of his father would have had difficulty working. Since the Maine quarries had all but closed, Benson typically ordered Buckingham slate; and yet the Monson quarry did fill special orders for him to carve the Kennedy family stones in a traditional New England black slate. His new carbide tools were just the beginning of progressive techniques introduced by Benson, who is noted for carving inscriptions on some of America's most prestigious monuments and buildings and for delicate botanical carvings.

Currently the Buckingham quarry in Virginia has been limiting itself to producing paving stones and roofing slate, so Nicholas "Nick" Benson, the third-generation carver now running the shop, has been using Welsh slate for several years. Nick also uses slate from Italy, though not for outdoor use, since it is soft and delaminates. His carving style is said to be much like his grandfather's, with rich ornamentation and strong letters, though he has developed his technique learning from the two generations of carvers before him.

Although marble replaced slate in the late eighteenth century as the favored stone for cemetery monuments, the beautiful lettering and idiosyncratic motifs of winged heads and floral columns on slate still stand sharp and clearly read today, even four hundred years later. Modern preference has also reduced both the amount of lettering and the intricacy of border designs on memorial stones, but slate still accommodates the simpler style. Lida Kindersley writes that her shop today uses many stones; but "since slate is impervious, it will stand in most environments for hundreds of years without lichen gaining a foothold. It is excellent for outdoor inscriptions, especially those that have long texts made up of small and fine letters." The Kindersleys' slate preferences have included Welsh blue/black, Cornish, and Cumbrian green; each selected for its distinctive color and appropriateness to its destination.

Because letter cutters through the ages devised and hand-carved their letterforms, their script styles have sometimes helped researchers identify the artists of unsigned grave stones. Even though today's monuments are sometimes sandblasted, the lettering's impact is still based on calligraphy and carvers continue to borrow or custom-design appropriate letterforms for their commissions. John "Fud" Benson and others have shown that computer-assisted lettering can save the hand-carver many hours of design preparation time, acknowledging the

fact that bad spacing will still ruin artful designs. Hand-cutting graceful letters on stone memorials will continue as an art form, with carvers using whatever new tools and techniques assist them in practicing this centuries-old system of rendering calligraphy onto stone, of using the word-form itself to enhance the written message. And slate hundreds of millions of years old will be quarried in the future to continue the tradition of commemorating lives and adorning buildings with carved symbols and elegant letters.

Jewelry

CHAPTER FOUR

At first, the concept of jewelry made from slate may strike one as impractical, or even unattractive. Yet the tradition of slate used as personal adornment in North America goes from pre-history and the Archaic period into the early Woodlands cultures of Native Americans, well before Columbus set foot on their side of the Atlantic. Native American artists created slate pendants, as well as bone, shell, and stone gorgets to be worn over the chest or near the throat, either suspended by a thin piece of leather or attached directly to clothing. Some experts suggest the gorgets may have been worn as arm bands or used as weights on an atlatl (a spear-throwing device). The gorget regalia were made from local materials like slate smoothly polished or exotic shells traded from afar and often were interred with the wearers at their deaths.

Flat slate gorgets are typically oval or rectangular with smoothly rounded edges, around two inches wide by four inches long, thin (even $1/8^{th}$ of an inch thick). They typically bear two cord-holes bored near the center, equidistant from the ends, though the number of holes varies and many are not drilled. Green, banded slate was commonly used, though gray, black, red, and other shades have been found. They were smooth and usually flat on both sides and only rarely inscribed, though shell gorgets were sometimes carved with birds, figures, or concentric circles. Gorgets made of slate suggest the desire for permanence in these medallions, perhaps worn by the elite members of the society. These gorgets of natural materials probably linked the wearers to their environment, clan affiliation, or social standing; gorgets may have been worn to provide protection from dangers.

Pic. 4.1 Native American *Gorget* (4" × 2⁵/₁₆" × ³/₈")
This banded slate biconcave gorget, found in Franklin county, Ohio, is from the Woodland (Adena) period. Most banded slate found in the Midwestern U.S. is known as glacial drift and was left behind by the retreating glaciers. Quarries of this material have been found in Ohio, Pennsylvania, and New York. Slate was traded into many other areas of the U.S. and southern Canada. (From the collection of David Stilp.)

Pic. 4.2. Native American *Pendant* (4¹/₂" × 2¹/₄" × ¹/₄")
More common than gorgets, pendants took various shapes. This pentagonal pendant of gray banded slate, from the Woodland (Late Hopewell) period, was found in Columbia County, Ohio. It may have been the centerpiece on a necklace. (From the collection of David Stilp.)

48	**Slate of Hand:** Stone for Fine Art & Folk Art

Modern jewelry makers who use slate tend to create smaller and more intricate pieces than gorgets. They pick up interesting fragments wherever found and polish the stone to bring out its colors or split it into thin wafers. Slate fragments may be drilled, filed, or cut into geometric shapes or natural forms, though "found" pieces have been simply arranged and soldered artfully, like abstract sculpture. The jeweler may fashion pendants, earrings, or brooches of unadorned slate or else incorporate the stone into pieces trimmed with enamel, gold, or silver.

Cumbrian geometry: *John Fletcher*

Pic. 4.3. John Fletcher
Two-toned cufflinks and earrings
Thinly cut slate from the Lake District features naturally banded colors.

England's Lake District produces a typically greenish-gray slate that is frequently banded. Sliced into thin pieces, this ribboned slate works up into delicate and light-weight earrings, as created by John Fletcher. He fashions his jewelry into simple ovals, circle quadrants, and dangling triangles that feature the natural striations; though to some pieces, he introduces a bright contrast to the slate's subtle green by adding a delicate, silver tracery.

The natural patterns of Cumbrian slate first attracted this self-taught artist, who has had some quarry experience. While working in the Lake District's Burlington Quarry, Fletcher devised the method of sawing very thin planes of slate from a block, much like slicing cheese. The industrial diamond saws cut with the grain of the slate and now provide Fletcher flat slices only three millimeters thick and 18 to 24 inches long by 6 to 8 inches wide with a pattern running throughout. He lays a cardboard template on the sheet and draws his designs right on the slate. Then he cuts the jewelry shapes out freehand with a diamond-edged wheel, getting as many pieces as possible from each thin sheet of slate. Since it is sometimes "hard to find well patterned slate," Fletcher uses epoxy with resin to apply silver designs when his cut pieces don't have enough visible pattern.

"The real shaping and polishing begins," he explains, as he "offers each small piece up to his stationary, diamond-impregnated angle grinder with water dripping onto it." He smoothes all the edges, grinds and polishes each shape, and matches patterns for

Pic. 4.4 John Fletcher
Silver embellished earrings
Silver tracery highlights plain slate without banding.

sets of earrings. "It's amazing how the weight drops down, as you grind and then polish each piece," he acknowledges. His final pieces are usually about two millimeters thick and light enough for earrings. With the final polish, Fletcher says, the slate "has a nice feel to it, much like it had been polished in a river." By its very nature, jewelry is meant to be touched.

Pic. 4.5. John Fletcher
Brooch of Cumbrian slate
Variegations and simple geometry play off one another in polished state.

Canadian abstracts: *Louise Desrochers*

An artist from the village of Saint-Camille in Quebec, Louise Desrochers has taken slate shards and "the scraps of society" to her heart. A landscape architect by day, she finds working with discarded slate allows her "to mix creative and practical arts" and create both jewelry and sculptural pieces.

While researching local Canadian slate quarries as part of an (art) grant, Desrochers carried odd slate chunks, copper wire, rusty scraps, and pieces of metal screen to her atelier for future projects. "I use slate fragments…, so quality of slate is not important. In fact, what is usually seen as defects, like oxidation, other stone or metallic intrusions, or fractures, are for me added qualities," she says. These irregularities bring something unusual and interesting to her sculptures – and she thinks of her jewelry as "small sculptures."

By collecting the slate fragments "first for their shapes and colors," she finds inspiration. "Since my beginnings as an artist, my tendencies have been toward sculpture," she explains. "The materials for my works (metal, wood, glass, stone, etc.) I collect while walking through society's denigrated and forgotten places: back alleys, dumps, landfill sites, and quarries. Through my sculptures and collages I integrate the forgotten and useless and infuse them with new energy, thus creating new realities or possibilities."

Pic. 4.6. Louise Desrochers
Abstract brooch (approximately 2" high)
Jewelry created as small sculptural forms includes found materials from Canadian quarries.

Desrochers neither drills nor carves her selected slate, but uses the pieces as they are found for her sculptural works. With her jewelry, she sometimes needs to split the slate fragments into thinner pieces, but she uses tools no more complicated than a hammer or plaster knife. Each piece she creates is unique, depending primarily on the features of the slate with which she works.

Painted scrap metal overlaid on slate fragments make up her jewelry series of brooches and earrings. She uses epoxy to fuse the components of the jewelry and with varnish enhances the natural, slate color to what it would be if wet. Typically she creates her pieces in batches of fifteen, over a four to five day

Slate of Hand: Stone for Fine Art & Folk Art

Pic. 4.7 Louise Desrocher
Brooches
Slate fragments and found objects from local quarries and visits to the slate regions in New York and France provide the basis for these brooches.

period. Most are abstract designs, but people often see animals or, in one case, an angel.

Desrochers has collected and stored slate fragments from her Eastern Township quarries and trips to Granville, New York, and Angers, France. In each case, she "fell in love with the different colors." Like a sculptor who has to live with a block of stone before carving it, so Desrochers feels about the stones she has collected. She just hasn't found what arrangement to shape them to, yet.

Kansas elegance: *Susan Ringer Koons*

Enamelist and jewelry maker Susan Ringer Koons suggests that "all artists look for new materials, for something they can respond to." Since childhood, Koons, like Desrochers, has collected and saved not only stones, but also leaves, acorns, and pinecones. Her art school training only reinforced her response to the beauty of these natural materials. But her approach to jewelry differs from that of Desrochers, since Koons manipulates her slate and introduces costly metals and enamels rather than only "found" elements. Her work radiates elegance.

Koons, a Kansas native, came to know a slate-producing area when she studied for her Master of Fine Arts in Metalsmithing at State University of New York at New Paltz. She was close to the Slate Belt along the New York-Vermont state line and recalls walking along railroad tracks and beside the highways in New York where blasting had exposed slate ledges. She picked up shards of slate there and on trips to Hyde Park, the Roosevelt family estate, or farther north at artist Frederic Church's magnificent estate, Olana, which features a polychromatic slate roof of an intricate design. While vacationing in Ireland, Koons found more slate pieces worth saving.

Color Plate 7 Susan Ringer Koons
Brooch (3½" × 1")
A half-moon of smooth enamel holds a textured, tapering slate with a dangling lapis gem.
The piece incorporates copper, sterling silver, fine silver, and fine gold.

Her found pieces, or "specimens" as she calls them, develop a "beautiful, natural patina from years of exposure to the elements." Koons works them into her jewelry designs believing "the combination of slate with other materials can cause beautiful and interesting contrasts." She creates jewelry that "conceptually plays off the material" and, once the pieces are

Jewelry 51

waxed and buffed, finds additional "hues and shines" in the slate (see Color Plate 7).

Frequently done in a series, most of her work is small. She may be working with an inch or less of slate, but even that can be unpredictable and she has found that slate "is not as forgiving as some stones." She concedes slate can be easily filed and trimmed, but understanding the layering properties and how to cut the pieces comes with experience.

Koons regularly incorporates slate and enamel into brooches and pendants, often surrounding them with 14 karat, 18 karat, or 24 karat gold and sterling silver. Because of the "natural edges" (squared corners at breaks) found in slate, she often abuts the stone against a bezel edge on the jewelry piece, as in *Metamorphosis*. At times she leaves the slate completely natural, as she did in her 1996 award-winning brooch with a glowing quartz pendant and wings of "especially pretty slate."

Her design process involves first handling several odd-shaped pieces of slate to experience the sense of touch and learn their limits. She begins sketching and "sometimes something quite wonderful comes out of this exercise." With her design sketched, she cuts and shapes the slate to her pattern, using files, saws, a flexible-shaft drill with various bits, and sandpaper.

Koons says she will "pierce the slate if it's not likely to flake away"; but because it does have a tendency to split, she cautions that the jeweler working with slate must be careful. Sometimes there are "happy accidents" but she tries to avoid even these by carefully inspecting the slate well before starting to work with it.

Some of her pieces are backed with silver, though some are plain. To affix slate to a silver backing, she "drills shallow holes in the slate to fit pegs soldered to the sterling. These holes do not go all the way through the slate, but the pegs match up" with the holes and then she bonds the

Pic. 4.8 Susan Ringer Koons *Metamorphosis* (3¼" × 1¼") This figural brooch is composed of a lapis oval and diamond set in 14k gold, atop a blue and violet enamel piece with 24k gold foil in it and set in sterling silver. A 14k gold bar separates the enamel from the slate skirt below.

Pic. 4.9 Susan Ringer Koons *Brooch with rutilated quartz* (2" × 1½") This piece, combining slate, 14k gold, and a subtle rutile crystal within the quartz pendant, won the Kansas Artists' Craftsman Award in 1996.

Pic. 4.10 Susan Ringer Koons *Circular brooch* (1¾" diameter) This round slate piece has inset elements of copper, enamel, silver, and 18k gold.

two surfaces with epoxy. She next applies a clear wax and lets it dry, before buffing it to a shine with a toothbrush.

For one brooch Koons started with a two-inch circle of slate, into which she cut a rectangular window. Into this centered window she set an eye-shaped piece of pink and lavender enamel in a gold bezel, filling the window. A gold bar attached with two small screws to the slate was added across the upper part of the window, and 18 karat gold beads completed the piece. The slate thus holds the enamel and gold adornments for this brooch.

Using small shards of slate, this Kansas jeweler emphasizes the integrity of the natural material as she adorns it with gold and silver. She also finds that adding enamel provides contrasts of rich color and smooth surface to be played against the muted, textured slate.

Welsh energy: *Sara Humphreys*

Sara Humphreys from North Wales has also created a distinctive line of slate jewelry (or, "jewellery," as spelled in Great Britain). Her work incorporates purple, green, and black slate found in the mountainous Snowdonia region of Wales. When she hikes there, Humphreys picks up slate shards and chunks that have been discarded by the quarrymen. Most of the quarries are now closed, but their towering dump tips rival the mountains themselves.

Like Fletcher, Humphreys looks for slate fragments with colors – those mineral irregularities in the stone that might have made it useless to the shingle splitter. Like Desrochers, she appreciates "making use of a natural but unwanted resource." She goes to the quarries twice a year and takes her time looking for the colors and patterns she likes. Colored variegations in the slate may include a band of green or a vein of light red or orange traced through the slate. She finds ovals of gray-green in dark gray or purple slates. When the bands of color in the stone merge, a woodgrain design sometimes appears (see Color Plate 1). Enjoying the outdoor exercise, Humphreys collects pieces from Llanberis, Llanrug, and Llanalenchyd near Bethesda where reddish and green slates are found.

Pic. 4.11 Sara Humphreys *Sun pendant* A gold overlay is carefully affixed above the oval inclusion of gray-green slate found in purplish slate common in North Wales.

Much like Desrochers, Humphreys started exploring slate with "sculpture on a small scale." Working on a BA degree in 3D Design, she was inspired by the slate work of Andy Goldsworthy and so fashioned her degree project in slate. With a diamond-tipped circular saw, she cut variegated slate pieces into jagged-

edged combs and then added splotches of metal. She left the spiked slate with rough, unsanded edges and sharp points; and she liked the results. At about the same time she was making a silver candleholder in the shape of a flamboyant splash with silver beads sparkling on it. She had a remnant piece of silver that she set aside for future use.

Sometime later, when making a gift pendant for a friend, Humphreys cut a small "splotty shape" from slate, capturing the essence of a splash – repeating a theme she enjoyed. She realized that her "off-cut of metal from the college project would fit over the design" and she carefully riveted it to the front of the slate. The silver splotch was domed (or curved) before being applied to the slate and the rivet nestled hidden into a recess in the back of the slate. This became the first in her jewellery line.

She now incorporates silver, gold, or oxidized copper (to get a red color) with her finely cut slate designs and has developed a method of her own for dropping metal sparkles. She softens the edges with various grades of sandpaper and polishes each piece with beeswax to enhance the slate colors. Humphreys uses either leather or a silver chain for pendants, preferring dark leather with the slate. Basically, her materials, except for the silver and gold, are inexpensive, but her biggest cost factor is that there is no quick way to work with slate. Her slate cutting process demands time and careful attention.

Taking inspiration from natural forms and shapes that seem to radiate energy, Humphreys frequently designs and cuts patterns suggesting "the

Pic. 4.12 Sara Humphreys *Splash pendant* and *earrings* Delicately cut slate shapes are enhanced with complementary silver (center) or gold.

Pic. 4.13 Sara Humphreys *Seahorse earrings and pendant* Precisely cut forms show off the inclusions found in Welsh slate.

Pic. 4.14 Sara Humphreys
Celtic crosses
Polished with a coating of beeswax, the naturally variegated Welsh slate is further enhanced with inlaid gold or oxidized copper.

sun, a splash, jesters, sea creatures, and insects." Customers request a full range of cut-slate jewelry, including earrings, large brooches, rings, and cufflinks. Whether the jewelry mixes slate and gold or is simply an unadorned sea horse of slate, Humphreys takes advantage of colors in her slate to accentuate her vivacious designs.

Her grandfather has helped make a bench-mounted jig saw with variable speeds and metal blades as fine as thread. This mechanized fret saw cuts delicate shapes from the slate, and Humphreys also uses a jeweler's piercing saw to hand-cut necklaces and earrings. She says it takes "a good few cuts to get the feel of the slate," testing to see which blade to use for each job. She pushes the slate into the blade, and a dust extractor fashioned from a vacuum cleaner motor and a garden hose sucks away the dust. She points out that it is important to wear a mask, as silicosis is a health threat for the quarrymen of years past and for anyone, including artists, working with slate today.

Humphreys re-uses her hand-drawn patterns, but each piece is unique due to the variety in her slates. As she removes her cut slate from the surrounding stone, she is left with a reverse silhouette and these delicate off-cuts are almost as enticing as the jewelry. People routinely ask to buy them, but they are given to customers as bonuses.

Northwest natural:
Sharon Boardway

Another jeweler who described herself as "a gatherer," American Sharon Boardway (1963–2000), collected beach stones as a child and felt drawn to natural materials, including semi-precious stones, fossils, and slate. She captured the beauty of Washington's mist-adorned Olympic Peninsula by incorporating subtly colored stones into designs that alluded to the shore and trees. Ovals and leaves of jade, agate, jasper, and ammonite blend with slate, sterling silver, and

Color Plate 8 Sharon Boardway
Leaf bracelet 1, 1999
Sterling silver, green and black slate, agate, and jasper spill like fallen leaves in this bracelet capturing the beauty of the natural world. (Photo courtesy of Boardway estate.)

bronze in her necklaces, pendants, brooches, earrings, and bracelets (see Color Plate 8).

Using carefully crafted leaf forms of these semiprecious stones and slate, Boardway linked the pieces with cast sterling silver shaped as twigs. She sometimes sandblasted or engraved words of poetry or Braille symbols onto the stones. And then further refined the letters using diamond-tipped tools. For one such necklace, she used slate from an old school blackboard, thinking the slate color was beautiful but also liking "the irony of permanently sandblasting something that once was used because it has erasable properties – now [making] these words … permanent." Boardway created art jewelry with materials meant to be touched, and she captured the beauty of native plants and stones which she took time to notice around her.

Pic. 4.15 Sharon Boardway *Wild rose necklace, series #2*, 2000 A haiku by Jessica Magelaner is carved (sandblasted) onto green slate set in sterling silver, with bronze and rose quartz accents. (Photo courtesy of Boardway estate.)

Pic. 4.16 Sharon Boardway *That was something in the rain woods* (detail), 1998 The title of this necklace is carved into green slate and archaen butterstone leaves, each set in sterling silver. (Photo courtesy of Boardway estate.)

Those readers who carry home a striped beach pebble or a round pinecone from a favorite vacation spot will understand the jewelry makers' interest in collecting and using slivers of slate. Desrochers, Koons, Humphreys, and Boardway share a "gatherer's" instinct, while Thompson seeks out a particular arrangement of banded slate for his work. Each appreciates the energy and beauty of nature. Slate's colors and textures, as well as the capability of being split or sandblasted, influence the artist/jeweler to blend slate fragments with more costly materials. Slate jewelry, both embellished and unadorned, becomes small-scale sculptures meant to be handled, as well as worn and admired.

Pic. 4.17 Sharon Boardway *Opposing leaf necklace*, 1999 Black slate and sterling silver leaves provide an elegant contrast. (Photo courtesy of Boardway estate.)

Painting

CHAPTER FIVE

CRAFTERS IN AMERICA NOW COMMONLY PAINT WELCOME SIGNS AND WALL DECORATIONS on recycled slate shingles. Any large craft show is likely to have a "slate painter" and retail shops sell commercially produced plaques. These pieces are done in oil or acrylic paint, frequently stenciled, and may be either mass-produced or individually painted. But the slate painting artists in this chapter rank as beyond the ordinary. Their works run the gamut from miniature to large scale, from detailed caricatures to bold swaths of color.

Slate has been used as a canvas in widely ranging eras – from *Ecce Homo* painted on slate by the renowned Renaissance artist Titian to little-known Walter Steward (1876–1946) a quarryman from Monson, Maine, who painted landscapes on slate in the 1930s. Cartoon-like characters populate the work of an English artist who painted on slate for almost twenty years.

Pic. 5.1 Walter L. Steward
Hebron Pond, Monson, 1935
(8" × 6⅝")
A local scene was painted on black slate by the Monson, Maine, quarryman and artist.

Figures in cityscapes: *Brian Gordon*

Brian Gordon, a self-taught artist who grew up in Liverpool, captured humor and characterizations in naïve-style paintings of scenes and interiors he remembered from childhood. He had sketched and painted prolifically over the years, but in 1978 Gordon picked up a roofing slate from a demolition pile he encountered on a return visit to his old neighborhood and decided he should use it as a canvas to paint his memory of the place. He soon found reclaimed roofing slates with their "evocative smell and feel of the soot and grime" triggered recollections of people, places, and events; they transported him back to childhood. He heard the street sounds and felt the fog on the River Mersey. He was inspired to paint scenes of people gathering in pubs, on the back steps, or on the sidewalks of Liverpool or Manchester.

Pic. 5.2 Brian Gordon
Three Women Watching a Wedding
(detail)
Drawing lines were transferred to slate and then engraved, before the figures and scene were painted.
(Sketch courtesy of the artist.)

Pic. 5.3 Brian Gordon *The Flower Sellers* (9¾" × 11¾") Capturing the sounds and smells of the river docks, the artist let the soot stained slate affect the paints used for sky and smoke. (Courtesy of the Boydell Galleries, Liverpool)

Color Plate 9 Brian Gordon *The Firewood Woman* (23" × 23") The camaraderie of local women amid the old buildings and factories is recalled by the artist, one of the small boys waiting. (Courtesy of the Boydell Galleries, Liverpool)

Gordon realized the gritty slates were "the very soul of [his] work," and that his "painting destiny lay in the use of slate." Conveniently, he had a friend in the demolition business who kept him supplied with slates and let him know their former locations. Gordon selected industrial slates for his scenes set in back streets or factory locals but farmhouse roofing slates for his country scenes, believing it appropriate to recreate scenes the slates had already experienced. For each piece he worked up a very detailed, full-sized pencil sketch and then used engraving tools to draw out the scene on the slate.

Having worked as a metal engraver, Gordon had years of experience lettering on silver presentation cups or large memorial plaques in brass and bronze. He made "a natural transition from metal to Slate [sic], as the same methods of engraving could be used, that is, hammer and chisels." He lightly scribed in the shapes of buildings and clusters of people before doing his exact engraving, which included details as precise as buttons, bricks, and the cobblestones under foot (see Color Plate 9).

Using thinned down oil paints, he applied colors not too thickly, so as to maintain the three-dimensional effects of the engravings. Because the slates were only-lightly cleaned before applying the paint, his oils interacted with "the stains and imperfections," some might "bleed and weep into the paint, creating some quite striking industrial skies," he explained. The engraved lines brought "a three-dimensional quality to the scenes and a sculptured emphasis to the characters," says Liverpool gallery owner Paul Breen. "The viewer is actually encouraged to touch the painting to feel the workmanship of the artist." Even with the finishing coat of paint, the texture of the engraved lines is still there.

In order to engrave and paint on large Victorian-vintage slate, Gordon trimmed the former shingles (sometimes as large as 28 inches × 32 inches) to eliminate the intruding nail holes from his "canvas." His exacting process required two to three months per painting and hinged on the slate being able to withstand his hammer and chisel. On only two occasions did his slate break, and Gordon recalls his family, sensing the disaster, quickly vacated the house. Finished paintings ranged in size from 9¾ inches × 11¾ inches up to

23 inches square and many of the two hundred painting/engravings have been made into prints.

Gordon has shared his engraving technique with his daughter, Rebecca Monti, a ceramist who, working from slides and sketches, produces fired-clay sculptural pieces of derelict Liverpool factories and warehouses. She engraves cobblestones on slate bases to mount her ceramic buildings and, in her father's tradition, scribes in roofing tiles on a reclaimed slate for roofs. Details are significant. Here is yet another example of the tradition of slate skills passing down through the generations.

Pic. 5.4 Rebecca Monti *Derelict Liverpool Warehouses* (10" × 4" × 3") Kiln-fired modeled clay was hand-painted and embellished with reclaimed slate, engraved for bases and roofs.

Painting variations

Another form of slate painting – or applying color to slate – is the marbleizing of slate, discussed in Chapter 2. Slate yards like the Tudor Slate Works of Inigo Jones & Company in Caernarfon, North Wales, offered a selection of marbleized or "enamelled [sic] slate chimney-pieces" at the turn of the last century. These fireplace mantels and surrounds were slate panels decorated with carved shelf-supports and painted designs; both marbleized and "hand-painted scenes" were offered.

Pic. 5.5 Inigo Jones & Co. *Enamelled Slate Chimney-pieces* advertisement. Commercial artists produced designs of hand-painted scenes or marbleized slate. (Flyer courtesy of Inigo Jones Slateworks)

In 1865, the Eisteddfod in Aberystwyth included for the first time an exhibition of the Art, Industry, and Products of Wales. On display were textiles, antiquities, painting, sculpture, and enameled slate ware, said to be a specialty of the Aberystwyth and Corris areas. The Ceredigion Museum in Aberystwyth displays examples of this enameled slate, both marbleized and hand-painted. Local artist Alfred Worthington (1875–1925) is credited with having painted many of the landscapes on these commercially produced panels, as well as on a table and some smaller items (see Color Plate 10).

Color Plate 10 Alfred Worthington *Llanbadarn Church*, circa 1900 This painting on a slate fireplace panel is one of several attributed to the artist who worked in Aberystwyth, where three slate enameling works were in production at the end of the nineteenth century.

One of Wales' most notable landscape artists from the mid-eighteenth century is traditionally thought to have created another commercial, though unique, example of a hand-painted slate. Richard Wilson, R.A. (1713–1782) used a slab of slate weighing "over a hundredweight" (112 pounds) to create an outdoor sign for the Loggerheads Inn, a public house near Mold, Wales. Famous for his Welsh and Italian landscapes, Wilson here depicted an argument between an unnamed local man and the vicar of Llanferris. Two men's heads face opposite directions in the painting, titled *We Three Loggerheads*, with the third person supposedly being the one viewing the sign. Hung outside a pub, the painting attracted many viewers; but because it was exposed to the elements, the owner brought it inside and placed it under glass in 1928. Recently it was examined at the National Museum of Wales, as part of an investigation of Richard Wilson's techniques, with inconclusive results as to when the piece was painted, or if it was definitely painted by Wilson. Since the paint was exposed to the elements, the sign was possibly touched up in restoration efforts.

Miniatures: *Ken Taylor*

Small, slate plaques with white line-drawings of Welsh castles and waterfalls have long been commercially produced, sometimes confusing tourists as to whether the scenes were painted, etched, or mounted decoupage. Ken Taylor's reaction to these mass-produced, silk-screened or transfer-design slate plaques and coasters was to paint his own miniatures and offer tourists a more personal and aesthetically satisfying memento from Wales.

Taylor creates detailed works of miniature compositions on dark gray Welsh slate, as well as on black mount board. His subjects include the animals, birds, and scenes he sees daily on walks with his wife along country lanes in their neighborhood. Painting on slate developed as a sideline to his miniature-painting career; and he finds his slate pieces are unique because few modern artists in Wales, if any, hand-paint directly on slate.

Taylor's first slate paintings were on random pieces of roofing tiles (shingles) which he sanded smooth with a power sander. Aware that the best silk-screened designs were applied to a velvety smooth slate, he eventually contacted a local company that printed souvenirs on polished slate disks and arranged to trade completed paintings for pieces of the prepared stone. These slates came to him cut as perfect circles of various sizes, sanded silky smooth, and thus saved him a good deal of preparation time. As frequently recognized by artists, the material may be inexpensive, but the time involved working with slate is what adds up and makes the finished product costly.

Pic. 5.6 Ken Taylor *Pistyll Rhaeadr* (1 7/8" diameter) The 240-foot waterfall in the Berwyn Mountains of North Wales is depicted in miniature.

The prepared circles of slate proved to be ideal for painting miniatures. With diamond-impregnated tubular cutters, slate yard workers had drilled into blocks of slate and extracted solid cores of slate in varying sizes: 2", 3", 6", or 9" in diameter. They then split the round cores into 1/8 - inch disks with natural,

slightly rough surfaces. Both the flat sides and narrow edges were sanded smooth and polished. Taylor used the plain, glossy circles and found he liked going smaller and smaller on these core samples.

Taylor frequently paints hedgehogs, foxes, cats, and birds on slate, because the combination of these natural creatures on the dark gray slate pleases his customers who have come to expect them. His specialty miniatures on 2" or 3" orbs are little cameos of country life, including an aging gate along a farm lane near his home which he has painted in four different seasons. The gate intrigues him with its differences in light and shadow, and its seasonal foliage or snow capped dressings. Though miniature, his works include berries, flowers, and even a rusty wire on the fence, shown as a red line with a black shadow.

Painting miniatures calls for a different technique from that used by artists who work large, explains Taylor. Not washes of color, but details are what are important – and he can accomplish these on polished slate, even in postage stamp size. Britain's Hilliard Society of Miniaturists defines miniature work as reaching up to a maximum size of 6 inches × 4.5 inches, including the mat and frame. Taylor notes that some galleries require that "you must be able to hold [a miniature] in [the palm of] your hand."

Taylor paints straight onto his polished slate circle with gouache, a water-based paint, applying it thickly, much like an oil paint. He starts with a photo reference of his subject, selecting the central point. Because he pursued a twenty-year career in the advertising industry before turning to miniature painting, he has developed an eye for subject matter and a sense for what makes a good composition. Loading his nylon brush with paint, he focuses on the center of interest and works from that center outward, always adapting the picture to fit the slate circle and introducing details as he goes along. His eye for composition and inspiration from his daily observations of nature come into play as he paints.

Taylor's palette selection of high-quality gouache is limited to seven or eight colors. Because his background of slate is dark, he mixes white with most of his earth tone colors to give them strength and vibrancy. He uses ochre, yellow

Pic. 5.7 Cylinders cored from blocks of Welsh slate leave a honeycomb remnant, depending on the diameter of the cut.

Pic. 5.8 Ken Taylor *Hedgehog with Berries* 1³⁄₈" diameter
Paintings of flora and fauna in miniature find a compatible canvas on black slate.

Pic. 5.9 Ken Taylor *Gray Squirrel* (3" diameter) Gouache flows easily on polished slate core samples.

ochre, siennas, and dark brown, all of which tend to be the more permanent colors, and he avoids those colors, like turquoise, which fade.

Taylor signs and sprays his finished painting with several coats of a clear lacquer. In the past, he used to brush on varnish; but he found it streaked on the miniatures and the brush strokes showed, so now he prefers the method that is easier and speedier. His painted slate circles are then glued onto matboard and framed.

Using a square of slate: *Barbara Kulicke*

Working at the other end of the size spectrum, Barbara Kulicke goes for grandeur of scale. When she decided she wanted more slate to paint on than the random shingles that fell off the roof of her old farmhouse in Blairstown, New Jersey, she went directly to a Pennsylvania quarry. Told that a roofer orders "a square of slate," she did the same, and then learned that "a square" covers a 100 square-foot surface on a roof with overlapping shingles. But her experience of visiting the quarry helped inspire her to produce one large art installation from that full square. She used all 115 pieces of slate, each measuring 12 inches × 24 inches and all without drilled holes.

Crossing the Delaware River, Kulicke had ventured into unknown territory in Pennsylvania's Slate Belt, a half-hour from her home. She asked directions for getting to the quarry entrance, though mountains of slate dumps were visible in the surrounding area. Passing through an open gate, she and a friend drove up a hill to the Doney Quarry, (Pic. 2.28) where she felt "the whole industry is in a time warp, left over from the late 1800s." Only a rope barrier marked the edge of the pit she was invited to view and she was not prepared for the sight.

"There on the other side of the rope was this abyss that went down about the same depth as the Empire State Building. It was a rainy day, so the slate was wet and black. The whole side of this hole was black and at the very bottom was this brilliant aqua blue water." She was thrilled by the "contrast of that luminous blue against the dark shining, wet slate. And then at the bottom there were all these tiny little ant-sized figures in yellow slickers working." Kulicke was "overwhelmed by the sight of this ... and realized it was such a phenomenal, extraordinary activity going on in our midst that nobody seems to know or care about, that [she] decided to commit [her]self to it for a while."

Since 1992 she had been using oils and watercolors to paint multiple interpretations of one landscape. Now with a large quantity of slate to use as canvas, she was able to paint the many variations of the river view from her studio window. She was enthralled by the "dramatic convergence of two mountains into the Delaware River."

"I have chosen to paint on slate because I like the texture, color, and consistency," she explains. "It works well with oil paint and as a background color for appropriate parts of the picture which are left unpainted."

Kulicke worked for four years to complete the *Homage to a Square from the Slate Belt*, her series of 115 pieces (see Color Plate 11). Each painting in the installation is unique, though the composition is constant and the seasonal view from her studio window only slightly varied – an "almost Yin-Yang mountain

view," as she describes it. The slate tiles hang at eye level in five rows of twenty-three horizontal pieces extending to a width of fifty feet.

She negotiated to use a nearby barn to hang and arrange the work in progress. "After I finished a few and they were dry, I put them in a wheelbarrow and walked them down the road," she says. She found it interesting when she installed "a newly finished painting with the others, to see the variety achieved within the limitations of the composition and subject matter." Kulicke had first worked out the whole design on paper with watercolor, at the request of an art consultant. Having captured the many seasons in oil paint on slate, she admits it was "kind of amazing," when the 115 pieces were assembled, to find the whole work looked so much like her preliminary sketch.

The foreman at the pit appreciated the tribute of her mural and "was really quite moved" by the fact that an artist had recognized the slate quarry industry. Kulicke also used the title of her work as an accolade to Joseph Albers (1888–1876) whose work she admired. Albers was from the Bauhaus School in Germany where artists believed industry, everyday life, and abstract art could come together in architecture; and he painted a series *Homage to the Square* which studied squares within squares in many variations.

After completing *Homage* in 1995, Kulicke painted a series of large 4 × 8 foot canvases in oils, needing to move out of the small slate format for a time. When she returned to slate, she ordered another square of the largest roofing shingles she could get from the quarry – thin slates 18 × 18 inches. A square of that size consisted of 106 pieces. Her subject matter shifted to the river's edge on the Delaware Water Gap, looking up at the gap. It was a dramatic view and changed from day to day, and even minute to minute. *A Square to the Gap* was exhibited as a work-in-progress at the Prince Street Gallery in Soho, New York City in the spring of 1999 and then in 2001 the 106-piece slate series became part of the Newark Museum's collection.

Color Plate 11 Barbara V. Kulicke *Homage to a Square from the Slate Belt*, 1995
A painted square of slate (115 pieces) was exhibited at ETS Gallery in Princeton, New Jersey.

Pic. 5.10 Barbara V. Kulicke A *Square of the Gap, Fall*, 1996 (detail) (18" × 18")
Oil paintings on slate form a mural of 106 parts, depicting the Delaware Water Gap. (From the collection of the Newark Museum.)

Pic. 5.11 Barbara V. Kulicke A *Square of the Gap, Fog*, 1996 (detail) (18" × 18")
The oil on slate mural captures variations of the same scene done in all seasons and weather conditions. (From the collection of Ed and Vera Silverman.)

Kulicke has created a number of large-scale installations comprised of dozens of identically sized, natural slates, either rectangular or square. Bristol-Myers Squibb Company commissioned her in 1996 to create a thirteen-foot slate mural in oils titled *Delaware Water Gap – Four Variations*.

Kulicke acknowledges, "In the history of art there are a few examples of paintings on slate. The nineteenth century painters used it occasionally as a painting ground and … Titian painted … a small figure painting that is hanging in the

Pic. 5.12 Barbara V. Kulicke *Delaware Water Gap — Four Variations*, 1996 (3' × 13') Vibrant colors of the seasons along the Delaware Water Gap were painted in oil on sixteen square slates (18" each).

Prado Museum in Madrid. Among my contemporaries there are more sculptors than painters involved with this material."

Painting that approaches sculpture: *Merrill Wagner*

Because she often uses layers of large pieces of slate, New York City-based artist Merrill Wagner allows that her work has a certain three dimensional quality, but she considers herself a painter, not a sculptor. Since the 1950s, this artist has been exploring color and, since the early 1970s, experimenting frequently with slate as her canvas. She says, "I paint on the surfaces of things, and I don't alter the shape of the material," as a sculptor might. She uses broken bits, slate shingles, and old blackboards from schools as a surface for drawing or painting with chalk, oil pastels, or oil paint.

Her earliest use of slate resulted from her work employing fabric tape and masking tape. She put wide bands of tape down to cover a surface painted with oil pastel or a soft pastel and then pressed the tape into the pigment. She lifted the tape, picking up the color, and then reapplied the entire drawing to either glass or Plexiglas®. The viewer then looked through the glass to the transferred image. Wagner was making "a kind of monoprint, a rubbing, or transfer where the image was revealed by the glass." But with her original art on paper, she found it tore easily as the tape was removed.

"So a stone surface seemed to be ideal for [solving] that," she says. "And that's how I got to be using slate." She "made a series of prints or images that

Pic. 5.13 Merrill Wagner *Cobalt 10*, 1983 (3' × 35') This slate installation in shades of blue leans on a wall and extends like a mountain range.

were pulled off the original drawing that was on slate."

Wanting a good supply of slate, Wagner bought used roofing shingles, floor tiles, flagstones, and "entire shipments of blackboard slate from school renovation projects." Like so many other slate artists, she admits to being "frequently interested in things that have had a life before – that have been used before, such as roofing tiles." Slate roofing tiles in various stages of deterioration have interesting irregular forms she says. "When slate breaks, it breaks in these beautiful shapes."

She has also used pool table slates, which are "very heavy and very thick. It's probably an inch [thick] and that's hard to manage. I did work with it all one summer and I hurt my back quite badly doing it." Wagner got these slates in pieces from "a billiard table manufacturing place."

She used the slates "to paint on, as though they were a canvas." She says slate is a "beautiful stone to look at. Sometimes it doesn't seem like a stone. It's really fascinating." Like Taylor and Kulicke, she often left some of the surface of the slate showing and she went through "various periods" studying colors. Her drawings and paintings in the 1970s and 1980s often used short strokes and bright colors, even "a lot of pinks." These works were done in oil pastels, casein, and oil paint.

She created a painting series in the mid-1980s on slate, other stones, and "pieces of cement from the sidewalk in the city. They were three dimensional ... stacks of rocks." She painted these piles "in a way that would indicate how they should be reassembled." The painted pile could be remade "like a puzzle," by aligning its geometric patterns.

Wagner says, "I didn't ever really consider myself a sculptor. I started doing things on the floor, but I was really arranging stones or stacking them." She painted her stone canvas and allowed slate itself to become her primary material. Fragments of blackboards with irregular surfaces were lined up fence-style and covered with paints.

For one series she painted "different pieces of slate with different brands of cobalt blue. They would look different to start out with," she explained, "because if you go to an art supply store and buy casein cobalt blue, Winsor Newton oil paint in cobalt blue, and Winsor Newton watercolor in cobalt blue, they won't all be the [exact] same color to start with." Left outdoors, these paints changed "at different rates and in different ways. Some of them [faded] to white and [got] lighter and lighter," she found. Some disappeared quickly; and some of them didn't fade for many years, if at all. For Wagner, this was an exploration of color on slate, where "all kinds of different things happen[ed] over a period of time." Linking slate to the passage of time and observing the anticipated but unplanned changes brought by nature's elements reflect a modern trend in the creation of art forms.

Wagner's slate works became part wall hanging and part sculpture, though she still considers them paintings, as is *Soar* created in 1998. Three pieces of

Pic. 5.14 Merrill Wagner *Folded Wing Puzzle*, 1985 (31" × 18" × 2")
This work of five overlapping slate pieces painted with pink, taupe, soft green, red, black, and brown oil paints is wall mounted.

Pic. 5.15 Merrill Wagner *Cat's Cradle*, 1989 (42" × 69") Strung like a musical instrument, a slate blackboard panel is flanked by two fuse box covers of slate and painted with oil pastels.

Color Plate 12 Merrill Wagner *Standing Figures*, 1998 (60" × 144") Created from five pieces of a broken blackboard, the work is painted in panels of Paynes gray and blue.

blackboard slate hang from L-shaped, square-cut masonry nails. Two blue bands in casein and oil unify the piece and allow gray slate to show above and below. "It has a shape but it is flat," she says. "I painted on the flat surface." The combination of slate pieces and blue paint creates a sense of sky or distance.

The William Traver Gallery in Seattle explains that Wagner's "works on slate are an investigation into the opposing elements of hard edges and how different types of line and plane can manipulate a space. The shapes appear as strong, rectilinear elements that are softly draped across jagged and sharp-edged groups of slate or positioned within the confines of a roughly cut piece of stone."

Her work titled *Standing Figures* is five angular pieces from one large blackboard leaning on the gallery wall. They could be "fit together to get the oblong they were in originally," says Wagner. She acquired them as broken shapes and appreciated that "the lines curve when they break." With casein and oil, she painted two areas in shades of blue, inviting contemplative investigation of the shapes and colors, while evoking a landscape or craggy mountain peaks, from which the slate might have originated. The irregular edges have a "found" quality that records past accidents. She uses the shapes, colors, and lines to create a simple and elegant installations (see Color Plate 12).

For Wagner, slate is a canvas, but a canvas that comes to her out of distant time, with a history, in beautiful shapes awaiting her painterly touch. An art reviewer in 1983 noted Wagner's "play between the human mark and the natural, timeless density of the slate surface. It's like bringing the cave wall into the gallery." Another review in 1987 noted Wagner's use of "somber, stern stones" and acknowledged that "she has done very much with very little: whether hanging or leaning, the altered blackboards transcend their homely origins and suggest geological shards or fragments charged by the intervention of her aesthetic intelligence."

Humans have been continuously painting on surfaces for about 20,000 years, using first the stone walls of caves and then on specially prepared indoor walls and canvases. Along the way some, including Titian and del Piombo, did prepare a slate sheet to accept their oil paints, chalks, or pastels, but these works must have been heavy and breakable in transport.

Gordon, Taylor, Kulicke, and Wagner – all modern artists – paint on slate drawn from commercially available products: recycled or newly quarried roofing shingles, polished cores, and discarded blackboards. Each brings past experiences from art training to stylistic experimentation to the stone; and the results are personal expressions of how they see the world. Miniatures, characterizations, seasonal impressions, monoprints, and strictly abstract works come to life on slate surfaces.

CHAPTER SIX

Relief Carving

AS DEMONSTRATED BY GRAVESTONE CARVERS, SLATE IS A GOOD MEDIUM FOR bas-relief carvings of figures, faces, animals, and scenes of human activity. Relief carvings in slate are frequently left unadorned. Replicas of ancient Mayan carvings are now being produced in slate taken from riverbeds in Belize in Central America. Most depict figures or calendar symbols and are simply coated with a protective sealant. In the Himalayan country of Bhutan, twentieth-century figures of deities are carved on slate panels that protect the entrances to Buddhist monasteries. These relief carvings are adorned with gold color to highlight the religious symbols. In other parts of the world, tinted beeswax may highlight significant features.

An appropriate slate for portrait carving will have an even color with no veining or distracting imperfections. High-quality mill stock, that is, slate for any architectural purpose other than roofing shingle, is frequently used for relief carving; but artists report waiting several months for newly quarried mill stock of the quality or size they require. Artists have found blackboard slates or the natural cleavage of quarry discards may also lend themselves to the carver's subject.

Slate carvings may be small, decorative wall hangings or multiple units mounted together to create a full wall-covering installation. The artist brings drawing skill and an understanding of how to make figures carved into a flat background material take on apparently complete forms and show more depth than is actually present. Frank Eliscu (1912–1996), a sculptor, carver, and numismatist, explained that "slate relief is just as low or even lower than the coin medal relief. To work a real low relief calls for much more skill and sculptural understanding than high relief."

Bas-relief: *Frank Eliscu*

Once President of the National Sculpture Society, Eliscu wrote *Slate and Soft Stone Sculpture* in 1972 on the premise that love is "evident between the sculptor and a piece of stone." His book discusses slate's properties and potential, reviews tool techniques, and presents his own works in slate, as well as notable other examples such as *Humpty Dumpty* (see Pic. 7.6) by the celebrated Isamu Noguchi (Chapter 7). Continuously in print, Eliscu's book was still available in bookstores after over thirty years.

Eliscu first realized the possibilities of working with slate as an art medium after scratching a drawing onto a discarded blackboard when no chalk was handy. Scribing the slate surface was extremely easy and led him to experiment with shallow relief carving, using as common a tool as a screwdriver. He carved stylized wildlife and Biblical scenes; he used black slate to depict an African

Pic. 6.1. Frank Eliscu *Reclining Nude* (30" long) This figure is from a carved slate series based in simple line drawings that convey movement and grace. (Photo courtesy of Frank Eliscu estate.)

Pic. 6.2. Frank Eliscu *Daniel and the Lion* (8" × 12") In this panel from a religious series the backgrounds are starkly textured and gold leaf is applied to the lion's eye. Daniel has only four toes, conforming to Orthodox Judaism's stricture not to create human beings in the image of God and thus is in compliance with the commandment, "Thou shalt not make a graven image." (Photo courtesy of Frank Eliscu estate.)

Pic. 6.3. Frank Eliscu *Mare and Foal* (15" × 15") Carved in bas-relief on black slate, this is one in a series of horse figures on slate fragments. (Photo courtesy of Frank Eliscu estate.)

Madonna or an African tribal drummer. He demonstrated that "slate can be cut with a hacksaw, carved with a simple woodcarving tool, even such makeshift tools as a screwdriver, an ice pick, or … a sharpened nail."

His book gives step-by-step directions for transferring designs from paper to slate, scribing the lines with a chisel, and creating a background texture with a toothed-chisel. Further modeling is done with a rasp (a shaped file) to enhance recessed areas near raised sections; and then an emery cloth or sandpaper smoothes away the rasp marks. Further texture is added with a sharp incising tool; and a household floor wax may darken the central subject, leaving the background unaffected. Eliscu's daughter Norma Banas explains further that he sometimes added white chalk "powdered into warm wax both around the design and to highlight all integral lines."

The use of natural chunks and slivers of slate became a hallmark of Eliscu's slate work; he frequently favored broken chalkboards. The broken shapes inspired his designs; and at times, when "a slate broke while being worked upon … he would alter or end the design to suit the break," reports his daughter.

For commercial work Eliscu purchased finished pieces cut to shape. Both New York-based artists Eliscu and Noguchi bought architectural slate from stone mason suppliers on Vernon Boulevard in Long Island City, New York. Eliscu used Friedman Marble and Slate Works, Inc., but there is no evidence to show where Noguchi obtained his slate panels. Because his former studio and present-day museum are on this same street, researchers speculate Noguchi knew the slate yards in this area. Eliscu and Noguchi even used a similar purple slate with touches of green for *Gregory (Effigy)* by Noguchi and *Horses* by Eliscu.

Relief Carving

Horses, a ten-foot square bas-relief in the lobby of the Bankers Trust Building on 529 Fifth Avenue in New York City, is composed of ten planks (5 × 2 feet) of purple-with-green slate. One prancing and one recumbent horse carved on the slate panels fill the entire wall between elevator doors. For another New York commission, Eliscu created a tall fire door of slate with caricatures of gem workers for the Diamond Center Building, 1200 Avenue of the Americas. He also used red or black slate to produce portraits, including one of Chief Justice John Marshall (1775–1835) carved on black slate for a California law office.

Bas-relief carving lends itself to slate work, as Eliscu demonstrated for gallery viewers, clients, and students of sculpture. Understanding techniques for achieving depth, employing texture to advantage, and embellishing with powdered chalk all served to bring his slate carving into sharp focus.

Pic. 6.4. Frank Eliscu *Chief Justice John Marshall* This carved portrait is based on a simple line drawing by the artist and done in a very low ("Coin Medal") relief modeling. (Photo courtesy of Frank Eliscu estate.)

Murals and beach stones: *Reg Beach*

Like Eliscu, sculptor Reg Beach has carved both large and small works in slate. He has produced large slate panels and wall murals, as well as decorative Celtic plaques, from his studio in Newport, Pembrokeshire, West Wales. When commissioned by Texaco and Gulf Company to create a mural for their joint office in Milford Haven, Wales, Beach used fifteen interlocking and overlapping pieces of three colors of slate to create *The Nantucket Whalers* (15 × 6 feet). (The subject depicts the Quaker whalers originally from Nantucket who emiguated with their families to the South Wales coast in 1790.) With purple and green slates from Penrhyn for the waves and a blue-black slate from Corris for the boat and backdrop, Beach devised a scene of three seamen, one with harpoon raised in an encounter with a whale on a roiling sea. The individually formed pieces were carved and textured with an angle grinder and the whale was additionally honed (smoothed with an abrasive after grinding away flaws) and polished.

Beach's earliest slate works were done on six-foot long slabs of flooring slate, "which could be obtained for next to nothing (in mid-Wales)," he recalls. Creating designs based on scenes from the *Mabinogion*, a collection of Welsh stories from the eleventh and twelfth centuries, he worked with tools that ranged from rasps and hand-carving chisels to high-speed engravers, angle grinders, wet saw beds, stone routers, and air hammers. Today he makes a two-hour drive bimonthly

Pic. 6.5. Reg Beach *Cwlhwch & Twrch Trwyth (Cwlhwch & the Wild Boar)* (approximately 6' × 2½') A scene from the Mabinogion is carved on a slab of flooring slate.

Slate of Hand: Stone for Fine Art & Folk Art

Pic. 6.6. Reg Beach
Dove of Peace, 1984 (4' high)
Texture plays a significant role in this meditative wall-mounted carving that relies on line and chisel markings for its effect.

Pic. 6.7. Reg Beach
Eagle Man: Welsh Legend (40" × 20" × 4" high)
Three-dimensional figural sculptures are carved from slabs or quarry off-cuts for small gardens or expansive lawns.

Pic. 6.8. Reg Beach
Mythical Bird (12" square)
No longer using beach stone, the artist now carves a Celtic design in low relief on a quarry discard and colors it with tinted beeswax.

to the closest working quarry, the Inigo Jones Company in Corris, North Wales, to pick up his slate order.

Another significant commission that Beach executed was a four-foot high panel titled *Dove of Peace* for the Lady Chapel in St Davids Cathedral at the tip of West Wales. Praying hands beneath a hovering dove are polished with beeswax. The negative space behind the figural elements is highly textured, in contrast to the smoothness and gentleness of the dove and hands.

Beach also creates garden sculpture from slate slabs, beginning by lightly scribing his design as a rough shape onto the stone. On a piece like *Eagle Man: Welsh Legend* he saws out the form, uses rasps to refine the shapes, and continues the process of delineating lines further with his engraver and then a hand chisel for finer details. For a silky finish, he uses wet and dry sandpaper, starting with 60 grade and working towards 600. In some outdoor pieces, separate parts need to be assembled and Beach drills holes and applies metal pins. His final step is the application of a wax polish.

Beach began relief work twenty-six years ago with "found slate," taken from a beach not far from his seaport home in mid-Wales. He climbed down to a secluded cove and picked up natural slate stones tumbled smooth by the tides. With a loaded sack he went back to the studio to carve and color Celtic designs, at a time when Celtic patterns were not as commonly available as today. Using a book of designs by George Bain, Beach began a long-running, popular series of small plaques featuring Celtic crosses, mythical birds, and interwoven coils that fit the smooth or split beach stones. He uses a flexible high-speed engraver to scribe the design and with a variety of engraver drill bits gives the background a textured finish. After warming the slate under a heat lamp or sometimes in the sun, he

paints the carved features with pigmented beeswax. When the slate has cooled, he buffs it to a gloss.

Though a trained sculptor with a good background in most materials, Beach, like Eliscu, had had no experience with slate and so self-taught himself the skills he needed. He explains that he "played around till he got it right," carving with slate panels upright and light coming over his shoulder. He still uses a dust extractor to minimize dust produced by his power drills and finds it is "much easier on the slate to use air hammers than it is to carve by hand."

The human figure: *Edmond Laliberté*

Canadian carver Edmond Laliberté agrees with Beach about power tools. Describing his power saw with its diamond-blade, Laliberté says, "It's not a romantic tool, like [those used when] carving by hand. But, slate is not made for hammers. If made by hand, the art is not produced so fast and the price is high." He has a smile when he says that carvers of any stone or wood "make the same work with a pneumatic hammer [as with a hand chisel] but get no back pain and no big arms."

Laliberté offers that "for slate there can be no impact. You can't hit it." When it comes to adding fine detail, he uses rasps to grind out small features by hand, as do Beach and Eliscu. Otherwise, Laliberté does all his modeling and refining with the same diamond blade saw. In almost every work he incorporates a face, a body part, or a torso in polished slate, sometimes surrounded by rough stone treated with copper colored beeswax.

Originally from Laval, north of Montreal, Laliberté now lives in the heart of Canada's slate belt in the Eastern Townships region of Quebec. He is close to the abandoned quarries of the New Rockland Slate Company and the Melbourne Quarry that were once the leading producers of Canadian-slate roofing shingles. Slate walls, slate roofs, and extensive "terrils" (piles of discarded slate) are easily found in the area.

While pursuing work as a model-maker for industrial products and also doing social work, Laliberté was carving and exploring slate in his spare time. For five years he spent forty to sixty hours a week working for industry and twenty hours a week carving slate for himself. His fascination with slate began when in his youth he had worked outdoors for a hiking company and noticed the colors of slate in all seasons. It was dark and glistening in the rain, textured in light snow, and beautiful amidst the greens of spring. The images went with him, leading him to explore slate relief carving.

From his studio he sold carved animals and figures in slate relief and in 1995 had his first slate exhibit. But, in 1997 he challenged himself to explore the potential of slate full time.

Laliberté often gets his slate from old stone walls whose owners have given him permission to remove stone. Sometimes the wardens in the quarries turn their backs when he asks permission to take blocks from the terrils. He laughs as he adds, "I never buy slate." Working on a shoestring, he keeps his expenses as

Pic. 6.9. Edmond Laliberté *La descente aux enfers/The fall in hell* (45" × 32")
A flat discarded slate chunk from a Canadian quarry provided the material for this figural work.

Slate of Hand: Stone for Fine Art & Folk Art

Pic. 6.10. Edmond Laliberté *Epoque/In olden days* (11" × 13") Highly polished black slate is embellished with beeswax tinted with copper powder on the roughly textured portion.

Pic. 6.11. Edmond Laliberté *Espoir de quartz/The hope of quartz* (30" × 21") Slate frequently has bands of intrusive layers of quartz or varying colors. Here the quartz layer added to the composition.

low as possible. He wants "to recoup his material costs" of which his greatest expenses are his diamond blades. He works with slate rather than marble, since slate is readily available and keeps his costs low.

When he gets an old piece of slate, he taps it with a hammer to test for cracks. Because it has been outdoors and gone through many freeze-thaw cycles, any cracks are usually visible and he breaks the stone at those points. "Fresh slate is good," he reports, but it is not so easy to see the flaws as with weathered stones.

His first step in creating a slate relief is to look at the stone and ask himself, "What does it say for me? What is seen?" His ideas come from looking at the slate and listening to what it has to tell him. He often sees a man or a woman, or just a part of a torso.

He likens the process to a composer who creates music in his head. Laliberté visualizes the figures as three-dimensional forms; and because of his business experience with tools and model making, he can easily work through the process of bringing the form from the flat surface.

Once he has identified the shape waiting to be carved, he either "draws on paper or right on the rock." If he draws on the slate, he uses watercolor paint. The first drawn lines are in blue; then he refines the sketch with green, followed by red, and at last yellow. This helps him define the form and "make an evaluation" of the composition.

Working the whole form at once, he carves with his diamond-blade power saw, making a lot of dust. "All my life I have lived with dust," he says. "Wood dust, plastic and metal dust. Now slate. They could do a geological study on my lungs, I think." He wears a mask and has made himself a box with a fan in it to draw away the dust from the air.

His slate sculptures are finished with 600 or 1500 grade sandpaper. The carvings take on a smooth texture and gently undulating curves. Laliberté adds copper powder to Chinese oil or beeswax, or both, to introduce a new color to the slate at this stage. He learned from Myles Tyrrell, Professor of Art at Dawson College in Montreal, how to make a patina of wax and copper that could be applied to a plaster bust to create the look of bronze. Both oil and wax bring a luster to his slate sculptures and the added copper further defines the carving, without overpowering the natural beauty of the stone.

Laliberté sometimes comes across a surprise in the slate that adds another dimension to the sculpture. For instance, he had sketched a hand with fingers fully spread just beneath a face in *Espoir de quartz*. He planned to carve texture lines around the hand to highlight it, but found that quite by accident he had tapped into a layer of quartz within the slate, just behind the hand. "Wonderful! I don't have to make the lines and highlights," he smiled.

Laliberté says there is "sort of a language between me and the stone. It's a dialogue with the stone. She responds and so we go with that. Slate makes for me an education for art."

Illustration carving: *Pam and Jim Martins*

Eliscu, Beach, and Laliberté experimented with tools and developed their relief carving skills independently, though artistic mentoring has also occurred within families, much like the quarrymen who passed techniques from father to son. Yet, in the case of Pam and Jim Martins the legacy passed from mother to son. Pam Martins is a trained artist who for twenty years transferred her illustration skills to carving figures, wildlife, and fantasy onto slate in Salcombe, a seaport town in South Devon, just a few hours' drive from the Delabole Quarry in Cornwall. With her wrist muscles starting to ache at age seventy, she decided to phase out her slate carving and focus on painting, which she plans to do well into her nineties. The decision came just when her son Jim, with a number of world-travelling careers behind him, decided to settle down in Salcombe and find work nearer home.

Pam Martins had first noticed slate gift-shop items with what she thought were carved white lines. She soon realized the slates were not carved but rather had a transfer design applied, or were perhaps silk-screened. Engraving lines on slate appealed to her though, and the idea led her to experiment. Taking a slate roofing shingle, she drew on it, then scribed in the lines, and cut into the background with a chisel and hammer. Her worked areas showed white against the dark slate, just as Eliscu had found working with an old blackboard and Joe George describes in his kits for etching on slate (Chapter 2).

When one chisel stroke made a hole in the shingle, Martins realized she needed a thicker piece of slate to experiment with carving techniques. In the rubble of a nearby cottage being demolished, she spotted a one-inch thick, slate pantry shelf, which the workmen were happy to give her. To cart the long slab to her studio, the men had to crack the slate in half so the two pieces would fit into the back of her little car, which then listed under the weight.

Martins experimented on half the broken shelf, using a number of chisels. For the second half, which had a better shape, she worked up a design and carved it carefully. Hoping to sell the carving from a shop in town, she loaded the finished piece into a wheelbarrow. Along the way a friend met her, loved the carving, and bought it from her. Martins found herself in the slate-carving business.

From the cottage workmen, she learned that the slate was probably from the Delabole Quarry in Cornwall; and so she visited Delabole and ordered "decent pieces in cut shapes." Since that beginning over twenty years ago, she has worked up more than six hundred patterns, frequently to fill client requests and often for her own pleasure. A distinctive aspect of her work is the spilling of her design onto a border, in a style common with illustrators working on the paper page.

Pic. 6.12. Jim Martins *Seahorse* (23" × 8") Designs that flow beyond their borders reflect Pam Martins' illustration background.

Pic. 6.13. Jim Martins *Fisherman at his nets* (12" × 8" × ⅝") Chiseled lines in black slate become white and bring texture and contrast to bas-relief.

Slate of Hand: Stone for Fine Art & Folk Art

Pic. 6.14. Jim and Pam Martins *Chess tabletop* (20" × 27") Dragons and courtly figures surround the chess board carved from Delabole slate. (Photo courtesy of the artists.)

"What's so joyful about working with slate is the contrast of textures and tone, the dark against the light," says Martins. Her technique for carving came from experiment and experience. "You learn when to stop with the mallet. You get a feel for the stone." One tip she shares with beginning carvers as they remove stone from a design is to "cut away from the line, not toward it."

As she prepared to set aside her mallet and chisel in favor of painting, her family requested one of her chess tables carved with fantasy characters. Her son, Jim, was seeking work after recuperating from a motorcycle accident that had punctured his lung and broken bones from his neck to his knees. He offered to help carve the table, and thus began the second generation of Martins slate carvers.

The Martinses carve both high and bas-relief by hand. Pam had worn a groove into a straight-sided mallet made of lignum vitae. ("Lignum vitae is the hardest wood," she reports. "It was used on old sailing ships because of its durability.") She favored that mallet because it had a comfortable handle. Her replacement mallet was cut from a bowling ball, and it now has straight sides with many scrape marks.

Both Martins wear gloves to carve, providing their knuckles a cushion on the slate. Jim has two layers of old, leather gloves. Pam's "old, grandma mittens" became frayed and threadbare and now hang as trophies on a nail above the workbench. From her years of experience, Pam recommended that Jim wear goggles when working with a mallet and chisel. Both are respectful of dust created but feel it unnecessary to wear face masks in their open-air workshop on the Salcombe harbor side.

Their other tools include tungsten-tipped stone chisels, wood-carving chisels, dental tools, wet and dry sanding paper, and fine-grained steel wool. They use an electric drill on the back of the slate to secure screws for brass hanging-plates. Also on the back of finished pieces, they include the carver's name, source of the stone, and the date. This information is scribed "fairly deep" to prevent someone else from erasing and reclaiming the artwork.

Their process starts with carbon tracing paper and a knitting needle, to transfer black lines of a design by Pam onto monumental-quality, gray slate, usually from Delabole, though they do use some Welsh slate. As he starts to carve, Jim

Pic. 6.15. Jim Martins *Farmyard scene* (approximately 8" × 12") Judicious texturing and polishing provides color contrasts as well as helping define depth.

asks himself, "Where's the depth?" He begins with the background, or recessed part of the design, and works forward. Details are added as the scene builds up. "It's a wonderful, creative game to play," he says.

It's important to know what's behind what and to create the sense of depth in the picture, he points out. Referring to a farmyard scene on a slate plaque, he says, "It looks as though you could put your hand in past the figures and reach back to the far wall, whereas in reality there is very little difference [in depth]." This is the required "sculptural understanding" valued by Eliscu in medallion work or low relief in slate.

Once the design is carved "to bring out figures," Martins polishes and sands his work. He uses a black wax-based polish that covers and darkens the entire surface. He goes back in to redo and touch up the white carving marks and scribed lines, before buffing the slate. The process assures a gleaming polish and sharp contrast of white on black.

He finds he is "working at making small changes in the background designs [of his mother's patterns]. It's all about the background and creating depth." Having a stronger arm than his mother, he adapts patterns to "get as much depth with shallow relief carving" as possible. He looks for movement in the designs and he's "able to bring the stone to life." In each piece, he looks for form, depth, movement, and perspective. Still, his mother's contributions of strong design, balance, and perspective are key to this slate carving partnership.

Trompe l'oeil: *Ivor Richards*

Trained artists bring their appreciation of design and proportion to experimenting with slate, but the skills and life experiences they have encountered

Pic. 6.16. Ivor Richards *Sight Unseen* (13" × 9" × 3") Seeming to have pushed through the slate, the raised face presents an image of humanity blind to the world.

Pic. 6.17. Ivor Richards
Rhwng y Llyaid/Between the Eyes
(15" × 7" × 3")
The riven slate surrounds and contrasts with the polished facial features.

may also affect their work. Sculptor Ivor Richards has friend and fellow sculptor Paul Davies to thank for introducing him to Snow Sculpture. Richards eventually participated in five international Snow Sculpture competitions, once as captain of the Welsh team, where they created semi-figurative pieces, including a family group, an ark, and a Trojan horse four meters high.

"Snow sculpture is just fun. Competition is a contradiction in terms in art," he explains. Yet, with three days and nights to complete a sculpture, the artist is offered "a chance to work on a monumental piece in a short period. A block of stone that size would take forever to carve." Competitors from Japan, China, Russia and the colder European countries gather at a designated city; and everyone wants to win. But few, including Richards, see this as "serious art."

Richards' serious art is sculpture from wood, bronze, stone, and other organic, sometimes atypical, mediums – once even sump oil, congealed blood on white sand, and dead rats. His involvement with slate began when he moved from Suffolk, East Anglia, to Bethesda, North Wales in 1983. "Bethesda owes its existence to the Penrhyn Slate Quarry – one of the largest in Europe. The quarry is surrounded by mountains of slate waste, so I found myself with an inexhaustible supply of material on my doorstep," he explains. Because it was convenient to acquire, he began carving it.

Quickly Richards "discovered [slate] had properties which appealed to the ideas [he] was trying to put over." He now uses slate for a majority of his carved sculptures, since slate is suitable, lending "itself to fine detailed carving in relief. Slate can have a very rough, riven surface but can also be worked to produce a very smooth and polished finish. I use this quality of contrast in my work," he says. Texture plays a significant role in differentiating planes on his carved stone. Similarly, Laliberté found this combination of riven and polished surfaces helped him define the soft and supple texture of his figures. Richards carves both facial images and trompe l'oeil designs with contrasting surfaces, enjoying the "rugged quality" that slate retains, even with very fine carving.

Searching the tips of discarded slate in Bethesda, Richards looks for appropriate shapes to bring his drawn designs to life. The "Penrhyn Quarry has been very helpful in supplying me with shapes. I showed them some drawings and they gave me a marvelous piece of slate," he said. When alone and searching the abandoned tips for raw material, Richards resorts to hurling chunks of slate from

the heights. If the slate remains intact at the bottom of the tip, he suspects it will be flawless. He recalls working a piece for four days only to hear an ominous crack when the slate split under his chisel. Now he tests by hurling or, easier, by tapping the slate before he begins, as the local quarrymen do. "You can tell by the sound whether there is a flaw," he has learned.

Crediting the quarrymen of the "old days" with becoming "skilled slate carvers" (especially in lettering), Richards points out that they supplemented their incomes with carving gravestones. Fathers taught sons and passed the skills through the generations. Richards "learnt basic carving techniques from the son of one of these quarrymen, who had carried on in his father's footsteps." Working almost exclusively by hand, Richards uses tungsten-tipped chisels, though occasionally he will resort to a mechanized "angle grinder to 'rough out' the shape."

With the fine carving techniques mastered, Richards produces the kind of images that interest him. He has a series using the human eye as an archetypal symbol. He plays with the concept where the viewer becomes the viewed; the eye within the slate seems to look out at the passerby. His sculptures are sparse, clean, and austere. A face or just eyes may peer out from slits or windows in the stone; or semi-abstract, rough-hewn heads and faces stare passively.

Like Laliberté and other sculptors, Richards looks for shapes within the slate. "Often there is an image there waiting to break out," he says. "The shape is suggested by the slate, which gives something to me. Then I carve it. It is as though what I am carving is hidden inside the slate and I release it." He may produce a trompe l'oeil flap of slate lifted to reveal a smooth interior texture within craggy stone. A glossy metal band seems to squeeze a block of slate in another piece of optical illusion.

A recent minimalist creation of his is a two-meter long slab of slate titled *Sleeper*. Of the sculpture installed on the floor at the Welsh Slate Museum in Llanberis in the spring of 1999, Richards says, "There is a tapering groove cut into the surface, which is filled with black oil." He confides that he doesn't use oil very often, though it was a part of his diploma show at art school.

Pic. 6.18. Ivor Richards *Mind's Eye* (22" × 13" × 2") The human eye representing mankind looks out from stone, as through the centuries — here with a trompe l'oeil stone flap.

Pic. 6.19. Ivor Richards *Etifeddiaeth I/Legacy I* (12" × 14" × 4") The apparently metal band squeezing stone is really one block of slate demonstrating its versatility of texture.

"People will stick their fingers in it to see what it is, then they discover they are oily and wipe them on the [slate] sculpture."

Though carving in snow may allow for quickly produced work, that sculpture is gone in a matter of weeks. This ephemeral quality is sought by Land Artists and those making environmental statements, but the tediousness and time-consuming aspect of carving in stone seems more appropriate for works meant to endure. While line etching on slate is quickly achieved, a longer life expectancy will result from deeper carving in relief. Richards appreciates that slate "is four hundred million years old and likely to stay around for another four hundred million years."

As each relief carver develops lines and shapes on slate, the image slowly comes to life on the flat surface. Depth of field and contours of figures are created by both deeply incised cuts and by softening or rounding edges on key portions, whether the tools used are controlled by muscle or power-driven. Background textures and highly polished features add to the image's overall impression of three dimensions. Additionally the whiteness of lines, both long grooves and short hash marks, bring a further indication of recognizable forms in portraiture and trompe l'oeil. Slate's relative softness, its textural versatility, and ability to maintain a sharp edge and fine details benefit the relief carver whose drawing skills and sculptural understanding applied to slate allow for individual expression in an art form destined to last for centuries.

Color Plate 1 Sara Humphreys *Sunburst* (9" × 14½"). The design is cut from mottled purple and green slate from North Wales.

Color Plate 2
For the newly restored and refurbished tower peak on Memorial Hall (built in 1870s) at Harvard University, an effort was made to match colored slates to the originals quarried in New York and Vermont.

Color Plate 3 Henry Hawkins, *Penrhyn Quarry*, 1832 (4' 3" × 6' 2") This vast quarry overlooking the Ogwen Valley in North Wales covered 560 acres. (Photo courtesy of The Douglas Pennant Collection (The National Trust))

Color Plate 4 W.J. Rice *Segmented dish* (17") A practical and decorative dish was created from alternating slate colors from Ffestiniog and Dyffryn Nantlle.

Color Plate 5
This red slate quarry has been worked by Sheldon Slate Products in Middle Granville, New York.

Color Plate 6 Martha Levy *Men Working in Slate Quarry* (24´ long) This mural depicts Depression-era quarry workers. (From the collection of the Slate Valley Museum, Granville, New York)

Color Plate 7 Susan Ringer Koons *Brooch* (3½" × 1") A half-moon of smooth enamel holds a textured, tapering slate with a dangling lapis gem. The piece incorporates copper, sterling silver, fine silver, and fine gold.

Color Plate 8 Sharon Boardway
Leaf bracelet 1, 1999 Sterling silver, green and black slate, agate, and jasper spill like fallen leaves in this bracelet capturing the beauty of the natural world. (Photo courtesy of Boardway estate.)

Color Plate 9 Brian Gordon
The Firewood Woman (23" × 23") The camaraderie of local women amid the old buildings and factories is recalled by the artist, one of the small boys waiting. (Courtesy of the Boydell Galleries, Liverpool)

Color Plate 10 Alfred Worthington *Llanbadarn Church*, circa 1900 This painting on a slate fireplace panel is one of several attributed to the artist who worked in Aberystwyth, where three slate enameling works were in production at the end of the nineteenth century.

Color Plate 11 Barbara V. Kulicke
Homage to a Square from the Slate Belt, 1995. A painted square of slate (115 pieces) was exhibited at ETS Gallery in Princeton, New Jersey.

Color Plate 12 Merrill Wagner
Standing Figures, 1998 (60" × 144") Created from five pieces of a broken blackboard, the work is painted in panels of Paynes gray and blue.

Color Plate 13 Christopher Curtis
Pondering, 1997 (68" × 28" × 8"). Colored slate banding found in the New York quarries was used to good advantage as the artist chipped into the colored layers before polishing the stone.

Color Plate 14 Susanna Heron *Island* (detail), 1994-95. Wet slate and rainwater collecting in the flowing lines of the engraving reflect the sky above Dublin.

Color Plate 15 Bill Swann *Tirlun Cymraeg/Welsh landscape* (9³/₄" × 9³/₄")
Piece of blue and mauve colored glass overlaid in a collage arrangement fuse to suggest the Welsh landscape from which the slate surrounding the glass was quarried.

CHAPTER SEVEN

Sculpture-in-the-Round

ALTHOUGH RELIEF CARVING ON SLATE HAS A LONG HISTORY, ARTISTS CREATING statuary art before the twentieth century appear to have avoided slate. Now modern three-dimensional sculpture-in-the-round has expanded the concept of statuary art to include freestanding works that are often nonrepresentational while they stress spatial aspects and viewer involvement. Sculpture-in-the-round has a physical presence that appeals to both the emotions and the sense of touch. Slate lends itself to such works.

International superstars in the world of art, Barbara Hepworth (1903–1975) from her St Ives, Cornwall studio and Isamu Noguchi (1904–1988) from his New York studio produced sculpture and other works to fill commissions in major cities around the world and to individually establish their own museums and sculpture gardens. Both responded to traditional sculptural stones like Greek and Italian marble, granite, or basalt boulders, but they also allotted about ten years each to explore the medium of slate.

Noguchi favored stone for his sculptural work, though he employed aluminum, paper, balsa wood, bronze and ceramic as well. He once explained, "I love the use of stone, because it is the most flexible and meaning-impregnated material. The whole world is made of stone. It is our fundament ... Stone is the direct link to the heart of matter – a molecular link. When I tap it, I get an echo of that which we are. Then, the whole universe has resonance."

Pierced, standing forms:
Barbara Hepworth

Studying art in Florence, Italy, Hepworth learned to carve stone, working on Carrara marble with an Italian master carver. Over the course of her fifty-year career she created figures and abstracts in wood and stone, as well as notable monumental bronze works; but her son-in-law Sir Alan Bowness, a prominent art historian, says she "was, and always remained, a carver. She loved to shape the wood or stone with the tools in her own hands." She ac-

Pic. 7.1. Barbara Hepworth *Two Forms (Apolima)*, 1969 (29½" high)
Hepworth learned carving techniques working on marble and here nestled black slate and white marble elements.

Pic. 7.2. Barbara Hepworth *Bird Flight*, 1971 (13¼" high) Three slightly tilted triangles of polished slate mounted in descending order capture the flutter of birds' wings. (Collection of the Hepworth Estate.)

Pic. 7.3. Barbara Hepworth *Four-square (four circles)*, 1966 (23⅞" high) This maquette of slate panels was produced before the larger bronze sculpture which now adorns the artist's studio garden and invites visitors to walk between the open forms. (Collection of the Hepworth Estate.)

knowledged that the slow process of carving was a "marvelous way of working on live, sensuous material."

The landscape of Cornwall and the area's Neolithic stone circles and menhirs (single standing stones) provided inspiration for her creativity, including works in slate. She saw those megaliths as frozen figures on a landscape she came to love. She created her own sleek stone pillars and hollowed out abstract shapes that spoke of relationships and the human presence in nature.

Hepworth and Henry Moore, friends and fellow art students, were considered the most distinguished English sculptors of the 1930s, producing the earliest abstract sculptures in Britain. She, not Moore, first used the device of a hole pierced through a form to open it and allow the viewer's involvement, a significant invention later to be associated by the public with both of them.

Hepworth established her art career in 1925, though it was not until the early 1960s, near the time of the peak of her career, that she started working with slate. One of her earliest slate pieces was the 1962–63 monolith *Carving (Mylor)*, a 33¼ inch high vertical slate with a wide piercing. Others of a similar scale in thin, elongated, upright slate forms followed: *Three Standing Forms* and *Two Figures* in 1964, *Slim Forms* in 1965, and the crested *Two Figures (Menhirs)* of 1964.

Hepworth's slate was from the Delabole Quarry, north of St Ives, and was the only locally available stone she carved. She once explained "that if they quarried very deeply in the slate quarry here at Delabole they could get a reasonable thickness for me, and a very fine quality. … The slates from these deep beds are very beautiful."

Conflicting reports explain how Hepworth came to explore slate. In one version, a studio assistant bought a billiard table of soft black Welsh slate and sold Hepworth all but one of the slate pieces. Artist Denis Mitchell, who shared the studio and etched or carved in slate, bought the remaining piece and may have shared his process with Hepworth. She did make sculptures from billiard table slate, it is known, and she used slate as bases for certain sculptures.

Another story from H.C. Gilbert, a former county architect who designed buildings in St Ives in the 1950s and 1960s, suggests that he "recommended Delabole slate to Hepworth on the basis of his experience of it as a finish-

ing material." It was less likely to shatter than other slates, he had found.

Either way, Hepworth departed from selecting orthodox materials to use Delabole slate, and she adapted her carving style accordingly. She said, "The material is precious, and you can't hit it with a hammer. You use a saw, and it's rather hard work. You can use a gouge and mallet if you're careful, but it's mostly filing. You can do some fine chiselling, [sic] but only with very light-weight tools." She listened carefully to the sound as her tools worked the stone, ever conscious of possible flaws.

In less than ten years, her team of three studio assistants in St Ives helped her produce over fifty slate sculptures – about half were under a foot high and most were pairs, trios, or groupings of related shapes. Biographer Penelope Curtis explains that the slate works "were generally multiple compositions, rather angular, even bird-like, attractive but unadventurous." But, some slate pieces are highly regarded by authorities, including *Bird Flight*, 1971, and *Two Forms (Apolima)*, 1969, which pairs slate and white marble.

Hepworth rarely made maquettes or even drawings of proposed works; but she did a few maquettes in slate for larger bronze works, notably the almost two-foot high *Four-Square (Four Circles)* which became the three feet, eleven inch high *Four-Square (Walk Through)* in bronze, now in her St Ives sculpture garden. Her distinctive beveled or straight-edged piercings are found in her slate works, just as in her marble, Hopton wood stone, and bronze masterpieces.

Pic. 7.4. Barbara Hepworth *Two Figures (Menhirs)*, 1964 (30" high)
This title links the human presence with the megaliths on the Cornish landscape, as the sculpture itself suggests two figures interacting. The "fossil leaf" appears on the left element. (Collection of the Tate Gallery London)

Pic. 7.5. David Kindersley *Hepworth gravestone*, 1975 Cornish slate provided the gravestone for sculptor Barbara Hepworth who lived along the Cornish coast for twenty-five years. (Photo courtesy Cardozo Kindersley Workshop.)

Michael Tooby, former Curator of the Tate St Ives and Barbara Hepworth Museum and Sculpture Garden, says that Hepworth believed "that part of working with stone is the discovery of what's in the stone." She, like so many other sculptors including Laliberté and Richards, respected the character of the stone or wood she carved and let the material dictate the sculpture's form. But in the case of *Two Figures (Menhirs)*, the discovery was more than pulling forms from the stone by filing away the excess. The two, pierced sections of this 29 inch high slate sculpture were carved from a single Delabole block, adapted by her to display individual qualities. Each form has a hidden, threaded steel rod fixing it to a shared wooden base. Hepworth gave one form a vertical, narrow-slot hole and the other a higher, circular piercing. She polished the two pieces and was rewarded with a fossil, just beneath the circular hole on the broader form.

The artist said this fossil "only appeared after the final polishing" and noted it was "the most gorgeous fossil of a fern," or a "leaf." One assistant who worked on several slate sculptures recalled that impurities in the Cornish slate "ripped the teeth of the hacksaw." He felt it would have been evident from the start. But if the two pieces were split, not sawn apart, the hidden fossil could have remained undetected until that last polishing, just as Hepworth described it. She knew the quarryman's method of splitting stone with a pin and feathering technique; since she acknowledged, "It's possible to feather slate: you bore holes and drive in wood wedges and wet the wood. As [the wood] expands, [the slate] splits."

Murray R. Gregory from the University of Auckland's Department of Geology inspected *Two Figures (Menhirs)* in the Tate Gallery London and suggests the "fern" fossil is not really a fern impression but rather a "trace fossil." These are "features made in soft sediment substrates by animals crawling, walking, moving … over the surface." This fossil is "12 cm in length with a width reaching 5 cm and of a vaguely feathery appearance, and with evidence for bilateral symmetry either side of a central longitudinal axial core." Known fossils in Delabole slates include "asteroid, crinoid, spiriferid, and pectinid fossils." The most famous is the "spiriferid," an ancient bi-valved creature (a brachiopod, commonly known as a "lampshell") and mistakenly identified in Victorian times as a butterfly, thus commonly referred to as a "Delabole butterfly."

When she was named a Cornish Bard honoring her contributions to the arts in Cornwall, Hepworth chose the Cornish name "Gravyor" (sculptor). "I think the name 'Gravyor' suits me and could well go on my headstone as showing my love for this land and its people," she acknowledged. Her gravestone is actually a simple arch with her name and span of life, hand-cut by David Kindersley on Delabole slate.

Biomorphic forms: *Isamu Noguchi*

Like Hepworth, Noguchi had a long career and responded to ancient stone works, though his were Cambodian, Indonesian, and Japanese in origin. Before studying art and portrait sculpture with Onorio Ruotolo at the Leonardo de Vinci School in New York, Noguchi had learned about hand tools, wood carving, and simple methods of construction, as he helped build a Japanese house designed

with interlocking beams. His American mother had informally apprenticed him at age ten to a carpenter/cabinet maker she had hired to build her home in Japan.

Years later as an established artist, Noguchi would buy an entire wooden building that was moveable and traditionally dismantled and reassembled as needed by Japanese farmers. He cut those antique wooden beams into block bases to enhance many of his smaller stone sculptures, though he dit not use them with slate.

Noguchi received special recognition in the emerging New York School during the 1940s for his experimental forms of interlocking construction, which may be reminiscent of Japanese joinery techniques he learned as a young apprentice. He interlocked and balanced thin, relatively cheap slabs of slate or marble, quarried to resurface buildings in New York City. These interlocking stone-slab sculptures are closest to a signature style for Noguchi, suggests Bonnie Rychlak, Curator of The Isamu Noguchi Foundation, Inc. These pieces gained him admission to the 1946 "Fourteen Americans" exhibit at the Museum of Modern Art, New York, and "pushed him into the limelight," she says. He was already known for his sculpted head portraits and for political and social works.

At twenty-three years old in 1927 and on a Guggenheim Fellowship, Noguchi had traveled to Paris and become a studio assistant for five months to Constantin Brancusi, who directed Noguchi's stone carving technique toward simplification of form and abstraction. Taking another lead from Brancusi, Noguchi strove to combine aesthetic concerns with utilitarian designs meaningful in daily life, by fashioning tables, lamps, and distinctive stage sets, most often for Martha Graham. Noguchi was able to establish an artistic identity that incorporated his Japanese traditions, his interest in "biomorphic" (body-related) images, and Western modernism. He produced more than a dozen slate sculptures and wall hangings in the mid-to late-1940s.

His biomorphic sculptures were built on surrealistic concepts, where components are arranged out of natural or expected order. The slate figures assembled from dissected elements appear spatially visible, yet somehow invisible. These are seminal pieces that link Noguchi's early realistic head portraits to his later works of figuration that interact with materials in a contemporary way.

Pic. 7.6. Isamu Noguchi *Strange Bird (To the Sunflower) (Unknown Bird)*, 1945 (4' 8¾" × 1' 10½" × 1' 8")
This interlocking biomorphic sculpture, created without glue or welding, depends on balanced construction, though here the slate has been cast into aluminum for easy transporting. (Collection of the Isamu Noguchi Foundation, Inc.)

Pic. 7.7. Isamu Noguchi *Humpty Dumpty*, 1946 (58¾" × 20¾" × 18")
Interlocking slate forms are slotted, balanced, and interpenetrating. (Collection of the Whitney Museum of American Art, New York.)

Pic. 7.8. Isamu Noguchi *Gregory (Effigy)*, 1946 (67½" × 15¾" × 12") Having explored figuration for years, Noguchi turned to abstractions in slate (and marble) to create complex figural sculpture of fragmented space and dissected elements. (Collection of the Isamu Noguchi Foundation, Inc.)

First drawing shapes on graph paper, he cut paper forms and created three-dimensional models of sculpture that could be taken apart. By working with paper models, he could see how the weight might fall and how the pieces might balance. Slate, being fragile yet heavy, required him to work out the interlocking sculptures beforehand. The struggle to make stone do what it is not meant to do (like defy gravity) seems to be Noguchi's interpretation of the true role of a sculptor, attests Rychlak.

Noguchi felt that working with slate and marble slabs, unlike working with metal or wood, led him to find the "minimum means of construction and expression" without the use of glue or welding. He used both a minimum of material and the space in between the parts. To carve these forms, he used pneumatic drills, rigged with diamond saws for the basic cuts. He said he took "particular satisfaction in ... [the resulting] fragility, arguing the essential impermanence of life" in these pieces. "Like cherry blossoms, perfection could only be transient – a fragile beauty is more poignant."

In 1945 Noguchi created nine sculptures using black or green slate. His *Ikon (Black Ikon)* (44 inch high) used black slate and string. *Little Slate* (11¼ × 11¼ × 6¾ inches) hangs as a wall-mounted sculpture of black slate with softly rounded edges and small interlocked appendages. Other pieces ranged from 11¼ inches to 60 inches high.

In 1946 Noguchi created four more slate sculptures of interlocking parts. The Whitney Museum of American Art in New York now owns his *Humpty Dumpty*, a formal abstraction in ribboned slate about childhood memories. The engaging sculpture interlocks carved and shaped slate pieces that interpenetrate one another in a work that is solid and yet partially open.

Gregory (Effigy) is a purple-toned slate sculpture that may be the most human in form, as also suggested by the name. With teardrop shaped slots and dangling appendages, it is exhibited upstairs in the Isamu Noguchi Garden Museum in Long Island City, New York. Nearby are *Little Slate* and a bronze casting of *Strange Bird*, a sculpture originally created in slate. Noguchi found the slate sculptures didn't travel well and so he cast several in bronze, including *Gregory, Strange Bird, Little Slate*, and *Trinity*. Three-dimensionally complicated, the fragile works could then be dismantled and laid flat in a box for shipping.

Since the nature of stone is weight and the sculptor has to fight gravity, Noguchi felt the challenge to "transform but not destroy" the nature of the medium. He was aware of "the activity of stone, actual or illusory, and in gravity as a vital element." Noguchi's interlocking slate sculptures from the 1940s reflect his desire to strip his work of nonessentials or flourishes and to impose on the stone a serenity he felt from his Asian inheritance. Like Hepworth, he worked for simplicity of form.

Zen-like forms: *Mack Winholtz*

The sparse, clean lines of works by Hepworth and Noguchi inspire other sculptors creating with slate today. As a young man, Mack Winholtz had designed and built "furniture with the simplicity and sculptural qualities [he] admired in Noguchi designs." Later, some of Winholtz's "inspiration for working in slate came from seeing pictures of several small slate sculptures created by the late English sculptor Barbara Hepworth."

In 1983 Winholtz created his first abstract sculptures by carving plaster or forming clay, during a studio course at the University of Missouri in Kansas City. Like Noguchi and Hepworth, Winholtz worked in stone, wood, and bronze, "selecting that material which best convey[ed] the spirit of a particular sculptural form." He learned stone-working techniques by observing and talking with local stone craftsmen. After that it "was simply trial and error (and plenty of each!)"

Experimenting with materials and methods over thirteen years, Winholtz gradually developed a distinctive style. Characterized in a gallery brochure by "an elegant simplicity of line" and "painstaking craftsmanship," his nonrepresentational sculptures are "classical abstracts." In 1992 he first began working with slate, using "the limited range of stones ... available from local stone suppliers" in Missouri.

Winholtz's preference for slate nourishes his simple forms that have an organic quality. He says, "If I tried to use stone that was highly variegated or polished, it would detract from the simplicity which is crucial to the sculpture; the slate I use is very compatible with this aesthetic." He adds that "slate has a natural, organic, even primordial quality to it – for me it has 'soul' which enhances the soulful quality of a sculptural form." He finds that the tactile quality of a slate surface "rubbed to a fine finish has a wonderful satin feel, a pleasure to the touch as well as the eye." Slate jewelry makers make the same observation.

Winholtz's sculptures of sleek lines are three-dimensional forms created from either black or gray-green slate. Prize-winning *Lyric* (60 inches high) on a stone base is black slate honed to a satiny polish. Winholtz says he uses "black slate to simplify and emphasize the lines of the sculptural form," as evident in *Essence* (30 inches high) with its paired elements and beveled piercing so reminiscent of work by Hepworth. The gray-green slate with a natural cleft surface and subtle gray veining used for *Divergence III* emphasizes "the organic or primordial quality of the sculptural form."

Preferring "simple or 'minimalist' forms in the Zen tradition," Winholtz works from sketches of nonrepresentational shapes. He draws "a great many sketches to develop ideas for new work, but most of these sketches never materialize as sculptures," he confides. Those that do become realized may be in stone, wood, bronze or other materials; and "when stone is the best medium, I usually prefer to work in slate." For several years now slate sculptures, ranging in size from 21 to 66 inches high excluding the bases, have represented over half his work.

Fig. 7.9. Mack Winholtz *Lyric* (60" high, 64½" with base) An Aeolian harp in black slate is suggested.

Pic. 7.10. Mack Winholtz *Essence* (30" high, 35" with stone base) Tool marks provide a texture on the deeply beveled piercing, bored into polished black slate.

Pic. 7.11. Mack Winholtz *Divergence III* (32" high, 37" with stone base)
A green slate with a natural cleft surface presents a minimalist form in the Zen tradition.

The sketches Winholtz particularly likes are enlarged and used as patterns on his slate. As he developed larger and larger designs, he had to "custom order cut-slabs of slate from quarries in Pennsylvania and New England (specifically, Vermont)," since Missouri, his home state, is not a slate-producing region. He has had problems acquiring unique specifications of slate, because quarries typically produce mill stock in "slabs of only standard dimensions for commercial applications." As other artists have found, the stone yards will cut large pieces to specified sizes for an additional fee.

Using power tools with carbide or diamond cutting surfaces, Winholtz first roughs out the form of the sculpture. He notes that "one of the peculiarities of slate is that it will crack or flake if it becomes too hot, so it is often necessary to apply water to the cutting surface to keep the stone cool," a standard practice in the Welsh quarry shops.

Over years of experimentation, Winholtz "tried and discarded a variety of tools and techniques" for shaping stone. With the form roughed out, he applies hand tools and various grades of carbide sandpaper "to shape and finish the surface of the piece. The final surfacing is done with steel wool" and then a stone

Sculpture-in-the-Round

sealer or paste wax protects the piece. For Winholtz and many others, the surface texture is a significant part of any sculpture.

Winholtz has also incorporated leaded glass into slate sculpture, as in *Passage II* (49 inches high). Relying on a local glass shop, he traces "the lines of the [worked] stone to make a precise pattern for the glass insert." He notes that he sometimes makes "minor adjustments in the lead glass ... in order to get a proper fit in the stone." In a reverse sequence, Welsh artist Bill Swann (Chapter 10) produces his own lead glass crystal and then orders the slate to fit.

Commenting on U.S. exhibits in the West and Midwest, Winholtz says he has not met other artists working in slate, but that his "slate sculptures often generate considerable interest and curiosity among other sculptors, as well as viewers." He feels slate "conveys a sense of its ancient origins, of durability, and primitive natural beauty" and this helps the viewer "shift ... consciousness from the busy world of practicality and calculation to a meditative, enchanted state of mind." This, perhaps, is the serenity sought by Noguchi.

Contemporary sculptures in the round, and particularly those in slate, are created by the balance of mass and negative space. The spectator may see sculpture defining the form of a space, yet the sculpture will change as the spectator moves. Artists like Noguchi created sculpture and also environments that drew the viewer in to become participants, rather than merely spectators. Hepworth's pierced sculptures also invite viewers to consider the inside, as well as the outside, of every form. The vitality of these sculptures reveals the interplay of space and volume.

Pic. 7.12. Mack Winholtz *Passage II* (49" high, 54" with base)
The polished surface of rounded edges emphasizes the natural cleft surface on this green slate with its arcs of blue leaded glass.

The innate nature of slate lends a sense of durability and organic familiarity that provides abstract sculptures with the capacity to evoke an emotional and aesthetic response in the viewer. Sculptors, like slate jewelers, find polished surfaces or cleaved slate textures to be both a pleasure to the touch and to the eye. Contemporary sculptures-in-the-round rely on sleek lines and balanced forms to present abstract expressions of emotion. We feel a sense of harmony, beauty, and wonder.

CHAPTER EIGHT

Stacked Sculpture

AUTHOR AND DRY-WALL BUILDER JOHN VIVIAN BELIEVES "A STONE WALL IS A WORK of art in its truest sense, ... a creation of order out of chaos, of beauty from dross – as much an improvement on nature as may be accomplished by the hand of man." Neatly stacked stones are found in building walls and rural fences; but as artists apply the same principles of dry stone and wet wall masonry, new expressions come into the realm of art. Stacking stone into either figures or geometric shapes creates a type of three-dimensional sculpture; and although widely different in scale and component material size, these stacked forms seem to encompass a category of their own in the history of slate art.

Unlike the sculptures-in-the-round discussed earlier, most of these three-dimensional, stacked slate pieces are intended for outdoor display. They may have been erected in a remote area and left to gently melt back with the environment they came from or they may have been created for long-term outdoor exhibit in gardens or public places. In either case, flat slate pieces have been ideal for erecting outdoor sculpture.

The process of layering and building up slate to realize a new form, a sculpture, resembles the metamorphic process that laid beds of sediment and then transformed them into strata of solid veins of slate. Geology or geological time has intrigued the artists who turned to stacking slate for their outdoor sculptures. And, just as Barbara Hepworth was familiar with the Cornish menhirs, so too most of these artists who stack slate have been attracted to cairns, petroglyphs, or ancient monuments in stone.

It might appear that the options for stacking slate are limited, but in actuality the variations are wide and become expressions of individuality. Artists incorporate their special knowledge of metallurgy, stone wall construction, archaeology, and environmental concerns. Complete shingles or small broken fragments, flagstones and rough chunks, square-edged off-cuts from the mill, and blade sharp curves of broken slabs have all been stacked.

Dry stone walling: *Joe Smith*

Joe Smith of Scotland is an accomplished, dry stonewall builder who learned the principles as a boy from a Yorkshire Dales shepherd. Smith has had many years' experience in horticultural and architectural stonework, as well as creating sculptural works with Andy Goldsworthy in Scotland, other parts of the United Kingdom, and the United States. Then, breaking out on his own about 1996, Smith developed a series of large, dry stone sculptures in

Pic. 8.1. Joe Smith
Two Urns
Using a slate knife and a makeshift anvil, the stonemanson curves the edge of each piece to create these elegant classical forms.

Pic. 8.2. Joe Smith
Pine Tree
A current departure from the vase theme, this slate pin was built in a traditional dry stone walling method without glue or epoxy.

the shape of vases, globes, and trees. His monumental urns and vases, ranging from two to eight feet high, are solid slate sculptures intended for gardens; including a trio of urns now in residence in Prince Charles' arboretum at the royal Highgrove estate in the Cotswolds. Creating art for the Prince of Wales meant, of course, that Welsh slate would be most appropriate for these outdoor pieces.

Smith's stone walls and sculptures withstand the elements without the need for mortar or cement, because of his understanding of traditional dry wall construction. Each stone is "tilted slightly upward to the middle," he explains of the stones in his walls and slate in his art. This way the structures "throw water outwards" should any seep in or get trapped as ice. Each piece or "length of slate" is laid layer by layer, covering over joints of the last layer, and fitting tightly together. He individually dresses, or trims the outside edge of the slate, before laying it in the curving urn, rising before him. His experienced eye guides him in contouring the successive levels of interlocking slates. These strong, durable slate sculptures will withstand the elements and "develop a natural patina of moss and lichen," he points out.

Smith can appreciate the beautiful flat surfaces of slate and he loves the way it cleaves. He admits, "You can split it open. It's three, four, five hundred million years old and you split it open and there's a little puff of dust and a little creak. It opens up. I love that quality of slate, but I also love the broken edge." He sees the broken edge, or the outer surface of a stone sculpture, as taking on a fabric-like texture reminiscent of tweed; this woven textile look in stone intrigues him. "It's just a different way of looking at slate, because I've come from the dry stone walling side of it," he says.

Smith uses slate varying in color from "dark gray through blues and mauves to olive green" from Scotland, Wales, the Lake District, and Cornwall, as his commissions require. He also keeps a supply handy in his yard after filling his truck on quarry visits. He typically constructs his large works on site in public gardens or private homes, in locations ranging from the Scottish highlands to the Sussex Downs and around the world.

Smith's latest series includes stacked slates, tapering vertically in the conical form of pine trees growing skyward with slate boughs that almost seem to sway. Like an artificial Christmas tree constructed limb by limb, the largest flags of slate are at the base and incrementally reduce in size to fragments of roofing slates. Even in these pieces, no mortar is used, though a metal pin at the top keeps the smaller pieces from being blown away in the wind. "There's no trick to it," he attests. "Because its center of gravity is right over the trunk, it's pliable" and stable.

Smith acknowledges that he was "influenced by [Goldsworthy's] new approach to stone and slate," though the walling technique he brought to their collaboration was that of an ancient craft undergoing a revival of public interest. When the time came for a break, Smith set out to create sculptures of his own design, applying his dry wall skills to slate art.

Ephemeral art: *Andy Goldsworthy*

The snow sculptures of Ivor Richards were intended to be short-lived, but this very trait is a part of the interaction with natural materials that sculptor Andy Goldsworthy explores. Goldsworthy brings a playful eye to his creations, even though many works force him to endure harsh weather and require concentrated diligence in the production. Some structures disappear within hours of completion, but he considers any changes to be part of the work. He uses a diverse assortment of natural materials: twigs and reeds, leaves and thorns, snow and ice, mud and water, or stones and slate in its several forms. His materials and the far-flung sites where he creates his art around the globe draw Goldsworthy "deeper into nature," he says, and into an understanding of how "all materials [are] the same energy revealed differently."

In 1983 he wrote,

> I have become aware of how nature is in a state of change, and that change is key to understanding. I want my art to be sensitive and alert to changes in material, season and weather.
>
> A rock is not independent of its surroundings. The way it sits tells how it came to be there. The energy and space around a rock is as important as the energy and space within. The weather, rain, sun, snow, hail, mist, calm, is that external space made visible. When I touch a rock, I am touching and working the space around it. In an effort to understand why that rock is there and where it is going I do not take it away from the area in which I found it.

Goldsworthy is interested in the journeys of quarried slate – "extracted violently from the ground, worked smooth by hand and machine, then laid carefully in a building." During the creation of his early works of slate in North Wales and Cumbria, he encountered the huge holes and staggering slate tips left on the landscape by the slate industry. Today he acknowledges that past industry by deliberately selecting slate quarry debris or discarded building materials. He avoids carving stone or breaking off "solid living rock."

Goldsworthy stacks pieces of slate into sculptures of arches, mounds, and three-dimensional ovals; these works have influenced several of the artists in this book. Such artists agree with Goldsworthy that the stone "takes on some of the strength and power it had when bedrock," once the fragments, shingles, or discarded flat pieces are regrouped into new forms. The slate's journey seems to come "almost full circle."

Not limited to, but frequently selecting slate as his medium, Goldsworthy explained to the author how slate fits his philosophy of art, saying, "I think layering is very important to how I look [at] and feel [about] the landscape. I see the landscape itself as being laid up in layers, through time, through seasons; and that stone is also made in layers. Slate is one of those materials that really expresses that."

Goldsworthy relies on fundamental forms and natural properties when he creates in either slate or other organic material. He said, "The forms that I work with and the lines that I make are determined by the nature of the slate. In fact those forms and lines are ways of exploring the nature of slate." He prefers not to impose forms onto nature but find the forms and lines already present. What he brings is the human element, the hands-on-quality of the artist, to these works. Many artists similarly share this recognition that their slate work makes evident their physical manipulation and laborious arrangement.

Pic. 8.3. Andy Goldsworthy *Structures at Bogg Farm*, 1997 Light plays on stacked slate forms. Round rocks project shadows onto the slate wall (left) and another play of light happens when the vertical slate insert (right) defines its own circular form.

Another of the reasons Goldsworthy turns to slate for his art work is that it is "a material that is beautiful in its ability to cut light, to turn light [both] dark and bright." He finds, "slate to be so responsive to light it [becomes a] way of talking about stone, not as something static, but something alive and moving."

One stacked sculpture that highlights the natural play of light on layered slate is a wall of horizontally-laid slate – old, roofing shingles – with a circle of slate laid vertically in its center. This contrasting arrangement allows light to play on the thin edges, as the viewer moves past the installation or the sun pans across the rough textured sides. Goldsworthy has compared the layering he does in a piece like this to shading a circle within a rectangle by using contrasting directions of pencil strokes. With the continually changing play of natural light, the stationary three-dimensional piece takes on a sense of movement.

This same oxymoron of a stone structure expressing movement appears in the arches Goldsworthy has created in several countries. He created his first slate arch during a visit with friend and world-famous wood artist David Nash in Blaenau Ffestiniog, Wales, in 1982. Using flagstone-like discards in the Welsh quarry, Goldsworthy constructed a large outdoor sculpture he titled *Arch*. The work is reminiscent of rural bridges spanning quick-flowing mountain streams in both Wales and Cumbria. He displayed other slate arches mounting four steps in the Centre de development culturel in Trabes (France); rising on a level floor in

Abbot Hall in Kendal, Cumbria; and balanced on the mountain side in Scaur Glen, Dumfriesshire, Scotland, open to icy wind and storms.

In a more delicate structure set on a hillside in Borrowdale, Cumbria, Goldsworthy carefully stacked layers of slate triangles, much as children do

Pic. 8.4. Andy Goldsworthy *Herring Island Cairn*, 1997 Created from Australia's Castlemaine slate, this cairn is sited in the Environmental Sculpture Park, in the only natural valley on an island upstream from Melbourne's central business district.

building a tower of cards. This work, *Balanced Slate*, was captured in a photograph with the artist reaching above his head to install the final layer at "the moment of collapse," epitomizing the ephemeral nature of his work. Other Goldsworthy works of stacked flat slates are gigantic egg-shapes, titled *Slate Cones* or *Slate Cairns*, which have appeared in London galleries, as well as outdoors on an Australian island and on a Scottish mountainside where nature slowly demolishes the work. These are ephemeral, but slow in deteriorating, depending on the weather.

Nature has a way of collapsing stone structures and Goldsworthy addressed this natural phenomenon when he proposed a large-scale project in Cumbria, known as the Sheepfold Project, initiated in 1993 by the Cumbria County Council's Heritage Services Department. Goldsworthy won the commission to remake or repair one hundred stone sheepfolds for Cumbria, where thousands of these stone enclosures had once been spread across the fells and upland pastures. Steve Chettle, public art consultant for Cumbria City Council, explained, "Although the proposal is massive, each part is very local, and provides a way for communities across Cumbria to take part in this millennium project at their own local level." The project

Slate of Hand: Stone for Fine Art & Folk Art

Pic. 8.5. Andy Goldsworthy *Conical form in the yard at Bogg Farm* Here the stacked slate shards form smooth walls and the solid structure reveals its inner core in a tear-drop shape reversal of Goldsworthy's familiar cairns.

involving slate and other local stone was extended to 2003.

Another Goldsworthy sculptural form composed of old roof shingles is a softly rounded mound with a hole opening to the secret interior. Ancient burial mounds heaped with stone and dirt present similar intrigue to modern eyes. In a variety of locations in Britain and Europe, Goldsworthy used flat layered slates in heaps of spherical shapes or long barrow-style mounds with a narrow slit running lengthwise. The black hole or crack in the slate pile suggests earth's "energy made visible." Goldsworthy says he is unnerved looking into a deep hole; "my concept of stability is questioned and I am made aware of the portent energies within the earth."

Earth's metamorphic heat and pressure that transformed slate from sediment to stone is illustrated when slate is scraped and produces a white dusty powder. In Brussels Goldsworthy used this property in an installation titled *Stone Sky*. With flat flagstones laid closely together on the floor, he scratched a large white circle across the irregular shapes of dark slate. He explains, "I have sometimes drawn lines and colour out of stone by scratching one against another, stone on stone, grinding out a dust, turning the hard rock into something closer to air or clouds." This is as close as he comes to carving or painting on slate, but it hints at the power in nature and the changed structure of slate.

In Dumfriesshire, he has been able to create both permanent and ephemeral outdoor sculptures, or Land Art, on property near his home. Goldsworthy says, "There's a small … old slate quarry near to where I live. It's abandoned and the slate is not particularly good quality, but it would have once been used for local roofs. And I go there quite often to work with it." Using natural materials in locations around the world, from Australia to the North Pole and from Japan to St. Louis, Goldsworthy has experience with many shapes and forms of slate.

I've worked with [slate] in Cumbria and in Wales, where it is of much better quality [than in Scotland.] And I've worked with it in many urban places in the form of roofing slates. And I like that connection. The roofs are made and remade in a cycle of repair. And during that process a lot of the slate is damaged or broken and it cannot be put back on the roof, and I've often made works using that.

Commissioned by the National Gallery of Art in Washington, D.C., to create a site-specific installation, Goldsworthy and a team of dry-stone wallers from Britain stacked hard Buckingham, Virginia, slate into nine abutting domes, each six feet high by 28 feet across. Completed in 2005, his ground level work titled *Roof* alludes to the slate roofs and several domes on the D.C. skyline. Black

holes at the hollow domes' crests tempt viewers to peer into the depths both from the ground floor and the mezzanine of the East Building.

Goldsworthy continues to explore the elements of nature and uses photography to record his ephemeral art. Appreciating the past uses of slate and its stackable quality, he has produced artwork from this common stone, fascinated viewers, and inspired other artists. He says, "I don't think I'm someone who is after exotic or [unusual] types of slate. I mean, one of the joys of slate is that it is so common and there is so much left over in the process of extraction that it is a very available material."

Figures: *Julie Levesque*

Like Goldsworthy who laboriously stacks and recycles otherwise unwanted slate, sculptor Julie Levesque has devised a method that brings new life to roofing slates, specifically to broken shingles. By stacking layers of slate shards in a slow and labor-intensive process, she creates semi-abstract figures with sparse, clean lines. Her sculptures often convey movement. She says that slate gives her the "massiveness of stone, and yet a fluidity." She points out that "one chip of slate is nothing, but a pile arranged is magical."

Early in her sculpture career, Levesque created works with flame-cut steel and stacked newspaper. These were layered and then torched, thus creating "a beautiful silky brown color" that people were fascinated with, though they couldn't recognize the material. She liked the idea of layering her elements to get the sense of complexity and weight. But when she saw stacked-slate Land Art by Andy Goldsworthy, she recalls, "He blew my mind." She decided to experiment with stacking slate into a figurative shape, instead of the ovals, arches, or blocks that Goldsworthy used. Being a Maine native, she had "always been attracted to slate as a material – its softness, as a stone, and especially the look of a broken edge." Discovering Goldsworthy's work came just at the time she was "looking to shift to a material suitable for outdoors."

Pic. 8.6. Julie Levesque *Turn About*, 1998 (21" × 7" × 7") The stacked slate figures twists in an attempt to change direction.

Slate of Hand: Stone for Fine Art & Folk Art

In her first slate sculptures she used a variety of slate colors – some were all red, some a mixture of gray, green, and black. Now she realizes that "texture is so rich that a color change is distracting. There's beauty in the simplicity." The textured surface of her gray figures can appear as smooth, subtle lines of a body or as flowing and frilly fabrics affected by wind. Some figures reflect her Catholic school upbringing with images inspired by nuns in flowing habits. The figures now have movement, whereas Levesque's earliest life-size slate figures, by her own description, were "sentinels. There was the sense of them just standing guard, the feeling of being bound."

Pic. 8.7. Julie Levesque *Still Waiting*, 1998 (54" × 15" × 9") A calm, slate figure with no exterior "skin" patiently poses, allowing the viewer to inspect both its interior space and surface texture.

"My main themes progress from a sense of stillness to movement and moving beyond the strictures that bind us up," says Levesque. Capturing movement, her slate figures are leaning, walking, striding. Their flowing garments seem to trail away. "They are starting to take off," she affirms.

Levesque frequently includes holes in the torsos. The holes may indicate the absence of something, she suggests. Or, they may be thought of as a window to the soul. Either way, the holes break up the body space and often allow the viewer to see all the way through the form. "The surface texture, the skin, actually goes right to the core," she says. There's no veneer of other materials, since the slate provides the basic nature of the shape you see. This visual metaphor presents the artists' stripping down to the essence. Like the abstract figures of Barbara Hepworth, Levesque's figures with holes invite viewers to contemplate the figure's spiritualization.

The questions Levesque asks herself about each piece are, "Is it alive? Does it have enough truth and enough of me to come to life?" She adds, "If you have to read a plaque on the wall to understand it, I've failed." Levesque sets out to communicate the human struggle. She uses slate to give her sculptures weight and "a massiveness that reflects the weight we [all] travel with that holds us down." Her works express the human ability to move and grow, even when there are structures that seem to prevent us.

Pic. 8.8. Julie Levesque *Out of the Woods*, 1997 (detail) (66" × 15" × 22") As the form moves through space, the figure seems to dissipate into shards.

Her sculptures range from two feet to six feet tall and can be displayed both outdoors and inside. For each, she first creates a small maquette in clay and then a base and full-size steel armature of support poles. The armature has a grid to match her clay model. "Once the model is made, all the decisions are done," she says.

Wielding a hammer to break up old roofing shingles purchased from stone yards or roofers, she works with a pile of broken pieces no bigger than a dollar bill torn in half. With her pneumatic glue gun, she dabs a spot of two-part epoxy to each shard of slate and lays in pieces on the base of the armature. The mechanized glue gun gives her a self-mixed epoxy and keeps her squeezing hand from tiring. She sometimes adds a sealant in cracks to protect against ice damage. The sculpture with smooth or fractured edges rises with each layer through this process she likens to putting together a jigsaw puzzle, since piece by piece the form unfolds.

Each outdoor sculpture sits on an underground cement pad to keep it level and is bolted to a wide aluminum plate. Larger pieces are created in sections and moved into place with poles inserted into tubing that allow the sections to be carried. The tubing holes are then covered with slate once the pieces are joined. One such sculpture is *Continuance*, a two-figure installation, at the Temple Shir Tikva in Wayland, Massachusetts. The larger figure, over six feet tall, has a four-foot stride and was created in three sections. Another life-size figure is *Out of the Woods*, one of Levesque's earliest pieces to express movement.

The heads on Levesque's slate figures have been proportionally small for the bodies, though they provide the surety that the shapes represent the human form. Tilting heads add further to the sense of motion of these textured figures. In her

Slate of Hand: Stone for Fine Art & Folk Art

most recent works, "heads have gotten progressively smaller until they have sometimes disappeared," allowing Levesque to experiment more fully with forms and materials as she explores movement through physical space.

Being a sculpture metalsmith, Levesque sometimes incorporates the glimmer and fluidity of metal into her textured slate sculptures. She introduces shafts of lead, as in *Stacked Deck* where she combined the figure with a residence, forming a peaked standing form. A lead-lined shaft runs up the middle of the slate form and two lead spheres inhabit the center section above the shaft. She comments that the lines of the shaft remind her of a passage in an Egyptian tomb. Such a byway could also indicate travelling somewhere, a direct line to a destination. Of the peaked sculpture, she says, "It's a shell, a hollowing out." Referring to the shaft that leads to the encased metal globes, she suggests, "It's a way in. Maybe a keyhole." Thus, Levesque's stacked slates create abstractions that project solidity from fragments, airy movement from weighty stone; and viewers are free to interpret, as they will.

Pic. 8.9. Julie Levesque *Stacked Deck*, 1998 (29" × 12" × 5") The polish of lead contrasts with the rough texture of slate in this sculpture that combines the human form with a peaked structure.

Levesque continues to use slate to express her need to break away from the ordinary. Because the slate sculptures demand so much time and patience, she is looking for "a more spontaneous method of working" with slate. She is experimenting with wax on slate and continues to combine the brittleness of slate with the slick, smooth look of lead. She continues exploring materials and pushing the boundaries of slate as a medium.

In addition to slate figures, Levesque also uses slate shingles as drawing surfaces. She creates a canvas of aligned roofing shingles, hanging them with cast-bronze t-screws that she designed. The screw heads take on a patina as they age, while the slates retain their already weathered marking from years of exposure to pollution and the elements.

Onto the flat surface she scores lines with a flexible-shaft drill, creating an engraved figure with many of the features seen in her three-dimensional pieces.

Figures drawn with straight, scored marks – reminiscent of petroglyphs – are softened with swirling trace lines, so the drawings won't be too severely delineated. "The scratching on stone is primal," she says, and she wants her drawings to have the same faded edges as primitive artwork. But unlike James Thompson in Scotland who shares her interest in prehistoric carvings, Levesque does not try to reproduce the ancient figures. Hers are modern representations of the human figure and its struggles, recorded on slate.

Cultural fossils: *Celeste Roberge*

Over a ten-year period Celeste Roberge was also interested in figurative sculpture and created massive welded and galvanized steel figures filled with granite, shells, sand, and shale. These works were often of women, sometimes nine feet tall, who speak not so much of femininity and fertility but of "power and presence." From this same period in her sculpture career came *Cambridge Rock*, a steel sphere filled with black slate, in a neatly geometric expression of her interest in geology and the turbulent activity of earth's formation.

Roberge is attracted to the "weight and physicality" of stones and has been working with heavy materials (slate, granite, lead, and steel) since 1979. Like Hepworth and Goldsworthy, she drew on the word "cairns" for the titles of some works, alluding to stones piled up, often as landmarks or burial mounds. These works by Roberge were described as "something primal and elemental that can withstand the raw threat of nature." She has traveled to Scotland's Orkney Islands, Newfoundland, Egypt, and Iceland pursuing her interest in stone and its ancient uses. "If you like stone," she says, "you have to go to stone. It's outside and in rugged terrain."

As a sculptor, Roberge has frequently been asked to create works with indigenous stone. Galleries find that people recognize their local rocks as "something in my back yard" and that makes sculpture more immediate for them. She has used cobble granite from the Truckee River for an outdoor piece in Nevada; shale and slate for a gallery show in Chicago; Arizona sandstone in El Paso, Texas; and slate from the northeast (New York) in the 1998 Portland Museum of Art Biennial in Maine.

In 1997 she began a new series, shifting from figurative sculpture to forms that deal with feminism by incorporating motifs of architecture, archaeology, and geology. The series called "Stacks" presents antique furniture embedded in drystacked stone, making references to "burial, stratification, and fossilization. The labor evident in stacking thousands of pounds of stone brings to mind the process of cultural sedimentation and the relationship of human time to geological time," she writes. Here the natural world encapsulates the human world and geological time over-rides human time.

The fifth stack in the series was created in 1998 from layers of red, green, and purple slate from Granville, New York. Roberge had a chaise lounge reupholstered in blue and embedded it in the striated stack of slate, referring to the piece

Pic. 8.10. Celeste Roberge *Cambridge Rock*, 1989 (36" diameter)
Reminding the viewer of the earth's core, this sphere of steel and slate exemplifies the bedrock of our planet and the containment of geologic forces.

Slate of Hand: Stone for Fine Art & Folk Art

Fig. 8.11. Celeste Roberge *Slate Stack*, 1998 (52" × 76" × 29") Beach rocks atop striations of red, green, and purple slate encasing a blue chaise lounge present the fossilization of civilization. The viewer senses the weight of the stone and is aware of modern concepts, with this Feminist response to the changing role of women.

as the *Slate Stack*. A red stack (*Stack # 2*) was created from a chaise lounge and red slate from Granville, layered with green Georgia shale and capped by jasper from Chile. Her *Yellow Stack* was yellow Arizona sandstone beneath and above a daybed upholstered in mustard yellow. The black stack (*Stack # 1*) used shale. The *White Stack* was designed around a small, square Victorian chair stacked with limestone and topped with obsidian.

Each sculpture took its length and width from the antique chaise lounge, which became a "fossil" within the stone. As fossils are organic objects preserved in stone, so the antiques became archaeological artifacts. The stacks are reminiscent of sections of stone walls, though New England stone walls, familiar to Roberge from childhood, are not typically so neatly stratified as her stacks. Yet, in the slate quarries the retaining walls of discarded slate are necessarily lined up as squarely.

"As I stack the stone," she writes of her dry-stacking method, "it is with an awareness of historical and architectural precedents such as the fieldstone wall, the stone sarcophagus, and prehistoric dolmens and menhirs. I construct within the limitations of structure and material." It takes Roberge two days to build, or rebuild, a stack that might weigh 6,000 pounds. Each time one is moved, it is dismantled and recreated. "It may get a little shorter, less crooked or some other variation," she confides. The slate circles of Richard Long (Chapter 9) are also reconstructed in this same directed, though inexact, manner. Merrill Wagner composes her "jigsaw puzzle" of unattached slate pieces but uses color to link and realign the elements.

Of her sculpture, Roberge says, "In some ways it is painting. I'm working with bands of color. The stone and the upholstery have color, and the rounded stones at the top reflect the tufted furniture." But unlike artists from antiquity through romanticism who frequently painted the reclining female nude on a chaise lounge, Roberge has broken from that art tradition. "From a feminist perspective, the reclining female nude is a cultural fossil," she explains.

In her *Stacks* Roberge allows the viewer to sense what it would feel like to lie on that bed, to have a bed of stone, and to be that weight that compresses the upholstery.

By thus "placing themselves either beneath the stone – a form of self-burial, or replacing the imagined [nude] body with the stone," viewers see the sculpture as a depiction of entombment, fossilization, and embedded artifacts. The stacked slate sculpture speaks about the body, the nature of being, and geological layering.

In her newest and a tangent series, titled *Stacks for Home and Office*, Roberge again turned to slate. She stacked the black slate of Monson, Maine, in stove-like forms and set cast iron frying pans holding shells, coal, gold leaf, and fossils atop, for a piece called *Hearth*. In the second sculpture in the series, *Volcano*, she built a cairn of red slate from New York layered with frying pans holding minerals she collected from Iceland. Explaining that "sculpture is a domestic activity with volcanic possibilities," she links traditional cooking with "molten metals of the sculpture foundry" and the "geothermal activity that is constantly bubbling within the earth."

For future projects, Roberge plans to continue to "play with slate." When she bought her slate from the quarry in New York for the *Slate Stack*, she ordered the three colors she needed – and then some more she "just wanted." She hopes to use sheets of slate in two dimensional works, perhaps using split slate or shingles. As she continues to explore the medium, Roberge acknowledges her enjoyment of creating with stone that splits easily and is of a manageable size. She adds, "Slate is workable and domesticated," thus sharing an appreciation in common with artists from seventeenth century gravestone carvers to the prolific Long and Goldsworthy.

Pic. 8.12. Celeste Roberge *Stacks for Home and Office*, 1999 (on left, *Hearth* [36" × 48" × 12"], and, right, *Volcano* [30" high × 40" diameter])
Monson slate forms *Hearth*, and a cairn of New York red slate peaks for *Volcano*. Not shown is *Hot Pots* (36" × 24" × 24") made of keystone from Florida. All incorporate skillets holding materials that are cooked or molten.

Pyramids and urns: *Howard Bowcott*

Building stone walls was one of the first jobs Howard Bowcott took upon leaving city life in Manchester, England, in 1979 for bucolic North Wales. Like Roberge and Smith, he understood historical aspects of walls and so felt he was making part of the landscape, or adding to it, as he constructed both drainage ditches and walls for the Ffestiniog railroad, the tourist train that climbs to mountain slate quarries. His manual labor allowed him to become part of the scenery and he loved being immersed in it. Like Roberge, he recognized a need to go to the sources of stone. The Welsh landscape, and especially slate, had inspired his final year's work in art school and had drawn him to live in Wales.

Bowcott's early artwork included photography, drawing, and "sculpture inspired by the slate mining of Blaenau Ffestiniog." He collected stones while on walks and made private assemblages for his personal pleasure. He made diaries of his

walks, much as Long did. Bowcott was in fact absorbing himself in slate and its touch. Additionally, he produced a photo-documentary on Bob Griffiths, "the last slate quarry blacksmith at work in Blaenau Ffestiniog" and also published a limited edition booklet of photographs titled *At the Edge of the Slate Tip*. A common theme for him at that time was how "nature takes back or reclaims what humankind has done."

Serving as Artist in Residence at the Welsh Slate Museum in Llanberis, North Wales, Bowcott created *Slate Sea*, a slate wall laid on edge, sprouting from a slate tip across the lake from the Museum. (see Pic. 11.3) The "landform" (sculpture) is returning to nature faster than he thought it would, because sheep no longer graze there and keep the grass trimmed.

A cultural exchange trip to Zimbabwe in 1987 had inspired Bowcott to concentrate on sculpture. Since African coil-built pots had captured his imagination, he built three urns for the first Art Festival in Criccieth, Wales, where the theme was "Sculpture for the Garden." One urn was made of slate pebbles, another of moss turfs, and a third of branches and down; they eventually became known as *Three Romantic Urns*. The title came about because a visiting Norwegian dancer attended the exhibit and admired the urns, was introduced to the artist, and later married him.

Bowcott fashioned the slate urn by stacking smooth slate pebbles around a hollow center, unlike the solid, dry stone urns of Joe Smith. Bowcott feels this was a seminal piece for him, as it was the first time he used a flexible adhesive to secure his slate. Also the urn featured an outside form that hints at the inside shape and draws the viewer closer to peek in. He would expand these concepts in major public commissions to follow.

Another outdoor sculpture of stacked slate, *Caldicot Cross* is a war memorial created for the Monmouth County Borough Council. Standing five meters high at a crossroads in Caldicot, North Wales, two columns of shards of Welsh slate rise to form a cross with a diamond-shaped opening at the crossbars. At his studio Bowcott had fashioned the cross from hollow blocks of stacked and glued slate pieces. He worked in sections, numbering each, before reassembling them by sliding the four-inch blocks onto one of the steel columns placed on the site. The steel armature is

Pic. 8.13. Howard Bowcott *Caldicot Cross*, 1995 (16²/₅' high) A modern commemorative with a sense of history, this monument is composed of Welsh slate, steel, and concrete.

concealed within the two columns of the sculpture, which is a single cross with a narrow aperture descending its full length, uniformly textured facings, and sharp corners. The award-winning piece conveys the sense of both traditional monument and modern sculpture.

In a method most similar to that of Levesque and echoing Goldsworthy's appreciation of slate as bedrock, Bowcott explains that he creates his sculptures "by layering stone upon stone, layer upon layer, like the laying down of time and geological strata built up over millennia." He creates sculptures in a "painstaking building up of thin slates or pebbles" into either geometric or abstract shapes. His wall mounted *Ordovician Spiral* invites inspection, as the Welsh slate coils into itself, making the viewer think of a fossilized sea conch.

Bowcott has adapted the triangle, for both a classic pyramid of stacked slate, *Ordovician Pyramid*, and for "slate wedges" (narrow, upright, slate triangles). He used Cumbrian slate formed from fine volcanic dust, a "green, much coarser, and harder" slate than that of Wales, for a courtyard commission at an environmental research facility in Whitehaven, Cumbria. His *Slate Wedge* is encircled by a nineteen-meter long labyrinth path of slate that serves as a timeline. Every two centimeters represent one million years of geological time. When the first remaining life forms appear along the time line, Bowcott incorporated sandblasted paintings of a dinosaur and a fish. He painted with an adhesive resist on the slate, sandblasted, and washed away the resist to leave a raised design in "flowing, calligraphic strokes." For the three centimeters of human appearance, he used the handprints of his two and half year-old son and one week-old daughter. (see Fig. 11.1)

In the coastal town of Tywyn in mid-Wales, when Bowcott was commissioned to create a sculpture for a green area outside the Halo Ice Cream factory, he offered to landscape the area with a wall of sculptural seating around the focal point of a stacked-slate, wedge sculpture. A niche in the back of the wedge, titled *Into the Mountain*, creates a tension and also draws the viewer closer, just as the hole in the top of an urn makes one want to look inside. The resulting park area invites people to sit and contemplate the award-winning, stacked-slate art. An audience that might not otherwise come in contact

Pic. 8.14. Howard Bowcott *Ordovician Spiral, 1992* ($1^{1}/_{7}'$ diameter × $2^{3}/_{4}"$)
Suggesting fossils or the ancient motif of a spiraling line, this stacked slate piece connotes ancient life.

Pic. 8.15. Howard Bowcott *Slate Wedge,* 1996 ($9^{5}/_{6}' × 9^{5}/_{6}'$ sculptural detail in *Land Readings*)
Set above a carved slate path representing the earth's timeline, the classic triangle shape in slate rises from the courtyard installation.

Pic. 8.16. Howard Bowcott *Into the Mountain*, 1991 (6½' ×6½' × 2' at base) The niche in the narrow side of the wedge, like a deep mountain fissure, reveals layers of tightly packed slate inside this outdoor sculpture.

with sculpture views it up close in a nonthreatening environment.

Bowcott's stacked sculptures have "a very human, handcrafted quality to them," he says. "That human, tactile quality is very important to me." People recognize the amount of work that goes into creating these pieces; they respect the craftsmanship and realize someone cared about the project and material on exhibit. Recurring in his work today is the "awareness that artists manipulate natural materials," as the starting point of creativity.

Bowcott, like other artists who stack slate, takes 450 million year old stone, cuts it, shapes it, and interacts with it, thereby creating sculpture of here and now. There is an interaction with the natural form, he says, and then it takes on a life of its own, a new life provided by the artist. His stacked wedges and other slate sculptures have shown him that "the artist can make a difference in the environment" by transforming materials and creating "a sense of place, a sense of community, and even a sense of well being."

Not all stacked slate sculptures are intended for outdoor placement, but for these artists it has proven a worthy material, impervious to weather. Whether the artists used epoxy or created in dry-wall fashion, these stacked sculptures are at home in a natural setting. Some structures are even meant to succumb to the weather and time, as they continue the stone's "journey" back to the earth's strata.

The weight and mass of piled rock from prehistory frequently provide the reference of longevity for artists working today to express their awareness of time and changes, both seasonal and cultural, to viewers who are probably not as connected to the land as were people of a century ago. The slate artists see the changes, feel the integrity of stone, and invite the public to contemplate and expand their awareness of nature's forces and the materials of earth.

Contemporary/ Abstract Forms

CHAPTER NINE

THE FIELD OF MODERN ART INCORPORATES A WIDE VARIETY OF ABSTRACT WORKS, with a long list of labels and narrow categories. Under the umbrella of modern abstract sculpture falls our stacked-slate category that runs the gamut from wall-like structures to rounded figures, sculpture-in-the-round with tactile elements frequently featuring polished slate surfaces, and now abstractions in slate arrived at from creative play. These works with their intriguing aspects of form, line, volume, and color may not be recognizable objects or common shapes. The artists make use of other elemental resources like water and light, incorporate "found objects," and manipulate natural materials in experimental ways.

From slate fragments and found objects salvaged from quarries in Canada, Louise Desrochers makes both jewelry and sculpture. In an exhibit titled *Un jardin d'ardoise (A Slate Garden)* she brought together texts, pictures, paintings, and sculptures created from cast-off, rusty metal, and interesting shapes of slate all from the New Rockland slate quarry. Her sculptures *The Slate Wing* and *The Guardians* both combine scrap metal and three colors of gray slate from the New Rockland, Danville, and Kingsey quarries. Whereas Noguchi chose to interlock and balance his slate components, Desrochers has held her metal and stone works together with wire and careful placement. Both artists determined their slate works would not be permanently fused.

Desrochers intends that her sculpture will intrigue viewers with a "recognition of what ... has been and what ... is today. [Her work] offers a new look, far from the usual prejudices for those abandoned sites. It allows [viewers] to discover and rediscover the slate quarry." Her sculptures illustrate how artists see lines, shapes, and other visual qualities in the found objects they select.

Pic. 9.1. Louise Desrochers *The Slate Wing* (9" × 18" × 10") A sharply pointed slate block is wired and balanced on a piece of scrap metal — all found objects selected by the artist for the 1997 exhibit *Un jardin d'ardoise (A Slate Garden)*.

Pic. 9.2. Louise Desrochers *The Guardians* (13" × 9" × 6") One of three sculptures in a series combining gray slates from abandoned Canadian quarries, this piece is composed of two blocks from New Rockland.

Using natural sculpture: *Christopher Curtis*

Vermont sculptor Christopher Curtis has been collecting stones since childhood and now likes "finding appealing pieces of stone and using them as [art] objects." He says he "makes the discovery, selection, and recovery of the raw stone an important and enjoyable part of [his] work." In both abandoned and working quarries, he sees discarded stones that are "individual, natural sculptures by themselves" and he knows he just has to have them. Curtis visits quarries in both Vermont and Maine to select large chunks and boulders, which he will "cut a little bit" to "accentuate the natural beauty of the chunk." Though black slate is available closer to his home, he loves the jet-black slate from Monson in northern Maine, because he can carve or hone it into such a "beautiful tactile silkiness."

Viewing the stone as an "object, not only [a] material," Curtis created *We Two, Oui Tout*, from a two and one half-ton angular block of Monson slate with square ledges. People think he carved the natural, squared corners on the "masculine side" of the upright block, but actually his carving was in the incised canoe-shape motif on the "feminine" side of the piece.

For a commission to be set in a garden and designed so children might climb on the sculpture, Curtis was drawn to another Monson stone with a "very distinct wavy shape." He angled the undulating slate block and honed only the elevated tip with its narrow band of "quartz that makes that particular piece [titled *Monson I*] sing." Relishing the idea that children would climb on the sculpture, Curtis believes "very strongly that sculpture is made to touch" and he strives to develop appealing textures, especially silkiness, that will intrigue viewers. Surfaces resulting from a combination of natural processes, honing, and minimal carving are significant features of his sculptures.

In *Pondering*, Curtis selected a red slate with a strongly contrasting banded green layer.

Pic. 9.3. Christopher Curtis *We Two, Oui Tout* (4" × 3' × 2') This black slate quarry-discard from Monson, Maine, riven and square-edged on the side shown, has an upright polished carving on the reverse.

Pic. 9.4. Christopher Curtis *Monson I* (30" × 31" × 31") The artist waited a year to carve this block taken from an abandoned quarry in Maine. Preserving most of its natural form, he honed only the upward angled tip with its quartz band.

Knowing the green stone was not as structurally sound as the red, he used that property and created an "undulating topography" by carving away most of the ½ to ¾ inch green strip. He then introduced a hole through the piece, preferring a "gentle approach to the interior – not a sharp edge," and honed the red surface with its splotches of irregular green shapes. Mounted on a stainless steel post, the totally abstract shape that was initially a quarry discard becomes an art piece of seemingly molten material (see Color Plate 13).

Working in mica schist, granite, and slate, Curtis finds he is continually inspired by stones that "broke out of the quarry in really fabulous shapes." He uses the natural breaks, introduces piercing, and works textures for desired results on the stones that usually have character already. By adding the evidence of man to the natural material, he transforms the stone and continues it on its journey as something new.

Color Plate 13: Christopher Curtis *Pondering*, 1997 (68" × 28" × 8") Colored slate banding found in the New York quarries was used to good advantage as the artist chipped into the colored layers before polishing the stone.

Engraved panels: *Susanna Heron*

For Desrochers and Curtis the found-object quality of the stone lends itself to their pieces. Cornwall's Susanna Heron conversely turns to milled slate for her work, making use of the flatness of the slate panel in her installations. She admits her "reason for using slate is that it's so flat and thin. It's a very good reflective plane. And, the whole … notion of the flatness is in its structure. Everything about it is really to do with a plane." In several major works she has used engraved slate panels, sometimes in conjunction with water, and each time drawing on the effects of light cast across the slabs of carved slate.

She obtained her first large slabs of slate from an artist-friend who took over a former club to use as a studio. Heron bought pool-table slates left in the club and then stored them for several years before deciding to experiment with drawing or engraving on them. These doorway-sized pieces became a 1992 exhibition installation at the Newlyn Art Gallery in Cornwall. A combination of seven engraved, vertical panels leaned against the gallery wall, while a horizontal floor piece filled the center of the room. Her engraving motifs suggested channels of energy, as in nerves, roots, and paths – motifs she would use again in future slate engravings.

Heron won a commission to create a work of art in the main Conference Room Foyer of the European Union Council Building in Brussels. She used an

Pic. 9.5. Susanna Heron *Slate Frieze* (sketch) Heron developed as a form of notation for the engraving and texturing that would eventually span 23 panels. (Drawing from *Stills from Sculpture*, courtesy of the artist.)

electric rotary drill to engrave twenty-three, black, Italian slate slabs, each two meters high by nine hundred millimeters wide. *Slate Frieze* (69 feet × 6½ feet × 4/5 of an inch) invites inspection, for the carvings loop and flow as people pass by them. Heron first created a line drawing to scale, photographed it, and then projected it onto the slate panels in her studio. This line drawing acted as a two-dimensional plan for her three-dimensional engraving of furrows and ribbons in a tangled skein of lines that unravel between carved freeform shapes of rimmed textures. The natural light in her London studio helped Heron determine the details of her engravings, including smooth V-cut lines, evenly textured swirled forms, and irregular split-edged strands.

As the viewer walks past *Slate Frieze* in Brussels, the reflected light changes and so alters the spatial relationships in the engraving. Heron was very aware of

Pic. 9.6. Susanna Heron *Slate Frieze* (detail 1), 1994-1995 Riven texture and various engraved lines loop across panels of black slate at the European Union in Brussels.

the fact that people would see the installation one section at a time, rather than in a single view of the whole. She expects viewers to "accumulate information." Comparing the art experience to watching a film or reading a book, she says, "You don't see the book all at once. ... It accumulates as you go through it." So, viewers find "an echo" of information, as they become familiar with the work and one element reminds them of something previously noted.

Next, Heron was invited to create an artwork to be installed at the entrance of the new British Embassy in Dublin, Ireland, in 1995. Here again, she was presented with a path and the awareness of people coming and going. Her work

Pic. 9.7. Susanna Heron *Slate Frieze* (detail 2), 1994-1995 Here a worked texture is contrasted with polished slate, over which lines of various depths and angles swirl.

Color Plate 14 Susanna Heron *Island* (detail), 1994-95 Wet slate and rainwater collecting in the flowing lines of the engraving reflect the sky above Dublin.

titled *Island* includes an entrance walkway of twenty-one meters (the same length as *Slate Frieze*), a moat, and an arrangement of slate features highlighted by the weather and dependent on the viewing point of the passerby. A low, slate boulder sited on a grassy area to one side of the walkway displays meandering, carved lines that channel the runoff of rainwater. Similar engraved tracery adorns a flat, slate-panel island in the moat, suggesting an underground stream that invisibly connects the two slate pieces (see Color Plate 14). When wet with rain, the carvings on both the boulder and the island visibly change as they reflect light and then dry slowly; yet a third slate element, an ellipse of smooth black slate, lies submerged beside the island and tranquilly echoes the boulder on the grass.

Heron incorporated many visually accumulative references to water in this pensive work, which she intends to suggest "a quiet mutual presence in hope of peace at this time in history and for the future." One subtle connection between water and slate, Heron points out, is that "slate itself comes from river-beds and Delabole slate has markings that look very like water."

For another installation where point of view and reflections from water affect the slate work, Heron

created *The Sunken Courtyard* at Hackney Community College in London. Here viewers from above lean on railings to gaze down into two pools with granite mosaic floors and a rectangular slate platform seeming to float just beneath the surface of the upper pool. The engraved slate panels of the platform are visible in certain lights and the wet panels mirror a dominant blue wall. A nearby slate boulder from Delabole counterbalances a tree at the far end of the courtyard. Again, passers-by and those in the adjacent library are invited to observe the installation and note the changing details in the work made evident by reflected light and shimmering water.

About creating large public installations, Heron explains in the preface to her book, *Stills From Sculpture*, that "A public work of art does not exist in isolation nor is it cocooned in an anodyne space. It is a living thing, seeping into the everyday life of those who come across it, seen out of the corner of your eye as you go about your daily business." Whether noticing elements along a path or seeing slate engraving in sunlight at different times of day, viewers become familiar with the parts and then recognize the whole.

Heron's large slate panels and boulders engraved with lines flowing and angling in the light bring a new aspect to the traditional custom of incising calligraphic lines on stone. Like the letter carvers, she relies on the angle of her cuts to reflect light, but adds the dimension of water and its reflections to her work. She brings a sure-handed modern touch to engraving on slate, deftly linking separate elements and using nature's shared gifts.

Desrochers, Curtis, and Heron are exploring the possibilities for slate in contemporary sculpture. Two other artists who have left their marks on the art world, beginning their careers in the 1960s, have worked with various materials, yet included slate during significant periods.

Total abstraction: *Phillip King*

The British sculptor Phillip King grew to prominence in the early 1960s, as the first English sculptor to create works in fiberglass and plastic, often brightly hued; but he also rediscovered natural materials when he had a "love at first sight" encounter with slate. In the early 1970s, King became fascinated with the materials of a building demolition next door to his studio. The rubble included bricks, reinforced steel, steel mesh, and roofing slates. At this point he reflected on his fiberglass works and felt "almost as though I'd cut out the idea of the material from my notion of what sculpture was about." The fiberglass works were often masked with coats of color that hid the material, and so he determined to reclaim the "notion of material ... back into [his] work." He "rediscovered" bricks, steel, and slate and created a series, first of bricks and reinforced bars and then with slate.

King saw sculptural materials as free of any associations and open to any configuration. Although he would begin sculptures with "an aim and a general direction," his additive process involves a freedom of making choices. With his new emphasis on the materials, he relied on his own direct physical and sensory contact with his evolving work. As he puts it, you have "to be conscious of what your body is telling you and what your eye is telling you." Working in this way, "dead ends don't exist" because the artist is always open to new physical and

sensory inputs that can cause the overall aim to change. Slate and other found objects were fitting materials for this approach to sculpture.

His "discovery" of slate led him to go look at the slate-producing quarries in Wales. He was fascinated to find that in the villages and quarries "slate was the order of day. Everything was made out of slate, including the furniture – chairs and tables – and fences. The whole place seemed to be [black] slate" in this lush green landscape near Corris. He hired a caravan (camper) and lived in the area for two weeks, making slate sculptures in the quarry, using a hammer to break the slate and then assembling the work.

King soon felt he needed a "whole quantity" of slate and so bought a trailer load of "twenty tons in one fair swoop," which he transported to his farm-based studio in Dunstable, Bedfordshire. The quarry purchase included discarded mill stock and off-cuts of smooth slate pieces, as well found pieces of rough slate. Like Hepworth and Noguchi, King used slate, along with other materials, over a ten-year period of exploration. He produced many works combining slate, wood, and steel throughout the 1970s, and yet still has plenty of slate left from his first, and only, quarry purchase.

Because of their size and his emphasis on natural material, King's slate sculptures were often intended for outdoor display. "Having worked out of doors on site in the quarry to begin with, it made it much easier for the larger pieces to be placed out of doors," he said, "and I think I've always felt they would look happy out of doors. And, in fact, they did." He does acknowledge, however, that "from the point of view of conservation, they would have a longer life inside," mostly because of metal corrosion.

His 1978 work titled *Shiva's Rings* unites steel, steel rope, wood, and a unique piece of slate peppered with drill holes. A quarryman explained that the stone was probably over 100 years old, from the time when the workers "had to sharpen their own chisels. ... It must have been used for testing the chisel bits to see whether they were sharp enough." The slab of slate leans precariously against a steel spine and seems tethered with multiple metal rods looped through the holes in the slate. A wooden plank is angled on top with another weighty boulder on it, this one lashed with steel rods to keep it from sliding. This unusual piece projects tension in a complex arrangement of natural materials and steel.

A number of King's sculptures from this time used elm and rough pieces of Welsh slate, in effect, found objects. Contemporary artists see the potential in these discarded materials and use their colors, shapes, textures, and associations to enrich their works or bring new appreciation to viewers, as suggested by Desrochers. Additionally, King acknowledged the cost benefit of using these materials, rather than the more expensive steel.

In *Open Place* from 1977, King aligned steel frames and milled slate panels. The slate pieces, produced in Corris probably for billiard tables, were "cut and fitted into a steel structure" in a rambling tent-like arrangement. King described

Pic. 9.8. Phillip King *Shiva's Rings*, 1978 (6' × 6' × 3') Found objects of steel, slate, and wood from the Welsh quarry in Corris are balanced and locked together in a complex arrangement.

this application as "using the slate almost as if it were a stained glass window, with the steel acting as a kind of leading." The weight and solidity of these slate slabs balanced to create an earth-hugging enclosure, which conjures a sense of sanctuary or hidden refuge. Of the heavy slabs treated as fragile panes, King points out that the "very process of gravity being allowed to be a part of the process of making something has always been important" to his work, just as it was to Noguchi.

Pic. 9.9. Phillip King *Open Place*, 1977 (4¼' × 7½' × 8¾') Milled slate panels are encased within steel frames, much like stained glass is held in place by leading.

King is recognized as a "highly distinctive and innovative sculptor" who is "undaunted by materials" and has created some "startling sculptural inventions." His use of steel, brightly colored fiberglass, and crude slate slabs or honed slate planes all reflect his open-ended approach to creating sculpture. Like Curtis and many others who use slate as an art medium, King found beauty in discarded slate and adapted that beauty in his abstract works.

Land Art: *Richard Long*

Innovations in art result as artists experiment with new materials and create new techniques. As King delved into unusual sculptural materials, so has his student and countryman Richard Long also contributed greatly by conceiving new methods of creating art. Internationally known, Long formulates his artwork from nature's most common elements, including stone, wood, mud, and wind. Since the early 1970s, he has influenced abstract art through the development of his Minimal and Conceptual Art, creating "Land Art," which uses direct interaction with nature as its subject.

Early in his career, Long saw the 1964 Tate Gallery exhibit titled "Painting and Sculpture of a Decade," which included sculptures on the floor by Isamu Noguchi and others. Long responded to these works that articulated indoor space and soon began creating his sculptures on the ground, outdoors. His works in the landscape allowed him to deal directly with nature and its forces; and he contributed something new to the art world, while basing his works on familiar, simple forms.

Between 1977 and 1997, he created at least fifty slate sculptures, both in the landscape and indoors. Some of these international works include concentric rings of flagstone-like slate, circles of squared-off and irregular logs of slate off-cuts, overlapping flat slate in straight-line paths, circles of sharply peaked slate chunks set upright on flat bottoms, and rings of flat slate standing on edge. One of Long's red slate circles, *Red Slate Ring* (1986), created with rich red slate

from Middle Granville, New York, was exhibited in the Solomon R. Guggenheim Museum in New York City. He used slate with a distinctive, burnished-gold tinge from nearby Cornwall for his *Delabole Slate Circle* in the City Museum and Art Gallery in Bristol, England, and gray slate off-cuts in *Whitechapel Slate Circle* now on exhibit in Washington, D.C.

In *Six Stone Circles*, Long created a permanent, outdoor sculpture of six concentric circles of Delabole slate, placing the smaller pieces in the inner rings and building to the largest on the outside rim. Sited in a private garden, this arrangement was not ephemeral, as are so many of Long's sculptures that are made to relate to the landscape around them.

Pic. 9.10. Richard Long *Whitechapel Slate Circle*, 1981 (diameter 15') This work was prominently displayed on the marble floor at the Concourse entry of the East Building of the National Gallery of Art, Washington. Gift of the Collectors Committee. (Photograph © 2001 Board of Trustees, National Gallery of Art, Washington)

Long's slate circles (and other gallery installations) have been sold and moved to new locations, and he provides a certificate with directions, "a sort of formula," for reassembling the works. Michael Tooby, a museum professional, reports that he assembled one of Long's slate spirals eight times over three years and found they came out pretty much the same with each re-creation.

Long explains that, "the stones are not numbered," nor do they have "a particular place in the work." The certificates for each sculpture "give the dimension of the work, and ... describe the type of placing – whether it is a single layer or a double layer, whether they are touching or not touching, the density of the stone, [and] various other practical details about how to make it." Long's intention is that another person can remake his artwork. "It doesn't have to be made by me," he says. This process is less exact than dry-stone wall construction or Wagner's color-coded stone paintings that can also be reassembled; but Long says if his directions are followed to create "a proper circle" with "the same amount of stones, the same density and everything, and the same haphazard pattern ..., then the work will more or less look the same every time." Long does not feel a sculpture of his "is the same as a painting, which is painted once on canvas and then is the same forever," but his sculptures are "made new" repeatedly, with a "kind of fresh, new-made ambiance ... every time each stone is in a new place."

Long cites another way to view the process of creating and recreating with stone. "I often talk about the way my sculptures are made [by] sort of comparing it with a Japanese rock garden ... in Kyoto, like the garden of white pebbles, where every morning the monks rake the surface of the garden into a new pattern," he said. "So literally every stone is moved in its place, every day, maybe for hundreds of years. But, never the less, the garden always looks the same."

Allowing others to re-create his sculpture, Long brings the world of art and nature right back to the personal level. He shares his involvement with nature and the sense of touch he felt handling the stones and deciding on their placement in the artwork. For both museum staff and then the viewers of art, the physical senses of touch, sight, and sound are fed, along with the customary

mental involvement. Long and King both understand art to be an actual physical process of interaction with materials. For them and other artists, including dry stone wall builders and stacked slate sculptors, the physical "evidence of man" is an expression of the artist's energy or creativity and a significant aspect of their work.

Explaining his choice of slate as an art medium, Long told the author:

> My work is quite complex and it has many layers. I am an artist who uses the landscape in many ways. So I use the material of it, I use the time and space of it. I use the distance of it. And so, one particular facet of my work is stones. In a way, that's what the world is made of and that's what seems to be the most common material, always to hand, wherever I am in the world.
> In one way, stones are important to me because they're practical, ... because they are very common. ... One of the reasons I started using slate was, I sort of like it. I can use ... the thin form of the slate [to make] the sculpture. It fills space on the ground without using any height. So it has a kind of formal elegance.

He added that pieces of slate are "pick-uppable ... another important aspect of my work. I like using stones that I can pick up. I don't need an earth digger," as artists in the American Land Art movement typically do.

Slate quarries today, as in decades past, prepare their product to standard dimensions or customers' specifications and then discard the off-cuts. For most projects, Long selects and orders his slate directly from the quarries. He said,

> Whenever I go to a quarry for whatever reason, usually to find stones for an exhibition, I always go there with an open mind and just choose the stone that takes my eye, really. The quarries are always changing, so one quarry will be completely different one year from what it was the previous year. That's the nature of [the business.] It's organic; they're always uncovering slightly different strata, [and] different colors. ...
>
> In a way I can say that I was an opportunist. If I see something that I hadn't seen before, I take it just because it's a good chance to use something new. I do like to take the off-cuts – the pieces that have been cut on one edge and then thrown away. And the reason I like using those is because, there again, it's practical. It has a cut edge and I can lay it on one side, on the flat floor of the gallery or museum and they can stand up and they're stable on the ground. ...
>
> All the quarries, whether in Cornwall or Middle Granville, cut the stone for their own uses for local builders or architects ... and I come along as an artist and use their stones, or what they throw away, completely for my own reasons. [My use is] completely coincidental to why the slate is quarried.

Although he sees himself as recycling the discarded slate, his use is "not dogmatic," he says. "I do like the idea that I can use things that other people throw away."

Contemporary/Abstract Forms

Pic. 9.11. Richard Long *Spring Ellipse*, 1999 (longest diameter approximately 49') Created from nearly 16 tons of Delabole slate and first sited at Salisbury Cathedral, England, this work was part of the *Shape of the Century* exhibition, a retrospective of twentieth century British sculpture.

Long refers to himself as "a modern artist" and looks upon slate as "just one part of my art language, as are photographs, words, walking, circles, water, etc." He has demonstrated that a walk of his through any landscape can be a work of art. The walk is perhaps his trademark and affected a redefinition of the word "sculpture." No longer limited to three-dimensional works of art, sculpture is now considered by many artists and critics to be any form of art activity, other than painting. "A walk is a line of footsteps, a sculpture is a line of stones," Long has said.

He has walked back and forth in a flower meadow to make a line. He has walked in the Sahara Desert, left a path in the mountains of Bolivia, trekked in the Atlas Mountains of Morocco, and produced a map of a meandering four-day walk in Wales. On his walks he is inspired to collect natural materials – frequently stones – and form them into circles or spirals, lines, a cross, or another

geometric shape that appropriately fits the landscape. These works reflect Long's concern with nature's textures, forms, and symbols.

Long creates sculpture with walks, examining mileage and distance. He also uses water and mud in his art, but asserts that "the stone works are, obviously, a very important category in my work." He has also carried stones on his walks, finding "stones are ... very practical, because they're like atoms and I can move them around the world in space and time almost effortlessly."

Because so much of Long's work is in inaccessible locales or exists for such brief periods, he wants "to share [his] work through photographs of sculptures made in ... remote regions of the world," as well as to bring "real sculptures [into] public places like galleries, exhibitions, and [museums]." He has told interviewers that his "photograph[s] and texts feed the imagination. The sculptures that you can see directly in the gallery feed the senses." His photographs, like his sculpture, are meant to be "very simple and straightforward."

A *Guardian Guide* reviewer in 1991 pointed out that Long's exhibit at the Hayward Gallery in London included "a circle of rocks [that] is very concrete, situated in the real world of present time and space." When encountered indoors, such a work somehow startles us with "the jolt of being in a sophisticated, sanitized gallery, and gazing at the rough and raw material of uncut rock and mud placed on the floor in clear and simple geometric shapes." The viewer senses that the wilderness "has crept into our tamed and domesticated lives under the guise of art, and we jump in some flicker of recognition of our kinship with nature's rhythms, shapes, and materials." Here again slate as the medium permits artists to reinvigorate our senses and remind us of man's real place in nature and in the scheme of creation.

On both sides of the Atlantic, contemporary artists respond to found chunks, recycled pieces, and milled discards of slate for their abstract sculpture, seeing the possibilities in shapes and angles of cuts. Manipulating the slate with graceful engraving, judicious placement, or attendant mixtures of natural elements brings new life to the ancient stones and increased awareness of nature. They call up personal observations about the nature of art and bring raw, natural elements of the earth to us in galleries, outdoor installations, and photographs where the ordinary person then encounters the world of art and is made richer.

CHAPTER TEN

Mixed Media

THIS SEARCH FOR ART FORMS BASED ON SLATE LEAD TO MANY UNANTICIPATED WORKS of art. Creativity doesn't typically follow a straight path and so some of the artists in this chapter were inspired to incorporate their skills in other art forms with slate in experimental mixings of the arts. Some artists are included because they have focused on the slate quarries as subject matter – two with cameras and one with a pencil.

M.E. (Mary Elizabeth) Thompson (1896–1981) was a trained English artist who gained permission from the Penrhyn quarry manager in 1939 to do life studies in several Welsh quarries, creating a series of drawings that captured the slate industry of her day. She learned Welsh in order to talk with the working men and join their discussions and banter. The fact that she was female and a dwarf with severe curvature of spine did not deter her from clambering up and down ladders in all sorts of weather. But, her physical limitations probably restricted her medium to easily carried paper and carbon pencil, rather than paint with all its paraphernalia, as she focused her attention on the details of quarry jobs and the world of the workers. "Nearly all her quarry drawings are now in the National Museum of Wales," reported her sister in 1981.

Pic. 10.1. M.E. Thompson *Rockmen, William Owen Gallery*, 1948 (28" × 20¾") Quarry men remove loose blocks of slate after a black powder blast. (Photo courtesy of the National Museums & Galleries of Wales)

Many artists, notably Sir Kyffin Williams, RA and Rob Piercy, have been inspired to paint the Welsh mountains and abandoned slate quarries, but it is the work of a nineteenth century painter that greets visitors at the Welsh Slate Museum in Llanberis, North Wales. *Penrhyn Quarry in 1832*, a painting by Henry Hawkins (died 1881), has been enlarged and reproduced to mural size. The original work hangs in Penrhyn Castle, three miles east of Bangor. (see Color Plate 2) The scene depicts close to two hundred men and boys working the quarry shelves and tiered faces. They become mere specks or gray bumps on

the distant peaks of slate, while the visitors at the lower right are seen in varied attire as they smoke and lounge. The closest workers lean on metal rods, seeming to assess the guests, while other laborers at a little distance use their rods to forcibly pry stone from the ledges. The dramatic panorama of the painting is arresting. No machinery, no safety gear. Small trams loaded with stone are being pushed by hand from below the main rock face.

Juxtaposed with this enlarged painting of physical labor and the enormity of the quarrying process, there in the Museum's entry stands a musical instrument of slate. The visitor is torn between wanting to inspect the details of the painting and being drawn to click fingernails on the keys of the slate xylophone (correctly speaking, a marimba.) Clear, delicate tones result from finger tapping.

Music: *Will Menter*

Will Menter, an English instrument maker and musicologist, spent three months in 1986 at the Welsh Slate Museum in Llanberis as an "instrument maker in residence." Funded by the North Wales Arts Association, Menter, also a composer and performer, sees "instrument making as part of the creative process of music, more than an end in itself." During his residency he gradually developed the idea of performing a program about slate – using slate to produce music in the heart of the slate quarry region.

When he lived on a farm near Bristol, Menter had made "rope ladder style log xylophones" from sycamore branches he cut himself. He had experimented with musical sounds produced from dripping water and developed his skill for hearing music in natural materials. As he walked over the piles of discarded slate in North Wales, he listened to the musical results of his own footsteps and for the music of wild goats running over slate. He selected pieces of slate that made sounds he liked. Likewise, quarrymen are able to recognize good slate from flawed by the sound of tools ringing on the stone.

Beginning to explore slate as a musical material, Menter extrapolated his past experiences making wooden xylophones and marimbas, different from xylophones in that they have resonators beneath the keys. Menter developed his instrument of "slate bars [the keys] about 5 mm thick ... supported on rubber tubing at the nodal points. Underneath each bar is a plastic resonating pipe." He tuned the notes by grinding the under side of each bar with a file, or, "quicker but noisier, with an angle grinder."

Menter soon learned that "tuning with an angle grinder in a public corridor, slate dust filled the air." He was warned, "Once the dust gets in your lungs it stays

Pic. 10.2. Will Menter
Slate Marimba (Llechiphone)
The musical keys 1/5" thick are split pieces of Welsh slate, set above plastic resonating pipes.

there." So he wore a mask and worked outside to allow the dust to blow away, while keeping visitors away from this portion of the process. He would come to recognize "the feeble walk and posture of some of the older men in the area whose lungs had been ruined by long exposure to the dust."

Menter's first slate marimbas have now been pounded with percussion beaters of rubber balls on wood or leather-bound wood for over ten years and are still "going strong." Fingernails from many countries have also tested the keys.

Although Menter doesn't speak Welsh, he says, "It seemed right to give [the slate marimbas] a name based on the Welsh word for 'slate' (*llechen*, singular; *llechi*, plural)." He called his instruments "llechiphones." (The pronunciation of "ll" in Welsh is somewhat like the sound of a "wet k.")

His first llechiphone was made from seven slates split from one rock, in a process similar to that used to create a slate fan. The keys were all the same length, but of different thicknesses and turned out, by chance, to be a five tone scale: D2, E2, G2, Bb2, C3, D3, and E3. This harmonious scale is used in "the beautiful music of Hukwe Zawose from Tanzania" with which Menter was already familiar. He has made many llechiphones with this scale, others are fully chromatic models, and a number have less usual tuning. He reports that his "particular favourite at the moment is an equipentatonic tuning, where the interval between each key is 2.4 semitones."

The sound of the llechiphone is "more like an African marimba than an orchestral one – something like a metallophone but not such a long ring," he explains, trying to define the sound for those well-versed in musicology. An audiotape of Menter's music reveals that the sound is mellow and gentle. Some might compare the llechiphone sound to that of the harp.

For musicians, Menter adds further that he has made llechiphones from C1 (two lines below the bass clef) up to G5 (an octave above the treble clef). "The tone is strongest and most distinctively slate between C2 and G4," says Menter who makes "a standard range of llechiphones," as well as fulfilling commissions for individual needs.

In 1990, Menter's dream of presenting a musical program based on slate coalesced into a cross-art performance titled *Can Y Graig – Slate Voices*. Six poems were commissioned from Gwyn Thomas, a poet at the University College of North Wales at Bangor. Singer Sianed Jones helped set these poems to music written by Menter. To create the right ambiance, sculptors Andy Hazell and Lucy Casson made a set from scrap and industrial materials that captured the look of the quarry landscape. Textile artists Annie Menter and Barbara Disney created batik backdrops using the colors and shapes of slate. Additionally, a three-screen projection system intermingled slides of the slate area and some archive film of quarry workers.

Can Y Graig – Slate Voices was presented fifteen times in six locations. Two performances had the "special resonance" Menter was looking for. At the Welsh Slate Museum in Llanberis one performance took place in the foundry building, amidst the industrial saws and planes, next door to the largest waterwheel in mainland Britain. The atmospheric indoor space was cavernous.

The more exciting location of the other special performance was in an underground cavern at the Llechwedd Slate Mine in Blaenau Ffestiniog. Here 400 feet below the surface, the audience wended their way through the low-roofed tunnels

Slate of Hand: Stone for Fine Art & Folk Art

carved from the rock to a mammoth grotto hollowed out of solid slate. They sat beside an underground lake on the floor of the mine, now lit by electricity but still invoking the blackness the miners would have known with only headlamps for light.

"For evoking the life and work of the slate workers over the years, this context couldn't be surpassed and many of the audience said afterwards they were deeply moved by the experience," Menter reports. The acoustics were dramatic and resonant. Menter captured *Can Y Graig – Slate Voices* on a private label CD and included the poems/songs written by Gwyn Thomas in Welsh and translated by him to English.

Though slate marimbas are Menter's major instrument in slate, he also has "simple hanging chimes made from random pieces of slate ranging from a few centimeters … to almost a meter." He has set them up as "wind blown instruments and also in arrangements as mobiles, where they collide with each other producing more random rhythm and series of sounds." He says the bigger ones "are dominated by overtones rather than the fundamental pitch and give very rich individual tones."

Not long ago Menter took five of his llechiphones outdoors to photograph them under a large oak tree. As he climbed in the branches to shoot downward, rain started. His first inclination was to rush the instruments back indoors, but his musically tuned ear focused on the wonderful new sound as the water dripped from the tree onto the slate keys. Instead of whisking the llechiphones inside, he brought his tape recorder outside and captured the music, to be later used by two singers as accompaniment. Menter felt he'd found the "prototype design for a new instrument – the dripping llechiphone."

He has since devised more ways to unite water and slate, in new musical instruments. *Rain Songs*, a self-contained sculpture/instrument, makes delicate, continuously changing melodies. A large triangular basin of water serves as the base for a network of pipes and slate plates suspended with resonating tubes below each. An electric pump circulates water that drips to create the soothing sound. Menter sees this as "definitely more of a sound sculpture than an instrument," typifying the evolution of his instrument making into more sculptural forms. His *Choeur de Chene* group of single-note marimbas of slate mounted on weathered oak beams is reminiscent of Isamu Noguchi's sculptures that use blocks of antique house beams for bases.

Welcoming the new millennium, Menter and about fifty people met in Nolay, France, at a waterfall known as Le Bout du Monde (the edge of the world). They held what he explained was the "reviving of an ancient ritual, which took place every thousand years and was intended to send vibrations right around the world." Based on the principles of *Rain Song*,

Pic. 10.3. Will Menter
Rain Songs, 1998
Oblongs of Welsh slate suspended over pottery resonators dangle from a steel frame, as water circulates and drips to create a soothing sound on this part-instrument, part-sculpture piece.

Pic. 10.4. Will Menter
Choeur de Chene, 1999
Four single-note marimbas of Welsh slate, French oak, and hemp rope reflect the instrument maker's leaning toward sculpture.

The Sounding the Edge of the World project used nine special instruments supported on long wooden shafts. Each was a tuned slate with a pottery tube resonator hung beneath it and held out into the cascade of chilly water. The nine "falling water resonating devices" were extended in a predetermined order and selected pairings. The Performance Art ceremony closed with a "free sequence culminating in all nine being sounded together." Menter continues to create slate-based instruments and to be "interested in making sound sculptures and instruments that suggest a way of playing together as a group."

Pic. 10.5. Will Menter
Falling Water Resonating Device, 1999
One of the nine special instruments made of Welsh slate, Provencal pottery, and hornbeam wood used to welcome the new millennium at Le Bout De Monde in Nolay, France.

Photography and poetry:
Jean Napier

The abandoned quarries in North Wales have inspired musicians, afforded the subject for poets, and provided the raw material for photographers who sense times gone by and lives now past. Photographers also seek to present issues of environmental concern, relying on pictures to tell the story of slate quarry upheaval and corresponding social changes.

Jean Napier is one such artist inspired by slate and slate quarries. Over the years she has traveled to China, Tanzania, Zimbabwe, and Nepal, as a photo expedition leader, and to build up stock images of these countries. She spends many hours alone and guiding youth groups and corporate adults in the magnificent Welsh mountains of Snowdonia National Park, which is the main inspiration for her work.

Napier was introduced to the Rhosydd Quarry two miles west of Blaenau Ffestiniog, while on a climbing trip in the Moelwyn Mountains of North Wales in 1987. "That day I was taken on an awe-inspiring cold, wet journey through the underground levels and saw where the slate had been hewn from inside the mountain by the underground quarrymen," she recalls. Rhosydd is remote and very exposed, with its main working area 1,500 feet above sea level. She resolved to return with her camera and try to capture on film the emotions the ruins evoked in her. "This is an amazing place," she felt, "and it stayed in my mind. The slate quarry kept calling me back."

Between 1989 and 1996 she took hundreds of pictures of the quarry ruins. She selected the most evocative prints to mount a photo exhibition, titled "The Old Boys of Rhosydd," that toured in the U.S. and Britain for five years. Her next project was to create *A Personal View*, a book using the pictures of the abandoned quarry and its reminders of past generations together with historical text.

Pic. 10.6. Jean Napier
Doorway view of abandoned quarry buildings
Many Welsh mountain quarries offer nothing but broken stone and abandoned ruins, where once an industry thrived.

Pic. 10.7 Jean Napier
Old 'megryn' wheels underground
Wheels left in place on the track underground stand immobile, no longer of use.

"I wanted something to work the images around," she said. Many poets have written about the stark life in Wales, and so Napier used a haunting poem written by Richard Owen, the last caretaker of the Rhosydd Quarry who worked there in the 1930s after its closure. She realized it told "a story of a dying industry" recounted by a man who remembers the past lives of those who worked the slate. The poem and Napier's pictures tell of ghosts and how the abandoned quarry is returning to the quiet times before the slate industry disturbed the mountains.

Napier's photographs speak to these bygone conditions of both hardship and camaraderie and also capture elements of nature that haven't changed. Outdoors she faced photography problems dealing with inhospitable weather in the Welsh mountains; her visits were made in rain, snow, and ice conditions. Slate gets very slippery when wet and can be extremely hazardous, she cautions. Other dangers exist in rotting wooden flooring and avalanches of piled slate waste.

"I had the most technical problems with the underground images," she says. "The blackness eats up the flash." In the tunnels she used seven flashes per image

Pic. 10.8. Jean Napier
Slate gravestones at St. Anne's, Bethesda
Carvings on the reverse of these stones record the lives of former quarrymen and their families, but the smooth blank backs greet visitors first.

to more-or-less paint the walls with light. "Each exposure was about 15–20 minutes long with a small aperture set on the camera for maximum depth of field."

Napier takes her black-and-white landscape photographs with a medium format 2¼ inch square, Mamiya camera. She prefers to use black and white film, because she can have total control over the processing and printing, which is not so true of color film. As she composes her pictures, she looks for shapes; and when she prints, she crops the image to further interpret the mood she wants.

One telling photo captures a Bethesda cemetery on a hill, where the carved slate gravestones face the quarries of their origin across the valley. Napier recalls walking into the cemetery and encountering only the blank backs of the tombstones. "The slate backs are blank, seeming to say that the faceless quarry workers have plain stones with no details." In the distance, the tips of slate and Carneddau Mountains whisper of life in bygone days and "when you walk around and see the beauty of the carvings, [the stones] become people," who lived here and had stories to tell.

In another photograph, a fence of slate slabs is rammed into the ground and strung together with barbed wire; these fences are found dividing sheep pastures on many Welsh farms. The sharply defined picture (Pic. 1.1) leads the eye to read graffiti on the nearest slate and also inspect the lichen that dots the length of the fence. The question arises as to which is the greater intrusion on the land, the ingenious fence of slate slabs or the message of a passing hiker.

Napier's photographs show realism and the austere beauty of the slate ruins. But her images appeal to the sense of nostalgia, too, as viewers realize there was once the bustling activity of a prosperous business in these remote mountains. Now nature is reclaiming its own, as expressed in the poem and also experienced in Howard Bowcott's stacked work on the Llanberis hillside. (Pic. 11.3)

Old Boys of Rhosydd

They come to me constantly in their turn,
Old Boys of Rhosydd on loving pilgrimage.
I hear their voices again – there come to mind
The leg pulling and cheerful wit of yore.

They converged on the quarry from far-off homes
Daring the wind and rain and biting cold,
Without vain yearning for better times;
Uncomplaining was their journey along weary path.

The quarry is no more, it is a sad ruin;
No sound of machines, the stillness overwhelms;
The wind whistles between the loose stones
And a host of lively workmen are in the grave.

But some like me live on nearby,
Until it falls our lot to rest in the earth.

1930 – Richard Owen

Slate of Hand: Stone for Fine Art & Folk Art

Landscape Photography: *Roger Tiley*

Roger Tiley, another photographer who has explored the Welsh slate region with his camera, grew up in South Wales, "where coal is king" and the men in his family worked in the coal mines. It was not until he was commissioned by the Arts Council of Wales to photograph the effects of the slate industry on the landscape of North Wales that he even visited North Wales. Yet he found similarities in the coal mines and the slate quarries. Both industries "were very dangerous, both made Wales famous throughout the world, both were major employers, both were privately owned by wealthy gentlemen [who] did not treat their workers very well." While coal is always mined, slate can be mined underground or quarried from the top, he learned.

Over two years, Tiley explored and photographed remote and abandoned slate quarries and villages, turning from photo-journalism and documentary work to landscape photography. This was a new subject for him and a new focus for

Pic. 10.9. Roger Tiley
Penrhyn Quarry, Bethesda
One upright block of slate rises from a pile of discarded slate glistening after a rain at the Penrhyn Quarry, where high quality roofing slates are still produced today.

his camera. He, like Napier, developed both a touring exhibit of photographs and a book. Tiley's title, *Grazing Slateland: The North Wales Slate Landscape*, was taken from a poem by Ros Moule. The book's images "show how slate was once a major employer [in centuries past.] But when the quarries closed, they left many of the hills and mountains in North Wales silent."

In the book's introduction, Dr. R. Merfyn Jones captures in words what Tiley captured on film:

> It is the incongruities which strike the eye in the landscape.... The debris of industry scattered across the mountain slopes; the wrecked machinery rusting in the heather; the precise, directed lines of sawn slate blocks and of rail

Pic. 10.10. Roger Tiley *Nant Dwr-oer, Blaenau Ffestiniog* Discarded perhaps a century apart, these inanimate objects (slate debris and a tire shall attached to an axle) distill the sense of time passing.

tracks on the sculpted slate tips – all rude interruptions to the natural curves and jagged complexity of the rugged mountain contours.

Tiley's photographs attest to the grandeur of the mountains and vastness of the quarry operations in their midst. He worked in the quarries around Blaenau Ffestiniog, Llanberis, the Nantlle Valley, and Bethesda, where the slate industry "had dramatically changed the environment." He noted that "nearly all the disused quarries had been left, looking as they did the day they closed. The only changes were the effects of the [weather] eroding the past." Tiley directed his camera at the beauty and the scars.

The small, lightweight Fuji Professional 6 × 9 cm format camera with a fixed, wide-angle lens was ideal for long treks necessary to find the remote quarries. Tiley sometimes hiked two to three hours in rugged terrain before reaching his destination. He used a fixed lens because he believes strongly in "choosing the camera angle on foot, rather than using a telephoto lens" to set up the shot. The wide-angle lens "distorts the perspective from the foreground to infinity," perspective gets more dramatic, and closer objects look larger, he explains of his lens choice. The other equipment Tiley lugged with him into the mountains included a tripod, red and yellow filters, a cable release, and a Gossen hand-held light meter.

His wife Angela accompanied him into the remote areas, both for company and as a safety precaution. "When you are walking on the quarry site, it is very easy to fall and cause damage to yourself. The slate rock can be sharp and, when wet, slippery." Some of the old quarries are now owned by local farmers who do not like "walkers or photographers" on their land. Tiley suggests always asking permission to walk in the quarries. "The massive Penrhyn Quarry, which is in Bethesda, will not let many people on their site, but I was lucky to get permission," he adds.

Pic. 10.11. Roger Tiley
Rhyd-du, north of Beddgelert
The graphic shape of a single tree breaks the uneven curvature of the mountain line, the Llyn Cwellyn Reservoir, and the quarry waste mounding on the right.

The film he chooses is Agfapan APX 25 (25 ISO black and white film) with eight exposures per roll. With this slow ISO rating, he takes "extremely long exposures, emphasizing movement with water or clouds. It also allows the film to build up an image rather than just releasing the shutter for a fraction of a second," he says. An exposure of fifteen minutes will detect many changes in a seemingly still landscape. Light and shadows change, water flows, clouds travel across the viewfinder.

Tiley processes and enlarges his film himself. He mixes his "own developers from raw chemistry to obtain subtle tonal changes from cold blues to warm browns." He adds further that his prints are tinted "in a variety of toners to achieve subtle effects. They include sepia, blue, gold and selenium." Selenium not only changes the color but also helps achieve archival permanence.

In a recurring theme expressed by artists working with slate, Tiley writes that he is "particularly interested in the theme of 'time' and of course timelessness, in … my photographs." He looks for the relationship of past to present. At a deserted quarrymen's barracks on the mountain above Pont Cyfyng, near Capel Curig, he found "the most sinister" quarry he visited. The buildings that remain are crumbling under the extreme winter weather, and sheep graze the land as they did before slate was extracted. This place "evokes the mind into hearing the echoes of the past, distorted in the howling wind. You can completely lose track of time, feeling that you are in the late eighteen hundreds. The only evidence of the modern day is the occasional fighter jet rushing across the sky-line."

Photographers bring the atmosphere and artistry of abandoned quarries to those of us who might never see the actual source of slate.

Mixed Media 127

Pic. 10.12. Roger Tiley
Pont Cyfyng, near Capel Curig
Crumbling barracks of quarrymen echo the past here, as the wind howls in the abandoned mountains today.

Art Glass: *Bill Swann*

When artists do live in slate regions, painters and photographers find subject matter, carvers and jewelers stockpile easily available stone, and trained and untrained sculptors have material for experimenting. Like Menter who combined slate and music, another artist has been motivated to produce works that incorporate slate with a specialized art medium. Bill Swann, a former potter who now creates mouth-blown crystal, has found "artists cannot detach themselves from the landscape and environment" where they work. He has fused slate and art glass.

Porthmadog, in North Wales, offers Swann easy access to some of "the best slate mines in the world" and a history steeped in the slate industry of Victorian Britain. At the Porthmadog docks, shipbuilders once fashioned seagoing vessels and loaded them with slate roofing shingles for delivery to burgeoning cities in Europe and the British Isles, approximately 80,000 tons in 1874 alone. The Snowdonia Mountains provide a backdrop to the coastal town and visitors now come from all over the world to ride the 13½-mile narrow-gauge railroad from the harbor at Porthmadog to Blaneau Festiniog and the slate quarries high in the imposing mountains.

Swann's sculptures of slate embedded with blown glass present "an image of landscape" and "tell the story of time, past and present." The thought provoking

Color Plate 15 Bill Swann
Tirlun Cymraeg/Welsh landscape
(9¾" × 9¾")
Piece of blue and mauve colored glass overlaid in a collage arrangement fuse to suggest the Welsh landscape from which the slate surrounding the glass was quarried.

Pic. 10.13. Bill Swann *Emergence* (19½" × 11¾") Two glass inclusions in tones of teal and blue swirl as though two aspects of a primordial sea surrounded by slate.

Pic. 10.14. Bill Swann Slate and glass sculptures at the Chapel of Art in Criccieth (1999) provide a beauty of contrasts in texture between the circular inclusions of impenetrable glass and their sculptural frames of Welsh slate.

pieces encourage the viewer to "look further into the glass at other worlds beyond," says the artist (see Color Plate 15). The atypical coupling of materials intrigues gallery visitors who evaluate the match up of new and old elements, of transparent and impenetrable surfaces, and of the colorful with stone-dull components.

At a local slate yard Swann carefully selects his blocks of stone to fit a particular glass design; but at other times he says, "I work the glass to marry the slate." Some of the slate he selects has rough edges, but most are geometric, off-cut blocks or pointed spikes with an architectural feel. Into his slate form, he usually incorporates circular glass inclusions, thus producing vivid color in stone sculpture and combining slate molten millions of years ago with newly forged studio glass. "Porous slate and impenetrable glass [are] joined to highlight the extremes of materials," he says.

Although Swann asks his local slate supplier to drill holes into selected blocks of slate, he does also adapt the drilled stone himself to accommodate his individually produced glass insets. Having taken a slate-carving course with sculptor Meic Watts, Swann will "shape, split and carve into" the slate as needed to manufacture a snug fit.

His mouth-blown lead crystal is created in cylinders of colored glass, which he later cuts into small pieces and then overlays into a collage. The colors are fused into a pattern before being subjected to multiple firings in a kiln. Swann builds up fluid designs of "layered images within the glass" contrasting, yet compatible with, the slate's "rough and smooth contrasts from the process of mining and splitting." His sculptures uniting Welsh slate and kiln-worked lead crystal underscore the transformations of natural materials, the beauty of contrasts, and the resplendent Welsh landscape surrounding him.

M.C. Ritz, a French artist now living in Cambridge, Massachusetts, calls herself a matchmaker because she too enjoys meshing her glass works with different

materials, including slate. She likes slate's "ascetic quality as well as its serenity" and perceives this stone as one with an "almost eternal quality to it." For *Absence* she set a 1½-inch-thick, square window of pale green, ultraviolet (UV) glass into a honed slate stele, standing on a bronze base. The window was actually two pieces of UV glass, each sandblasted with half the mirror image of an acorn. With the glass pieces fused together by totally transparent UV glue, the two halves of the acorn are seen as a single "hollow form floating in space." Her title derives from "the absence of the presence" of the acorn (a seed), used as a symbol of life. Ritz selected slate for this freestanding sculpture because of "the softness and malleability of slate" carved for tombstones, contrasting that with the hard, brittle quality of glass.

Similarly, Missouri sculptor Mack Winholtz (Chapter 7) has incorporated arcs of colored glass in his sleek slate sculpture. (Pic. 7.10) Thus, the coupling of glass and slate has appealed to artists from different disciplines around the world.

Photographs imposed on slate:
Shlomo Shuval

Photographs and slate have other connections than those already discussed. After the turn of the last century when marbleizing was popular, a second process for decorating slate surfaces developed. Known as "Struco," this technique was less expensive and quicker than marbleizing, though able to withstand water and

Pic. 10.15. Bill Swann *Untitled*, detail (7¾" × 5 5/6") A square inset of muted glass featuring looping lines and sublet mauve in lower left is framed by a slate block.

Pic. 10.16. M.C. Ritz *Absence* (5 1/3' × 1' × 1½') An acorn etched as a symbol of life into a square of ultraviolet glass was then embedded in this polished slate stele.

Pic. 10.17. Shlomo Shuval Slate tabletops are embellished with wildlife photographs.

changes of temperature, as well as to resist chemicals. It was used on mill stock and applied to radiator covers, wainscoting, clocks, lamp bases, and more. Struco called for a base coat lacquer to be sprayed onto a polished slate slab. Then a copper plate engraved with a photographed pattern of veined marble was applied in a printing process. This was followed by a transparent surface coat and polished once it dried.

Just as the art of marbleizing slate has gone out of vogue and been rediscovered and adapted by some modern practitioners, so a process reminiscent of Struco has been invented by Israeli-born artist and craftsman, Shlomo Shuval from Berkeley, California. He works with slate and historic photographs, not with images of marble. Shuval now creates slate wall hangings and furniture, such as slate table tops and lamps, embellished with antique photographs superimposed on the ancient stone–a combination he calls "a great marriage." The process is one he devised himself, experimenting with various materials over two years.

Earlier, Shuval had created a craft business, painting characters on stone when he first arrived in California in 1990. With clients bringing him snapshots of his subjects, he started thinking about ways to merge the pictures and stone. "When you work with the public, you get ideas," he says.

He experimented with dyes and different silk-screen materials and consulted with experts in the Berkeley community. His process needed "a substrata with a rugged surface, though one that was not too porous. Though slate is somewhat porous," he says, "this worked." Thus, he used the flat

stone as though it were paper and found his black dyes gained character from the slate. Slates of different colors or with surface irregularities were selected to best accentuate the photograph. "Fossils [or imperfections] and textures blended in with the images," he saw. No two pieces are alike, even if duplicate photographs are used, thanks to the individual textures on each slate. The slate background allows people to "see different things in them. Some see the sky. Some see a cloud."

But this same texture in the stone could distort facial features and Shuval decided, "Modern people didn't seem to relate to the slate." This led him to experiment with antique images of Native Americans, wildlife and endangered species, American Civil War scenes, and California history. Today, most of his photos are in the public domain, though sometimes he does buy rights from modern photographers. He pays a fee to historical societies or the Library of Congress for the rights to reproduce images in their collections.

Pic. 10.18. Shlomo Shuval *Native Americans plaque* (on wooden base)
This Wild-West photograph is superimposed on a light gray slate speckled with mineral inclusions.

To produce his slate/photograph creations, Shuval buys his slate imported from China, India, and Brazil and has used some California slate, as well. He cuts each piece to a customized size, washes it, and then applies the photograph. The largest commercial size slate he can order at a reasonable price is ¼ inch or ½ inch thick pieces 24 inches square. Beyond that slate becomes very heavy and difficult to ship, he says. He creates tables in various sizes and does his own metal work for the frames. Custom work may lead him to design a wall surface composed of 16 pieces, framed with a slate border and connected with grout. Enlarged photos are separated to the proper size for each slate and then a mural is fit together like a puzzle. His clients request scenes of the Gold Rush or old California, cowboys or wildlife, as well as Judaica. A commercial sealer protects the surface once it is mounted on the wall.

Of the process he keeps secret, Shuval says, "A thin web [holding the image] is embedded in the surface of the rock itself to create three-dimensional and special effects." His process is so permanent that the slates can be displayed outdoors, in direct sunlight, or under water splashed by a fountain. Adding color to the photos has been the latest addition to his work; and Shuval finds some slates with colored images seem to require a frame, whereas the earlier black prints did not. Four hand-cut slate pieces with subtle variations form the frames that complement the colors in the photograph.

Proud of how durable the process is, Shuval believes that his experimentation has led to "the only way photographs will last hundreds of years." His "pictures

are forever and will outlast any other photograph," since the process seals the photographic moment on a timeless slate canvas.

As the centuries have progressed, slate has found wide-ranging applications. The earliest uses tended to be architectural, applied both indoors and out. While frequently decorative, these applications from shelving to roofing were more typically defined as utilitarian. In the hands of modern artists with interdisciplinary tendencies, slate became integrated with the work of photographers, glass blowers, and a musician. The industry and its aftermath have also provided the subjects for poets and artists working with pencil and paint. This bedrock material of the earth's crust becomes a pleasure for the eye and ear, as experimenting artists learn from the material and find ways of adapting it to their own purposes.

CHAPTER ELEVEN

The Slate Timeline

SLATE'S VISIBLE TEXTURE AND SOLIDITY, OR FRAGILITY, ARE THE OUTWARD manifestations that appeal to artists when they determine slate, not some other stone, will be the medium for their art. In any discipline the artist takes time to study and experience materials, and those using slate have reacted to its beauty of color, texture, cleaving property, or range of scale from massive weight to wafer-thin delicacy. But there is something more. Slate strikingly suggests the passage of time, and artists using slate repeatedly comment on its timelessness and explore their perceptions of time and change through this medium.

Slate and time interrelate in two significant ways. The first has to do with the eons-long duration of slate. As a primordial stone, it can represent the bedrock of reality and permanence, demonstrating it could outlast us all. We express our understanding of this quality of endurance, when we recount colloquially that something "isn't cast in stone," meaning that something is not yet permanent.

Pic. 11.1. Howard Bowcott *Land Readings* (detail), 1996 The labyrinth of plain and sandblasted slate tiles from Cumbria present the earth's geological time periods, with humanity's entry being 1 1/5 inches of the 62-foot long pathway.

The second way slate and time interrelate is, conversely, through representing the concept of change. Here is where slate stands out from other stone as an art medium. First, as a metamorphic stone, slate has evolved from a combination of

minerals and sediment into a wholly new structure. Second, after slate lay dormant in the earth for hundreds of millions of years, the slate industry brought upheaval by disturbing the quarry beds. Then, in a comparatively short time, most of the quarries and tips of slate were abandoned and silence again prevailed. Furthermore, the common uses of slate as roofing shingles, flooring, and shelving mean that slate selected for artistic purposes has frequently had a previous life, a past function. These different forms of change and of time passing often contribute to an artist's concepts. This combination of slate's metamorphic nature and its commercial journeying gives slate art a symbolic power different from other stone art.

Perhaps the slate art piece that most obviously embodies dimensions of time is Humphrey Pritchard's seven-foot slate clock (Pic. 2.30) residing in the Old Line Museum in Delta, Pennsylvania. Here is a masterful slate sculpture based on a Gothic design and created by a quarryman who wanted to express the beauty he saw in this raw material of everyday use. He drew on his woodcraft skills and slate quarry techniques; he used the slate of three regions and worked until he had the proportions in balance. His material was ageless slate, his subject human time.

Slate as bedrock

One common way slate is used to indicate the passage of time is through the concepts of geological time and awareness of the earth's evolution. Isamu Noguchi worked with a wide range of stones, including polished marble, rough boulders, and milled slate, and felt all stone was fundamental to the sculptor, since the earth is made of stone. He and other artists share a mutual awareness of stone's geological fundament.

Andy Goldsworthy sees landscapes as layers laid up over geologic time, not unlike the view of Barbara Hepworth who recognized sculptural forms in landscape. Howard Bowcott noted that his slate wedges and urns all reflect the strata and layering of earth; and he also created a slate-walk labyrinth, depicting geological ages in sandblasted raised-designs. Ivor Richards peeled back the layers of slate exposing the inner material in *Real Time*, seemingly giving us a glimpse into the earth's layering and ancient times. In this way, Richards presents the substance, strata, and durability of slate from ancient seas.

Using the material at hand, artists adapt regional slate with all its colors, impurities, and broken edges. Merrill Wagner let the irregular edges of broken blackboards evoke mountain peaks and thereby the enormous passage of time required to create slate. Sara Humphreys and John Fletcher work streaks and mineral color variations formed millions of years ago, into slate jewelry. Edmond Laliberté and Bill Rice have both used natural bands of quartz in slate to produce one-of-a-kind works of art.

Artists like Hepworth and Noguchi knew and closely observed ancient stone formations from prehistoric people and this knowledge contributed to their works. Many, like Celeste Roberge and Goldsworthy, drew titles for their slate works from the terms for ancient man-made formations: cairns, menhirs, barrows, and dolmens. Some of the earliest human cultures left scraped images on rocks around

Pic. 11.2. Ivor Richards *Real Time* (17" × 9" × 3") Slate, rubber, and gold foil represent layers of time being peeled away, revealing something precious.

the world. These petroglyphs of geometric shapes have found their way into modern uses of slate, frequently unattributed by the crafter or artist who selected the concentric circle, spiraling line, or z-rod arrow just because it fit the slate mantel design, tombstone border, or jewelry motif. Others, like James Thompson, consciously re-create ancient designs as appropriate patterns for the ancient stone.

Contemporary art

Sculptural sensibilities in the past were immersed in structure, scale, and material; today's art definitions have expanded as artists reinterpret the world around them by continually seeking materials they can respond to and use in new ways. They now additionally use the space around the sculpture, the light and shadow played on it, and the natural changes it will endure over time. In 1946, Noguchi wrote that, "the essence of sculpture is … the perception of space, the continuum of our existence." This space is measured by line, shape, volume, point, and proportion; but, he added, "Movement, light, and time itself are also qualities of space."

Susanna Heron, anticipating that viewers will build familiarity with her art over time and through repeated observations under varying conditions of light and weather, has used reflections bouncing off water and slate, as well as cast shadows and rainfall on engraved slate panels. Richard Long's *Spring Ellipse* (see Pic. 9.11) was specifically sited on a lawn knoll at Salisbury Cathedral where ant hills eventually peaked in the cracks and blades of grass softened the square edges of slate. Curator Annette Ratuszniak reports that the work "created an added presence within its site, revealing and adding to the sense of place and time much as an encounter with another person influences our experience of [that] place and time." This particular sculpture then moved from its grassy setting where its tone was altered by the elements and the changing light from Cathedral windows and stonework to a London location at One Canada Square at a new plaza for an extension of the Jubilee underground line. Here it showed its "great organic strength"

Pic. 11.3. Howard Bowcott *Slate Sea*, 1987 (30' × 18') Slate, grass, and windblown objects come together as the seasons progress and the artwork gently melds into the hillside in Llanberis.

amid high-tech steel and office buildings, being a focal point viewed from London's highest building and echoing the curve of the entrance to the underground. Passersby again reacted to the sculpture, as children tiptoed across it and adults bent to examine the raw stone placed beside the path of commuters.

Goldsworthy and Long play with many natural elements and often create their works outdoors, frequently in remote locations. Much of their work is ephemeral and expected to undergo change at the mercy of natural forces – from wind and vegetation to tidal currents and ice upheaval. In a like manner, Bowcott laid out his wall of slate on edge against a sheep pasture hillside in North Wales and waited for nature to reclaim the sculpture, titled *Slate Sea*. This reformation parallels the mountainous tips of slate around the world that are now redefining themselves as natural landscapes. Since slate is nonpolluting, it merely goes back to earth naturally over the seasons. Just as slate gravestones sometimes use the Biblical phrase of "from dust unto dust," so the course of slate's journey through time may literally be from dust to dust.

The cycle of seasonal changes provides slate artists a vehicle for expressing the passing of time. For the Museum of Scotland, Goldsworthy used four walls of horizontally stacked slate arranged around objects relating to agriculture and hunting. In each wall he angled a circle of slates, so the lines of the circles turn clockwise when viewed left to right. "The turning of time and stones is a quiet, but, I hope, powerful expression of a connection between the agricultural tools and implements on display and the practice of working the land in a cyclical process dictated by seasons and weather," he wrote. At other times, Goldsworthy has created works in streams or on hillsides that he knows will be destroyed as day turns to night or as winter turns to summer. Barbara Kulicke has used her squares of slate to depict the ever-changing seasons along the Delaware Water Gap, finding the timelessness of slate an appropriate canvas for showing the passage of time. She has laid slate shingles side by side, not as roofing material, but in a modern configuration of repeated designs.

Recycling

Some artists who use slate have adopted the principles of recycling; they reuse old materials. In an effort to bring new life to cast-off slate, artists, including Louise Desrochers, Christopher Curtis, and Phillip King select discarded quarry blocks or off-cuts from the mill as their medium, creating abstractions or geometric forms that arrest us with their distinctive arrangements. In many cases, the artists speak of being pleased to recycle natural materials; often they intend the echo of the original form to still be sensed in the new artwork.

Paring down old blackboards that had once conveyed messages with chalk, Sharon Boardway delighted in introducing lines of poetry or Braille to her slate jewelry. She recycled in a manner that compliments the slate's original practical use. Merrill Wagner's broken blackboards or slate panels become a canvas for her exploration of color.

Slate roofing shingles are recycled in various ways. They have been broken and stacked into contoured figures by Julie Levesque, etched with Pictish designs by Thompson, and both etched and painted with Liverpoolian characters by Brian

Gordon. Gordon would leave the pollution stains caused by industry on his slates because the stains added an element of reality to his artwork based on memory.

Pic. 11.4. Celeste Roberge *Volcano*, 1999 (detail) Cast iron frying pans laden with minerals from Iceland suggest the relationship of domestic and geothermal activities — the mundane played against the forces of the universe.

Playing on the recycling theme with outdated household items, Roberge overtly builds feminist statements into her slate stacks. She mirrors the relationship of human time with geologic eons; she compares antiques and social mores with fossils in stone and then hearth fires and cooking utensils with the volcanic heat and earth's metamorphosis.

Capturing history

Photographs of slate art have several functions. They preserve times past and capture passing moments. When Daniel Farber developed techniques for archiving gravestone carvings as photographic images, he was addressing issues of preservation, remembering history, and safekeeping artistry of past generations. Not all gravestones were carved from slate, but many of the earliest relied on the workable nature of slate for the best results.

Jean Napier and Roger Tiley visited abandoned slate quarries and sensed both the commotion of the quarry activities in the past and the return of the quiet times before the industry opened up the mountains. Setting up their camera shots amid slate tips, they lost track of the hours and sometimes felt themselves in a time warp. Their quarry pictures show the evidence of natural changes and of time passing. A sense of reminiscence, decay, and desolation are especially common in their photographs.

Shlomo Shuval tried painting on stone, but wanted something longer lasting. He turned to a chemical process that allowed him to impose antique photographs on slate and so extend the images' life expectancy and arrest the images' fading with the passage of time. Historical moments or people and places from bygone times are preserved on the uneven surface of slate, which complements the antique quality of the images.

By its very essence, photography captures a transient moment. Understanding that longevity might not be possible for each piece, Long and Goldsworthy use photographs to capture the space and time around their ephemeral interventions in the environment, their Land Art sculptures so frequently composed with slate. Goldsworthy recognizes that his photographs root themselves in a moment of time, just as his ephemeral works of melting ice swords or precariously balanced slate arches represent only a fraction of the journey his natural materials experience. He writes, "Photography has made us aware of the passing of time."

Poetry

In creating a photography exhibit or a musical event about slate quarries, artists Napier, Tiley, and Will Menter drew inspiration from Welsh poets. Welsh poets sometimes write their poems using slate images to reinforce a tone and to express their experiences of life. Often, the poems conjure up the abandoned quarries and describe deserted sites of former habitation in the Welsh countryside, thereby addressing the issue of time. Bleakness is the most common theme. Maurice Rutherford's "Slate" demonstrates this attitude: "the brittle man of Wales shuffles black dominoes / and builds, on the shards of his father's dream, / ... where grieving winds / polish the grim sarcophagus at Blaenau Ffestiniog."

Though the slate tips seem dark and gloomy to many and some environmentalists decry their blight on the land, poet Ruth Bidgood picks up on the theme of change and points to the many alterations earthbound stone has undergone. She suggests change will continue. She explains how the stones (easily read as "slates") speak of and celebrate past lives. She proclaims in "Mid-Wales,"

 This land is loved so sadly
 And with such disenchantment.
 Some in her ruins
 See only dereliction,
 Some drown in her silence,
 Vainly clutching the spar
 Of an imagined voice.
 Yet a story does not stop
 At the first chapter,
 And a life is not invalidated
 By having ended.
 You who love so sadly,
 Weeping at the broken house
 And the fern-choked fields,
 You forget the older time
 Before the walls were built,
 Before the fields were made.
 These tumbled stones are language
 In which a life is written –
 Read, and rejoice that it was lived.
 Drink with joy the silence offered
 In this cup of hills, this Grail.

Pic. 11.5. *Spiral of life*
The ancient motif is carved on a 1748 gravestone in Massachusetts. Among the earliest designs produced by mankind, the Spiral is an art motif that has been passed down through time.

In her poem titled "Stone," which aptly applies to slate, she writes,

Only stone lasts here.
Stone proclaims life, affirms a future
by virtue of so many pasts,
yet baffles questioning. As I touch walls
warm in the sun today, and feel
so many summers gentle to my hand
and yet withheld, I would crush stone
in my fist, if I could, till truth's milk ran.

Shakespeare's "Sonnet 55" claimed poetry would outlast any stone monument, and the bard linked time and the slate gravestone laid in the floor of a church, when he wrote:

Not marble, nor the gilded monuments
Of princes, shall outlive this powerful rhyme.
But you shall shine more bright in these contents
Than unswept stone, besmeared with sluttish time.

Slate art may have started with the gravestone cutters who used it because it could be worked with common tools. Perhaps the quarrymen who carved fanciful household pieces to improve their skills were first. In either case, slate art has played a role in the daily lives of ordinary people over many generations and in regional history on both sides of the Atlantic. More recently, slate has earned a position in modern art as a viable medium, frequently relating to some aspect of time. Through the passage of years and the continuing process of defining art, slate art forms are now found in sophisticated jewelry adorned with silver and gold, as welcoming works in corporate lobbies and sculpture gardens, and in major museum masterpieces.

We use "starting with a clean slate," "slated for business," and "on the slate for today" in our ordinary conversation. We sleep beneath roofs, walk across the patios and foyers of slate, and recall that blackboards in schools were once made of slate. Creativity and a mastery of wide-ranging skills now offer us slate art with great visual appeal. The artists among us have seen the expressive potential in this ordinary stone and remind us, as did Noguchi, that "Art is everywhere. The whole world is art. The only thing is, some people see it and some people don't."

Appendices

Glossary of Selected Terms and Places

BANGOR: (1) a city in Gwynedd County in northwest Wales; (2) the county seat city in Penobscot County in central Maine; (3) borough and town in Northampton County in eastern Pennsylvania – all three near slate quarries

BARROW: a heap of rocks or earth marking an ancient grave

BAS-RELIEF (or LOW RELIEF): sculpture in which figures carved in a flat surface project only a little

BETHESDA: village in North Wales; the site of the Penrhyn Quarry

BEZEL: a sloping surface; the groove or flange holding a gem or a watch crystal in place; or the slanting face of a cut jewel

BIOMORPHIC: an abstract-art term for shapes based on forms found in nature

BLAENAU FFESTINIOG: Welsh mountain town amid slate quarries in Snowdonia National Park in North Wales

CAIRN: a conical heap of stones piled as a monument or landmark

CALLIGRAPHY: the art of handwriting; typically, beautiful letter forms or fine penmanship

CAMBRIAN: a mountain range in North Wales; rock formed in the Paleozoic era, 540 million years old

CARBORUNDUM: an artificial sharpening stone made of silicon carbide

CLEAVAGE (also SLATY CLEAVAGE): the direction in which slate is most easily split. It also describes slate's ability to be split along parallel planes.

CONCEPTUAL ART: various forms of art projects introduced in the 1960s, 1970s, and 1980s with the most important element being the basic idea for the work, rather than the finished product, if one is ever created; avant-garde art form overlapping with body art, Land Art, Minimal Art, and Performance Art

COPING SAW: used for cutting curves, especially in thin wood such as mountings

CORE: a cylindrical sample (of slate) obtained with a hollow drill

CUMBRIA: county in the northwest of England, including the scenic Lake District region; here volcanic rocks and slate produced the Pennine Mountains and a landscape of lake-filled valleys

CUP-AND-RING MARKS: a design of concentric circles found all over the world. These are some of the earliest stone carvings by prehistoric peoples.

DELABOLE: town on the north coast of Cornwall; site of oldest continuous-use slate quarry in England

DEVONIAN: rock formed in the Paleozoic era, from 410 million years ago

DIRECT CARVING: a process of evolving a sculpture by working directly into the stone without using a model or a clay sketch

Dolmen: a prehistoric tomb or monument consisting of a large, flat stone laid across upright stone supports once covered in soil, but now exposed to view; a cromlech

Dry wall: a stone wall built with no mortar or cement; to build a wall of rocks in such a manner

Dumps: piles of slate quarried and discarded as unfit for commercial use; also called slate tips, slag, or terrils

Earth Art: see Land Art

Eisteddfod: any traditional Welsh gathering (local, county, or regional) lasting up to a week with competitions in the bardic arts of music, poetry, and literature, with selected artisans presenting local Welsh arts and crafts. The National Eisteddfod is the largest folk festival in Europe, held in alternate years in North and in South Wales during the first week in August.

Emery: an artificial sharpening stone. An emery wheel is a wheel-shaped, hard granular mineral used for grinding and sharpening metal tools.

Enameled slate: slate panels polished, painted, and hardened by baking in kilns; British term akin to marbleized slate

Engraving: a means of ornamenting metal or stone objects by cutting a design into the surface, inscribing it with a pointed tool. In pictorial arts, the designs are incised into a copperplate, inked and wiped, then pressed to reproduce an image.

Epoxy: a strong plastic glue; a combination of liquid resin and a curing agent that hardens into a highly resistant adhesive

Etch: to depict or impress sharply and distinctly; to make a drawing or design by engraving on a flat surface; also a process of making a design on a metal plate by scratching through an acid-resistant coating and then immersing the plate in an acid bath

Found object: natural object or man-made artifact not originally intended as art, which is found and used in artwork because of some aesthetic value

Fretsaw: very similar to the coping saw with a thin blade, but has a much deeper frame and is used for cutting intricate curves or fretwork; a bracket saw

Gorget: regalia of bone, shell, or slate worn over the chest or near the throat, either suspended by leather or attached directly to clothing; an ornamental collar

Granville: a small town in New York close to the Vermont border, in the midst of the "colored-slate capital"; home of the Slate Valley Museum

Hacksaw: designed to cut metal and so the 8"–12" blade and frame are made of very strong steel

Jeweler's saw: similar to a coping saw with a 6" blade, except it has an adjustable frame

Land Art (also Earth Art): a concept of art relying on the raw materials of earth, rocks, soil, wood, and other common materials; emerged in the late 1960s

Letterform: the development or design of the shape of a letter

Llanberis: the slate town by the Dinorwig Quarry in North Wales, now home of the Welsh Slate Museum

Llechen: Welsh for slate, plural *llechi*

Mallet: a (woodcarving) hammer with a round head, usually made of the very hardest woods, like dogwood or lignum vitae

Maquette: a small model of a planned sculpture

Marbleize: process of applying paint to paper in an imitation of variegated marble; a process of layering and baking paint on slabs of slate to create a faux marble or wood-grain surface

Menhir: megalith; a tall, standing stone erected probably as a prehistoric monument, found either singly or in a circle or row of such stones

Mill(ed) stock (or structural slate): slate that is to be used for some purpose other than roofing shingle – as in steps, wainscoting, baseboard, lavatory enclosures, and mausoleum crypts, as well as billiard tables, blackboards, and electrical panels

Minimal Art: a type of abstract art using plain, often industrial materials, in geometric or extremely simple sculptural forms, with a deliberate lack of expressive content in order to focus attention on the color, form, space, and materials used

Monson: a small town in Penobscot County in central Maine; site of black slate quarries; all slate from this region is referred to as "Monson slate"

Naïve Art: modern paintings with child-like vision, often with bright colors, lacking conventional representation skills, but with a fresh, direct expression

Negative space: the spaces between shapes in a sculpture – these can be as important as the pauses in a piece of music.

Off-cuts: quarry tailings; waste or refuse left in various processes of milling stone

Ordovician: from the Paleozoic era; rock formed about 500 million years ago

Peach bottom: slate region along the shared border of Pennsylvania and Maryland where hard, black slate was discovered in 1734. The slate from this region was commercially shipped out of Delta, Pennsylvania starting in 1785.

Pen Argyl: a town in eastern Pennsylvania's Slate Belt

Penrhyn: Lord Penrhyn owned Penrhyn Quarry in the village of Bethesda, North Wales. The National Trust now owns his home, Penrhyn Castle. The Penrhyn lockout of quarrymen was a strike that lasted from 1900 to 1903 and drove many slate workers to seek employment abroad.

Petroglyphs: rock carvings, especially prehistoric ones

Rasp: variously shaped, coarse files with raised points, instead of lines, used to round and smooth surfaces

Relief: in sculpture, the projection of images from a flat background; also, a work of art in this style

Resist: a protective coating applied to withstand or oppose sandblasting

Riffler: various curved tools used by carvers and sculptors, similar to a rasp or file

Riven: split. The "riven surface" is the unworked plane of cleaved slate.

Sandblasting: using a high-velocity blast of air or steam to convey sand to clean stone or carve into a stone surface

Serif: a graphic symbol, like a hairline or hook, used to finish the main stroke of a letterform

Shingle: a thin piece of wood, slate, metal, asbestos, or the like, usually oblong, laid in overlapping rows to cover the roofs or walls of buildings

Silicosis: lung infection caused by exposure to mineral dust

Silurian: from the Paleozoic era, rock formed about 440 million years ago

Slag: material quarried and discarded as unfit for commercial use; *rhybelwyr* in Welsh

Stela (or stele): an upright stone slab or pillar engraved with inscription or design, used as a monument or grave marker
Tailings: discarded material from the processes of milling or quarrying
Terril: French for any material quarried and discarded as unfit for commercial use
Tile: a thin square or rectangular piece of material (fired clay, stone, plastic, or metal) used for roofing or flooring
Tips: piles of slate quarried and discarded as unfit for commercial use; slate dumps
Trompe l'oeil: (French for "trick of the eye") a visual deception; an artwork that creates a strong illusion of reality
Tympanum: the semi-circular or triangular space centered at the top of a gravestone

Additional Background on Selected Artists

Reg Beach (b. 1946) attended Canterbury College of Art and took his Diploma in Art Design from Bath Academy of Art in 1968. He was a visiting lecturer on environmental art and art therapy for several years. From the 1980s Beach has exhibited in galleries and shops in England, Wales, and Ireland and produced sculpture and fountain commissions.

John Benson (b. 1939) studied sculpture at the Rhode Island School of Design. He designed and executed inscriptions for the Boston Public Library, the John F. Kennedy memorial in 1963 and the Jacqueline Kennedy Onassis tombstone in 1994, the National Gallery of Art, The Armand Hammer Museum of Art in Los Angeles, and the Franklin Delano Roosevelt Memorial in Washington, DC. He has created the typefaces Alexa, Balzano, and Caliban, which he licensed to Adobe.

John Howard Benson (1901–1956) trained in watercolor and printmaking at the National Academy of Design and The Art Students League. He was recognized as one of America's best designers of carved-stone lettering and a foremost U.S. calligrapher. He was awarded the American Institute of Architects' Craftsmanship Medal for Excellence in Calligraphy and an honorary degree from Yale University.

Nicholas Benson (b. 1965) studied calligraphy, type design, typography, and drawing at the Basel School of Design in Switzerland. He carved tombstones for Pulitzer prize-winning poet James Merrill and photographer Daniel Farber, complete with an etched camera hanging over an upper corner.

Sharon Boardway (1962–2000) moved to Seattle soon after receiving an MFA from State University of New York at New Paltz. While in college, she experimented with sandblasting and lapidary equipment, and studied the art history of various world cultures. This led her to an appreciation of stone, including slate, which she incorporated into her jewelry.

Howard Bowcott (b. 1956) was born in Manchester, England, earned BA Honours in Fine Art from Newcastle University, then moved to North Wales in 1979. Starting in 1985, Bowcott worked occasionally for artist David Nash in his wood studio. Bowcott represented Wales on the British Council's cultural exchange to Zimbabwe in 1987. He had a one-man show of slate works in St. James' Sculpture Garden in London and produced a large charcoal drawing of Snowdonia at the Victoria and Albert Museum in London, as well as numerous gallery exhibits. He now does consulting or design work and creates sculpture and landform predominantly for public art commissions. His commission from Halo Ice Cream won first prize from the Association for Business Sponsors for the Arts (ABSA) for the most innovative project in 1993.

Christopher Curtis (b. 1951) is a graduate of the University of Vermont with a degree in Zoology and a minor in sculpture. His first stone sculpture was cut

under the instruction of Paul Aschenbach. Curtis and his wife Tari Swenson manufactured stone products for gift galleries, including shops in the Guggenheim Museum, Philadelphia Museum of Art, The Whitney Museum, and The National Geographic Society. His sculpture is on display at their riverside studio and sculpture park in Stowe, Vermont.

Louise Desrochers (b. 1958) has a degree in landscape architecture from Montreal University. For a 1995 grant from the Arts and Letters Council of Quebec, she spent a year observing and photographing abandoned quarries in all seasons and created "Un jardin d'ardoise" (A Slate Garden), which appeared first at the Centre d'interpretation de l'ardoise (Slate Interpretation Center) in Melbourne, Canada, in 1997, and then at the Historic Society of Sherbrooke, Canada, in 1998.

Frank Eliscu (1912–1996), born in New York City, attended the Beaux Arts Institute of Design and Pratt Institute. He was an academician of the National Academy of Design and served as President of the National Sculpture Society (1967–70). He designed for Steuben Glass Company, created the All-American Football Trophy (the Heisman Memorial Trophy), did the reverse side of the official Presidential inaugural medal in 1974, and designed the Presidential Eagle for the White House. Cascade of Books, his five-story, twenty-ton, abstract bronze screen at the James Madison Library of Congress building, and his plaque of Uncle Joe Cannon, both in Washington, have been declared national monuments. He received the Herbert Adams Memorial Gold Medal for service to American sculpture.

Daniel Farber (1906–1998), while running his family's shoe manufacturing business in Worcester, Massachusetts, wrote articles for photography magazines and sold 19 photographs to Columbia Records for jacket cover art. He held one-man shows of photo images in 70 museums and galleries, and he photographed paintings and art objects, including the pewter collection, for the Museum of Fine Arts, Boston. The MFA's book on American pewter, illustrated with Farber's photographs, was named one of the fifty best books of 1974 by the American Institute of Graphic Arts. Thirteen hundred of his photos are in the permanent collections of sixty-five museums. The Farber Collection CD-ROMS with nearly 9,000 gravestones images are available on eleven CDs.

Andy Goldsworthy (b. 1956) was born in Cheshire, England, near the border of North Wales, and grew up in Yorkshire. He prefers to work around Dumfriesshire, Scotland, his current home. He studied at Bradford College of Art, took a BA in Fine Arts at Preston Polytechnic, and created his early Earth Art pieces outdoors in the Lake District. He has had one-man exhibits in London, Cardiff, San Francisco, New York, St. Louis, San Diego, San Jose, Paris, Tokyo, and Auckland. Goldsworthy has created major exhibitions and commissions all around the world, frequently producing Land Art in remote areas. Inventive Goldsworthy pieces have been executed at the North Pole, in Japan, the Australian outback, the Lake District and Yorkshire Dales, the Northern Territories of Canada, as well as in major cities such as Los Angeles, St. Louis, and Quebec. In 2000, he was appointed Andrew W. White Professor at Cornell University, a position that continued until 2006.

Brian Gordon (b. 1939) had a seven-year apprenticeship with a metal engraving firm, working on bronze, brass, and copper, followed by a career in metal engraving and sign writing. He studied design at the Liverpool School of Art. In 1978 he started using slate and by 1984 had a strong reputation. In 1986 Gordon had exhibitions at the Registry of Naïve Artists (RONA), at the Barbican Center, and in the Tate Gallery all in London. His first one-man exhibition was in 1991 at The Boydell Galleries in Liverpool. After completing about 200 slate paintings, his painting career ended because of a shoulder injury in a motorcycle accident.

Barbara Hepworth (1903–1975) won a scholarship to the Leeds School of Art at 17 and there befriended Henry Moore, five years her senior, with whom she would be closely associated for 20 years. In 1924, she and Moore graduated from the Royal College of Art in London. In 1939, anticipating World War II, her family relocated to St. Ives, Cornwall, for the safety of her 3 children, and eventually made St. Ives her permanent home, establishing her own Trewyn Studio there. Over the course of her 50-year career, Hepworth became a Dame Commander of the British Empire (1965), a Cornish Bard (1968), and an internationally known sculptor. She produced almost 600 works of art, including sculptures, drawings, paintings, and lithographs. She lived and worked the last half of her life in St. Ives, until her death in a studio fire in 1975. The Tate Gallery London then ran the Hepworth studio as a museum and sculpture garden from 1980, until the Tate St Ives took over when it opened in 1993.

Susanna Heron (b. 1949) holds degrees from the Falmouth School of Art, Cornwall and the Central School of Art, London. Her work in Dublin brought her the "Art for Architecture" award from the Royal Society of Arts and a 1995 Sculpture Award from the Henry Moore Foundation. She was also awarded a 2001 Arts Foundation Fellowship. Her book, *Stills from Sculpture*, is a personal account of three award-winning public commissions. Much of her current work is public commissions – with current projects underway in Tokyo, Cardiff, Westminster, Coventry, and Bristol. She is the daughter of artist Patrick Heron.

David Kindersley (1915–1995) apprenticed under Eric Gill from 1934 to 1936. He established his still-operating workshop in Cambridge in 1946. His work is seen in cathedrals and public buildings throughout Britain and in Europe. Kindersley invented a widely-praised system for the accurate spacing of letters. With Lida Lopes Cardozo, he authored the influential book, *Letters Slate Cut*.

Lida Lopes Cardozo Kindersley (b. 1954), born in Holland, received her early training at the Royal Academy in The Hague with Gerrit Noordzi. She apprenticed with David Kindersley in 1976, later co-ran his workshop and married him in 1981. Together they had three sons, who now are apprenticed in the carving studio in Cambridge, England.

Richard Kindersley (b. 1939) studied lettering and sculpture at Cambridge School of Art and in his father's studio. His inscriptions on public art commissions are seen on public art throughout England and Scotland, including the Vic-

toria and Albert Museum, Barbican Center, and the Arts Council of Wales. He has won seven brick-carving competitions and been awarded the Art for Architecture Award from the Royal Society of Art.

Phillip King (b. 1934) was born in Tunisia, studied modern languages at Christ's College, Cambridge, and then sculpture at St. Martin's School of Art with Anthony Caro. He worked as an assistant to Henry Moore and then as a college professor of sculpture at St. Martin's in London, Bennington College in Vermont, and Hochschule der Kunste in Berlin. He is arguably the best known of avant-garde British sculptors who gained recognition in 1965's New Generation exhibition. In 1968 he represented Britain with Bridget Riley at the Venice Biennale. He worked in Japan and Czechoslovakia and was a Trustee of the Tate Gallery from 1967 to 1969. In 1974 he received the Commander of the British Empire award, was elected an Associate of the Royal Academy in 1977, and was Professor of Sculpture at the Royal College of Art from 1980–1990. He was elected the 24th President of the Royal College of Art in December 2000.

Susan Ringer Koons (b. 1962) has won several awards, including scholarships and the 1996 Kansas Artist-Craftsmen Association Award. Her work is sold through galleries, such as Lumina in Taos, New Mexico; Elements, Ltd. in Des Moines, Iowa; and her own Hackberry Tree Studio in Liberal, Kansas. Her work has been included in the Guggenheim Museum in New York, The Downey Museum of Art in Downey, California, and the Baker Arts Foundation in Liberal, Kansas.

Barbara Kulicke (b. 1929) received her early art training at the Tyler School of Fine Arts at Temple University, Colorado College, and at Connecticut College. While living in New York City for thirty years, Kulicke and her (former) husband, painter Robert Kulicke, started a company designing and manufacturing innovative picture frames. Kulicke Frames attracted most of the artists in The New York School. She worked with Franz Kline, Willem De Kooning, Robert Motherwell, Josef Albers, Georgia O'Keeffe, and Andy Warhol. She has exhibited her oil paintings, watercolors, and works on slate in the Northeast, including 13 one-person exhibits and eight group-shows. The New Jersey State Council on the Arts awarded her the 1994 Fellowship Award for "Artistic Excellence." Her work appears in *New Jersey, Art of the State*, published by Abrams in 1999.

Julie Levesque (b. 1958) grew up in Auburn, Maine, and graduated Summa Cum Laude with a Bachelor of Fine Arts Degree in Metals from the State University of New York (SUNY) at New Paltz. She worked as a bench jeweler in two Boston-area jewelry shops, as designer and shop manager, and then worked for a company that created jewelry and small art objects based on museum originals. In the spring of 1997, she organized the first annual Art in the Garden show with six Boston-area sculptors. She was a featured artist in group shows at the Rice/Polak Gallery in Provincetown, Massachusetts, and had a solo show at the Clark Gallery in Lincoln, Massachusetts.

Richard Long (b. 1945) explored unorthodox approaches to sculpture while studying from 1966 to 1968 at St. Martin's School in London, where the faculty

included Anthony Caro and Phillip King. Long, born and still residing in Bristol England, has executed his art on every continent except Antarctica. For almost 30 years, Long averaged about six months a year producing art related to walking, frequently incorporating stone. Long was selected in 1991 by a committee developing a new national curriculum for the teaching of art in Britain as one of 60 artists, designers, and craftspeople whose works should be studied. Also on the list are such masters as J.M.W. Turner, John Constable, and Henri Matisse.

Pam Martins (b. 1928) studied art at Brighton College of Art, taking intensive drawing classes that focused on eight aspects of art, including anatomy, costumes, perspective, and still life. Over the course of her career she has created greeting cards and illustrated books. She paints in watercolor, pastel, oil, and mixed media and has authored and illustrated *A Brush with Cats*. She is the founder-member of the Feline Artists Society in London.

Will Menter (b. 1951) graduated from the University of Bristol in 1975 with a degree in sociology and then wrote his Ph.D. thesis for the same university in 1981, researching the social meanings in jazz and improvised music through a comparison of musicians' collectives in the US and the UK. He did further music research in Zimbabwe in 1987, 1991, and 1993; studied architecture for a year; and has moved to France pursuing his music and sculpture career.

Jean Napier (b. 1948) left her job as an engineer at Ford Motor Company to develop her photography skills and also lead a life as a canoeist and mountaineer. She enrolled in a full-time Fine Arts degree course of Photographic Studies at the University of Derby and graduated with a BA (Honours) degree in July 1994. She now also holds six City and Guilds Certificates in practical photography and in 1997 was accepted as an Associate of the Royal Photographic Society. Additionally, she is a Photographic Tutor for the Open College of the Arts.

Isamu Noguchi (1904–1988) was born in Los Angles and raised by his mother, Leonie Gilmour, in Japan but estranged from his poet father, Yonejiro (Yone) Noguchi. Isamu (Sam) attended high school in rural Indiana, enrolled in pre-med at Columbia University, but instead studied art at the Leonardo da Vinci School in New York, encouraged by his mother. In addition to his stone sculpture, he is known for a now classic, free-form coffee table with three legs that he created for the Herman Miller Company, and Akari "light sculptures" or lamps of bamboo and paper. He also designed playground equipment and public gardens for cities and corporations world-wide.

W.J. (Bill) Rice (b. 1938) designs and makes functional slate pieces that are sold throughout Wales. The jury for the contemporary Craft Exhibition at the 1997 Royal National Eisteddfod in Bala selected three of Rice's bowls of banded slate and quartz for exhibition. His work is shown in Welsh galleries, including The Chapel of Art in Criccieth and the Oriel Rob Piercy Gallery in Porthmadog.

Ivor Richards (b. 1941) studied sculpture at the Central School of Art and Design in London, earning a BA Honors degree in Fine Art in 1972. He added advanced studies in printmaking, etching, and wood engraving, and later took a course in bronze casting at Goldsmith's College of Art in London. When he won a British Council Travelling Scholarship, he visited the People's Republic of Mongolia to study Mongolian art and architecture. For one year he compared the "rapid change from the Buddhist religious influences on art" with the Soviet social influences after the revolution of 1921.

Celeste Roberge (b. 1951) took her undergraduate degree in sociology and a Phi Beta Kappa key from the University of Maine, Orono. She began her career as a sculptor taking courses at the Skowhegan School of Painting and Sculpture and the Portland School of Art. She took a BFA from the Maine College of Art in Portland, and an MFA from the Nova Scotia College of Art and Design in Halifax, Nova Scotia. She has exhibited across the U.S. and been invited to lecture along the eastern seaboard from Georgia to Newfoundland. For several years she has been an Associate Professor in the Sculpture Area at the University of Florida in Gainesville.

Shlomo Shuval (b. 1954) received his early art training from his artist mother and then went on to vocational training in welding and other practical skills. After his Army service, he supported himself in the arts—working with leather, making candles, doing paintings, and even drawing character sketches on the street, before establishing a successful business creating painted ceramics in Israel. He moved to California in 1990 and established his business, Sierra Slate Images.

Walter Steward (1876–1949) worked in the Monson quarries most of his life, though he may have briefly studied art in New York City. His father, Seth Steward, was a professional painter and probably taught his son basic painting. The Stewards typically painted Maine landscapes, trout, and deer on miniature paddles for tourists, board, and canvas, only rarely on slate.

Bill Swann (b. 1947) for almost twenty years was proprietor of Porthmadog Pottery and worked in management and public relations. Though a trained potter and ceramist, in 1989 Swann returned to Staffordshire University to earn a B.A. Honours degree in Art and Design specializing in glass. He participated in a two-week cultural exchange program with Kyushu in southern Japan. In recent years Swann has exhibited in England, at the Welsh National Eisteddfod in 1993, and at Expo Art 98 in Tokyo, as well as in Holland and Germany. He has mounted four one-man shows in Penrhyn Castle and another at The Chapel of Art in Criccieth. During Artist in Residence programs, Swan guides local school children creating works in glass and ceramics. His public commissions in glass may be found in public venues in both North and South Wales.

Tari Swenson (b. 1951) is a Vermont-based lettering artist who works on stone and paper, with fine art works often combining painting, illumination, and calligraphy. In 2001, she and husband Christopher Curtis completed a 700-word, hand-lettered, granite memorial fountain for the University of Arkansas Medical Center.

Roger Tiley (b. 1960), returned to college in 1984 to study documentary photography at Gwent College of Higher Education and was an industrial photographer, doing freelance work for national newspapers and magazines. Ffotogallery in Cardiff, South Wales, offered him a major commission to produce the "Valleys Project," a documentary on the effects of the coal miners' strike on the small, valley communities in South Wales. He considered himself a photographer of people, until his visit to the slate quarries.

Merrill Wagner (b. 1935) left Washington state where she was raised, to attend Sarah Lawrence College in Bronxville, New York, and earn a liberal arts degree with a concentration in literature and music. She next studied painting and drawing at the Art Student League for four years. Now living in Manhattan, she creates exhibits and installations in colleges and galleries on the East Coast, as well as in the Seattle area. In 1989 Wagner won a National Endowment for the Arts Visual Artists Fellowship Grant. She has taught at the University of Puget Sound in Tacoma, Washington; Princeton University; and at the Parsons School of Design in New York City.

John Williams (b. 1955) is a self-taught carver from St. David's, West Wales. His first slate carving project was done in high school, and he now runs a slate letter-cutting business with his son Paul. A horizontal slate sundial he carved was presented to H.M. Queen Elizabeth II by St David's City Council on receiving preferred City Status in 1994, and is situated privately at Windsor Castle. He has executed twenty slate commissions for various new buildings and presentations at Dean Close School in Cheltenham, including a vertical sundial in the school quadrangle.

Mack Winholtz (b. 1943) was formerly a professor of Sociology and Human Services at Park University near Kansas City, Missouri. He pursues his art career by exhibiting slate sculptures in juried shows in Colorado, Missouri, and Illinois, and has won several awards. From over 750 sculptures submitted for acceptance in the nineteenth North American Sculpture Exhibition, sponsored by the Foothills Art Center in Golden, Colorado, *Lyric* by Winholtz was one of 72 selected for exhibition and won him the $1,100 Anniversary Award in 1998. He has been associated with prestigious art galleries, such as the Lumina Gallery in Taos, New Mexico; the McLaren Markowitz Gallery in Boulder, Colorado; and the Jayne Gallery in Kansas City, Missouri.

Museums and Organizations for Further Exploration

Museums

Ardoisalle
This old slate quarry in the Ardennes in Belgium, near the French border, was active until 1958. In 1990, tours began, including a subterranean visit.
> Rue du Reposseau 12, B5550 Alle-sur-Semois, Belgium
> Telephone: 32 61 500334
> Web site: www.xs4all.nl/~jorbons/souterrains/mus/ardoisae.html

Bertrix: The Gourmet Mine
A visit to a slate quarry can be combined with a regional meal served in various stages during the underground trail.
> Domaine de la Morépire, Rue de Babinay 1, 6880 Bertrix, Belgium
> Telephone : 32 061/41 45 21
> e-mail: yves.crul@belgacom.net
> Web site: www.aucoeurdelardoise.be

Ceredigion Museum
Housed in the restored Edwardian "Coliseum Theatre," this museum displays a number of slate artifacts among its exhibits on archaeology, local folk-life, a cottage of 1850, agriculture, dairying, and various crafts.
> The Coliseum, Terrace Road, Aberystwyth, Ceredigion, SY23 2AQ Wales, UK
> Telephone: 44 (0) 1970 6330884
> Curator: Michael Freeman, e-mail: museum@ceredigion.gov.uk
> Web site: museum.ceredigion.gov.uk

Centre d'Interprétation de l'Ardoise / Slate Museum
Located in a former church with a slate roof and steeple, the Centre is dedicated to increasing knowledge about slate, including quarrying and objects made from slate. Its mission is to promote the importance of the slate heritage of the St. Francis Valley.
> 5, rue Belmont, C.P. 159, Richmond, Quebec J0B 2H0 Canada
> Telephone: +1 819-826-3313
> E-mail: ardoise@interlinx.qc.ca
> Web site: www.townshipsheritage.com/Eng/org/Interpretation/IC_ardoise.html

Gloddfa Ganol Slate Mine
The world's largest slate mine. Open to the public are huge underground chambers, displays of the slate mining industry, an observation gallery overlooking open cast blasting, three miners' cottages, a craft shop, Natural History Centre, and Narrow Gauge Railway collection.

Blaenau Ffestiniog, Gwynedd LL41 3NB, North Wales, UK
Telephone: 44 (0) 1766 830664
Web site: www.planetware.com/blaenau.ffestiniog/gloddfa-ganol
slate-mine-gb-gwy-wgl.htm

Haute Martelange Slate Quarry Museum
Former slate quarries are being restored.
Maison 3, L8823 Haute Martelange, Luxemburg
Telephone: 352 640753
Web site: www.xs4all.nl/~jorbons/souterrains/mus/martelae.html

Honister Slate Mine
In the Lake District, England's only slate mine offers underground mine tours.
Honister Pass, Borrowdale, Cumbria CA12 5XN UK
Telephone: 44 (0) 17687 77230
E-mail: info@honister-slate-mine.co.uk
Web site: www.honister-slate-mine.co.uk/

Inigo Jones, Tudor Slate Works
Established in 1861, the company today prefabricates architectural, monumental, and crafts items from Welsh slate. There is a craft shop and self-guided tour.
Y Groeslon, Caernarfon, Gwynedd, LL54 7ST North Wales, UK
Telephone: 44 (0)1286 830242
E-mail: info@inigo.jones.co.uk
Web site: www.inigojones.co.uk/info.about.html

Llechwedd Slate Caverns
Two underground rides exploring old slate mining skills and the lives of Victorian miners, a Victorian Village, slate splitting demonstrations, cafes.
Blaenau Ffestiniog, Gwynedd, LL41 3NB, North Wales, UK
Telephone: 44 (0) 01766 830306
E-mail: info@llechwedd-slate-caverns.co.uk
Web site: www.llechwedd-slate-caverns.co.uk

Maison de l'Ardoise (House of Slate)
This museum, like its sister museum in Fumay, celebrates the lives and dedication of slate miners in the Ardennes.
96 Rue Jean Jaurès, 08150 Rimogne, France
Telephone: 33 03 24 35 13 13; fax 33 03 24 35 13 55

La Mine Bleue, Ardoisières Angevines de St-Blaise (The Blue Mine)
An explanation and tour of a slate mine is offered, including an underground train ride.
49780 Noyant la Gravoyère, France
Telephone: 33 02 41 61 55 60
E-mail: jardin@art8.com

Musee de l'Ardoise (Museum of Slate)
This museum, like its sister museum in Rimogne, celebrates the lives and dedication of slate miners in the Ardennes.
>Fumay, France
>Telephone: 33 03 24 41 10 25
>E-mail: otfumay@wanadoo.fr

Musée de l'Ardoise de Trélazé
>32 chemin de la Maraîchère, 49800 Trélazé, France
>Telephone: 33 02 41 69 04 71
>E-mail : museeardoise@vousloire.com
>Web site: www.multimania.com/museeardoise

Musée municipale de l'ardoise de Renazé (Renazé Municipal Slate Museum)
This municipal museum exhibits equipment and photographs. It offers demonstrations of slate work.
>Ridge of Longchamp, 53800 Renazé, France
>Telephone: 33 02 43 06 41 74

Old Line Museum
Exhibits include local history, Welsh culture, and slate quarry artifacts from the Peach Bottom, America's first recognized slate quarry district.
>Borough Building, 604 Main Street, Delta, Pennsylvania 17314 USA
>Telephone: +1 717-456-7124
>E-mail: Ruthann Robinson at drrobinson@cyberia.com
>Web Site: www.deltaborough.org/home_town-10_016.htm

The Scottish Slate Islands Heritage Trust
>The Heritage Centre (former slate quarryman's cottage)
>Ellenabeich, By Oban, Argyll PA34 4RQ and
>Easdale Island Folk Museum, Easdale Island, By Oban, Argyll PA34 4TB
>Telephone, for both locations: 44 (0) 1852 300449
>E-mail: webmaster@slate.org.uk
>Web site: www.easdale.org.uk/

Slate Belt Heritage Center
Exhibits showcase slate and offer tributes to Italian, Cornish, and Welsh settlers.
>30 North First Street, Bangor, Pennsylvania 18013 USA
>Telephone: +1 610-588-8615
>Web site: www.slatebeltheritage.com/

Slate Belt Museum and Historical Society
The collection includes two dozen handcrafted slate pieces from the turn of the twentieth century, slate mining exhibits, and local history of the Pennsylvania Slate Belt.

2214 North Delaware Drive, PO Box 58,
Mt. Bethel, Pennsylvania 18343 USA
Telephone: +1 570-897-6181 or +1 610-599-5551
e-mail: Walter Emery at wemery@epix.net
Web site: www.geocities.com/Heartland/Ridge/7028/
slatebeltmushist.html

Slate Valley Museum
Exhibits of historic artifacts from the area's slate quarries and immigrant quarry workers, photographs of slate manufacturing companies, a quarry shanty complete with all the machinery and tools common to traditional slate quarrying, and a geological display illustrating the natural history of slate. Director: Mary Lou Willits

17 Water Street, Granville, New York 12832 USA
Telephone: +1 518-642-1417
E-mail: mail@slatevalleymuseum.org
Web site: www.slatevalleymuseum.org/

The Slate Way: Fontanabuona Valley, Italy
This is an open-air museum in several locations, where slate is extracted and worked.

Slate Museum at Cicagna, Mt. San Giacomo quarry area
Centre & Slate Showroom at Chiapparino di Cicagna
Telephone: +39 0185 971091
E-mail: mail@fontanabuona.ge.it
Web site: www.fontanabuona.ge.it/The%20slate%20way.htm

St Fagans National History Museum
(Museum of Welsh Life)
One of Europe's biggest open-air museums, with 100 acres of parkland and 40 original buildings moved to recreate 500 years of Welsh history. Slate artifacts are found in cottages, fences, and household architecture.

St. Fagans, Cardiff CF5 6XB - Wales, UK
Phone: +44 (0)29 2057 3500
e-mail: stfagans@museumwales.ac.uk
Web site: www.nmgw.ac.uk

Welsh Slate Museum
On exhibit are original machinery in the former workshops and foundry of the vast Dinorwig Quarry, including the second largest water wheel in the U.K. and a narrow gauge steam railway. Self-guided tours include a hospital, quarrymen's houses, and the Chief Engineer's House, as well as slate working demonstrations, an audio video presentation of quarry history, and invitational art shows.

National Slate Museum, Llanberis, Gwynedd LL55 4TY, North Wales
Telephone: 44 (0) 1286 870630
E-mail: slate@nmgw.ac.uk
Web site: www.museumwales.ac.uk/en/slate/

Other Useful Resources

The following organizations, mostly related to Welsh and Cornish heritage, also may lead to further information about the artistic uses of slate.

Alun John Richards
A guide to the many slate-related publications of Alun John Richards.
>Web Site: www.richards-slate.co.uk/

Association for Gravestone Studies
>278 Main Street, Suite 207, Greenfield, Massachusetts 01301 USA
>Telephone: +1 413-772-0836
>e-mail info@gravestonestudies.org
>Web site: www.gravestonestudies.org

Cornish-American Heritage Society
CAHS publishes newsletters, supports scholarship funds and hosts the biennial "Gathering of Cornish Cousins" in North America
>Web site: www.cousinjack.org

National Welsh-American Foundation
>143 Sunny Hillside Road, Benton, Pennsylvania 17814-7822 USA
>Telephone: +1 570-925-NWAF
>E-mail: NWAF@dfnow.com
>Web site: www.wales-usa.org

North American Association for the Study of Welsh Culture and History (NAASWCH)
This multidisciplinary association of scholars, teachers, and individuals advances and supports Welsh studies and Welsh-American culture.
>E-mail: ellis@umflint.edu
>Web site: spruce.flint.umich.edu/~ellisjs/naaswch.html

Penmorfa
Three of Dave Sallery's 13 Web sites are about slate in North Wales.
>E-mail: David@penmorfa.com
>Web site: http://www.penmorfa.com/

Pennsylvania Cornwall Association (Penkernewek)
Penkernewek serves to preserve Cornish heritage and culture.
>Penkernewek, 301 W. Pennsylvania Ave., PenArgyl, PA 18072
>E-mail: President Albert Jenkins at penanvre@netcarrier.com
>Web site: www.pacornish.org

Slated for Preservation
This comprehensive site about slate was developed by Prof. Philip Cryan Marshall of the Center for Historic Preservation and Allison Brooks Collins at Roger Williams University in Bristol, Rhode Island. Although it no long is hosted by the University, information is still available at Marshall's site.
 Web site: philipcmarshall.net/PublicationsNPS_Roofing_Conference_1999.htm

Welsh-American Genealogical Society
 c/o 60 Norton Avenue, Poultney, Vermont 05764-1029 USA
 e-mail: rootsweb.com/~vtwags/

Selected Bibliography

Books

Allport, Susan. *Sermons in Stone: The Stone Walls of New England and New York.* New York: W.W. Norton & Company, 1990.

Apostolos-Cappadona, Diane and Bruce Altshuler, editors. *Isamu Noguchi: Essays and Conversations.* New York: Harry N. Abrams, Inc., 1994.

Barbara Hepworth. Gimpel Gallery, April – May 1969. New York: Gimpel & Weitzenhoffer Ltd., 1969.

Barbara Hepworth: A Pictorial Autobiography. Tate Gallery Publications, London, 1985.

Barbara Hepworth: Sculptures from the Estate. Essay by Alan G. Wilkinson Oct. 8-Nov. 16, 1996. New York: Pace Wildenstein, 1996.

Beardsley, John. *Earthworks and Beyond*, 3rd Edition. New York: Abbeville Press, 1998.

Bidgood, Ruth. *The Given Time.* Swansea, Wales: Christopher Davies Publishers, 1972.

Bizley, A.C. (Alice C. Butler) R.M.S. *The Slate Figures of Cornwall.* Perramporth, England: Worden Printers Marazion & Penzance, 1965.

Bowles, Oliver. *The Stone Industries: Dimension stone, crushed stone, geology, technology, distribution.* London: McGraw-Hill Book Company, Inc, 1934.

Bowness, Alan, editor. *The Sculpture of Barbara Hepworth 1960–1969.* New York: Praeger Publishers, 1971.

Burgess, Frederick. *English Churchyard Memorials.* London: SPCK, 1979. (first published in 1963 by Lutterworth Press.)

Buruma, Ian and Bonnie Rychlak. *Noguchi Y La Figura/Noguchi and the Figure.* Monterrey: Museo de Arte Contemporáneo de Monterrey, 1999.

Causey, Andrew. *Sculpture Since 1945: Oxford History of Art.* New York: Oxford University Press, 1998.

Chilvers, Ian and Harold Osborne, editors. *The Oxford Dictionary of Art.* New York: Oxford University Press, 1988 and new edition, 1997.

Crossley, Harold. *Lettering in Stone.* Upton-upon Severn, Worcester: The Self Publishing Association Ltd, 1991.

Curtis, Penelope. *Barbara Hepworth.* St.Ives, Cornwall: Tate Gallery Publishing, 1998.

Curtis, Penelope and Alan G. Wilkinson. *Barbara Hepworth: A Retrospective.* Liverpool: Tate Gallery Publication, 1994.

Davies, Diana, editor. *Harrap's Illustrated Dictionary of Art and Artists.* London: Harrap Books Limited, 1990.

Dictionary of Twentieth-Century Art. New York: Phaidon, 1973.

Deetz, James. *In Small Things Forgotten: The Archaeology of Early American Life.* New York: Anchor Books, 1977.

Dietrich, R.V. *Stones: Their Collection, Identification, and Uses.* San Francisco: W.H. Freeman and Company, 1980.

Eliscu, Frank. *Slate and Soft Stone Sculpture.* New York: Chilton Book Company, 1972.

Farber, Daniel. *Reflections on a Trail Taken: The Photographs of Daniel Farber*. Boston: David R. Godine, 1991.

Finn, David. *How to Look at Sculpture*. New York: Harry N. Abrams, Inc., 1989.

Forbes, Harriette Merrifield. *Gravestones of Early New England And the Men who made them 1653–1800*. Boston: Houghton Mifflin Company, 1927; revised by the Center for Thanatology Research and Education, Inc., 1989.

Fuchs, R.H. *Richard Long*. New York: Thames & Hudson, 1986.

Gillon, Edmund Vincent, Jr. *Early New England Gravestone Rubbings*. New York: Dover Publications, Inc., 1966.

Goldsworthy, Andy. *Andy Goldsworthy: A Collaboration with Nature*. New York: Henry N. Abrams, 1990.

Goldsworthy, Andy. *Hand to Earth: Andy Goldsworthy Sculpture 1976–1990*. New York: Henry N. Abrams, 1993.

Goldsworthy, Andy. *Rain Sun Snow Hail Mist Calm*. The Henry Moore Institute, 1985.

Goldsworthy, Andy. *Stone*. New York: Henry N. Abrams, 1994.

Goldsworthy, Andy. *Time*. London: Thames and Hudson, Ltd., 2000.

Goldsworthy, Andy and David Craig. *Arch*. New York: Harry N. Abrams, Inc., 1999.

Graham, Judith, editor. *1995 Current Biography Yearbook*. New York: H.W. Wilson Co., 1995.

Hammacher, A.M. *Barbara Hepworth*, revised edition. London: Thames and Hudson, 1968 (translated from Dutch by James Brockway).

Hilton, Tim. *The Sculpture of Phillip King*. London: Lund Humphreys Pub Ltd., 1992.

Isamu Noguchi, A Sculptor's World. New York: Harper Row, 1968.

Jenkins, Joseph. *The Slate Roof Bible: Everything You Wanted to Know About Slate Roofs Including How to Keep Them Alive for Centuries*. Grove City, Pennsylvania: Jenkins Publishing, 1997.

Kindersley, David and Lida Lopes Cardozo. *Letters Slate Cut: Workshop practice and the making of letters*. New York: Taplinger Publishing Company, 1981.

Kudielka, Robert and Lynne Cooke. *Phillip King*. Hayward Gallery, London: Arts Council of Great Britain, 1981.

Lawton, Rebecca, Diana Lawton, and Susan Panttaja. *Discover Nature in the Rocks: Things to Know and Things to Do*. Mechanicsburg, Pennsylvania: Stackpole Books, 1997.

Liebson, Milt. *Direct Stone Sculpture*. West Chester, PA: Schiffer Publishing Ltd, 1991.

Long, Richard. *A Hundred Stones: One Mile Between First and Last*. Cornwall: Kunstahalle Berne, 1977.

Long, Richard, *Mirage*. London: Phaidon Press Limited, 1998.

Long, Richard. *Richard Long: Walking in Circles*. New York: George Braziller, 1991.

Lord, Peter. *Gwenllian: Essays on Visual Culture*. Llandysul, Ceredigion, Wales: Gomer, 1994.

Lord, Peter. *The Visual Culture of Wales: Imagining the Nation*. Cardiff: University of Wales Press, 2000.

Lord, Peter. *The Visual Culture of Wales: Industrial Society*. Cardiff: University of Wales Press, 1998.

Lippard, Lucy R. *Overlay: Contemporary Art and The Art of Prehistory*. New York: The New Press, 1983.

Lucie-Smith, Edward. *Art of the 1930's: The Age of Anxiety*. New York: Rizzoli, 1985.

Lucie-Smith, Edward. *The Thames and Hudson Dictionary of Art Terms*. London: Thames and Hudson Ltd., 1984.

Ludwig, Allan I. *Graven Images: New England Stonecarving and its Symbols, 1650–1815*. Middletown, CT: Wesleyan University Press, 1966.

Marks, Claude. *World Artists 1950–1980*. New York: The H.W. Wilson Company, 1984.

Meilach, Dona Z. *Contemporary Stone Sculpture*. New York: Crown Publishers, 1970.

Napier, Jean. *Rhosydd: A Personal View (Golwg Bersonol)*. Carreg Gwalch: Dyffryn Conwy, Wales, 1999.

Noguchi, Isamu. *A Sculptor's World*. New York: Harper Row, 1968.

Norwich, John Julius, editor. *The Oxford Illustrated Encyclopedia of the Arts*. New York: Oxford University Press, 1990.

Osborne, Harold, editor. *The Oxford Companion to Twentieth-Century Art*. New York: Oxford University Press, 1988.

Papadakis, Dr. Andreas C., editor. *Sculpture Today*. London, 1987.

Reed, David. *The Art and Craft of Stonescaping: Setting and Stacking Stone*. Asheville, North Carolina: Lark Books, 1998.

Reed, Jeanne Brown, Althea Haggstrom French, and Elizabeth Emanuelson Davis. *Monson, Maine History 1822–1972*. Monson, 1972.

Richards, Alun John. *Slate Quarrying in Wales*. Pwllheli, Gwynedd, Wales: Gwasg Carreg Gwalch, 1995.

Roberts, Gwilym. *New Lives in the Valley: Slate Quarries and Quarry Villages in North Wales, New York, and Vermont, 1850–1920*. Somersworth, New Hampshire, 1998.

Tiley, Roger. *Grazing Slateland: The North Wales Slate Landscape*. Powys, Wales: Incline Publications, 1994.

The 20th-Century Art Book. London: Phaidon Press Limited, 1999.

Vison, James, editor. *International Dictionary of Art and Artists: Artists*. Chicago: St. James Press, 1990.

Pamphlets/Abstracts

An Artist in the Quarries: An exhibition of drawings by Miss M.E. Thompson (1896–1981) – the life, work and landscape of the North Wales Quarries; Welsh Arts Council, 9 Museum Place, Cardiff, 1981.

Baker, F. Joanne and Daniel Farber. "Recording Cemetery Data." *Markers I: The Journal of the Association for Gravestone Studies*, 1980. Reprinted by University Press of America, 1988.

Bowcott, Howard. *At the Edge of the Slate Tip: Blaenau Ffestiniog*. Blaenau Ffestiniog: limited edition, 1986.

Burgess, Frederick. *Tombstone lettering on slate*. Unattributed Pamphlet.

Caffell, Gwenno. *The Carved Slates of Dyffryn Ogwen*. Cardiff: National Museum of Wales, 1983.

Celeste Roberge. NationsBank, Tampa, Florida, and The Florida Center for Contemporary Art with Tampa Bay Business Committee for the Arts, September 23–November 22, 1996.

Chettle, Steve. "Andy Goldsworthy: 'Sheepfolds' the Cumbrian context." *Jack's Fold*. 1996.

Delta's Slate Clock. Old Line Museum, Delta, Pennsylvania.

Delta-Coulsontown: An Architectural Perspective, A Walking Tour. Compiled by York County Planning Commission in cooperation with Historic York, Inc., 1981.

Eisenberg, H.O. "The Story of Slate." *Slate Centennial*. Pennsylvania, 13–33.

Gale, Matthew. *Catalogue Entry for T00703, Two Figures (Menhirs) 1964*. Tate Gallery, 1998.

Grasby, Richard. *The Story of Handwriting*. New York: Pentalic Corporation, 1978.

Gregory, Murray R. *Barbara Hepworth's Missing "Leaf."* In Wallace, C. Programme and Abstracts. Annual Conference Geological Society of New Zealand, Massey University, Palmerston North, 29 November – 1 December 1999. Geological Society of New Zealand Miscellaneous Publication 107A. p. 53.

Jones, Ivor Wynne. *America's Welsh Slatemen*. Llechwedd Slate Caverns, Blaenau Ffestiniog, Gwynedd.

Kelly, Susan H. and Anne C. Williams. *A Grave Business: New England Gravestone Rubbings, A Selection*. New Haven, Connecticut: the S.Z. Field Co., 1979.

Kindersley, Lida Lopes Cardozo. *The Cardozo Kindersley Workshop: A Guide to Commissioning Work*. Cambridge: The Cardozo Kindersley Workshop, 1999.

Kindersley, Richard. *Millennium Stones*. Wolseley Fine Arts, London, 2000.

Mack Winholtz: Classical Abstract Sculpture. Taos, New Mexico: Lumina Contemporary Fine Art, Photography, Sculpture.

The Mind is a Muscle: Two Installations by Ronald Leax and Celeste Roberge. The Farnsworth Art Museum. Rockland, Maine: March 7–April 25, 1993.

Morrow, John A. *A Century of Hard Rock: the story of Rising and Nelson Slate Company, 1970*.

Moore, Steven A. "The Matter of Stacks." *Stacks: Sculpture by Celeste Roberge*. El Paso, Texas: Adair Margo Gallery, 1997.

The Old and Best Way. (Letter cutting) CM.84. Unattributed Pamphlet.

Paquet, Guy and Line Bariteau (translated by Susan Petteys). *Slate and Heritage*. Melbourne, Quebec: Centre d'interpretation de l'ardoise, 1998.

Richard Long: Fogg Art Museum April 17 – June 1, 1980. Cambridge, MA: catalog.

Severns, Martha R. *Perspectives: Celeste Roberge*. Portland Museum of Art, August 10–October 8, 1989.

Slate: A Welsh Arts council photographic exhibition in cooperation with Ilford Ltd. Cardiff: Welsh Arts Council, 1974.

Slate Mining in Corris and Aberllefenni. Wales.

The Story of a Slate Fan. Inigo Jones Slate Works, Groeslon, North Wales.

Stilp, David. "Wisconsin Slate." *Central States Archaeological Journal*, 2001. Vol. 48, No. 1: 34–37.

Viera, Ricardo. *Barbara Kulicke: Homage to a Square from the Slate Belt, Installation.* Wilson Gallery, Lehigh University, September 6-October 17, 1996.

Williams, Merfyn. *The Slate Industry.* Buckinghamshire: Shire Publications Ltd., 1998.

Periodicals

Adams, Hugh. "The Woodsman." *Art and Artists* (April 1979): 44–47.

Alloy, Jan Leibovitz. "Photographs of a Vibrant Past." *Stone in America* (August 1998, volume 111, number 8): 12–15.

Belanus, Betty J. "Along Vermont's Western Border Look Up To Slate For a Legacy of Beauty." *Vermont Life* (summer, 1982): 12–15.

Bell, Tiffany. "Merrill Wagner." *Arts Magazine* (May, 1986): 100.

Campbell, Robert. "Harvard's Fancy New Hat." *Preservation: The Magazine of the National Trust for Historic Preservation* (Volume 52, Number 3 (May-June, 2000): 60–64.

Coast Lines & Countryside News. (Bodmin, Cornwall: North Cornwall Heritage Coast and Countryside Service, 1999). Includes several articles.

"Daniel Farber obituary." *Maine Antique Digest* (December, 1998): 6-A.

"Down to Earth." *The Boston Globe* (May 8, 1997): F1, F 4–5.

Dutton, Valerie. "Valerie Dutton discovers that Slate has more artistic uses than simply tiling roofs." *Popular Crafts* (October, 1990): 37–38.

Duval, Francis Y. and Ivan B. Rigby. "Early American Gravestones: The Iconography of Mortality. A photo-essay." *Lithopinion* 39 (Fall 1975, vol. 10, #3, issue 39).

Griffiths, John. "International Sculpture Since 1945," *Sculpture Today*, ed Dr. Andreas C. Papadakis (London: Art & Design, 1987).

Harding, Anne. "Carving his niche." *The Boston Globe* (March 30, 1997): C1, C2.

Jones, Sarah-Jane. "Castle plaque will mark site of first National Eisteddfod." *Tivy-Side Advertiser* (October 8, 1993): 10.

Kangas, Matthew. "Visual Arts: Time travelers." *The Weekly* (November 18–24, 1987).

Kelly, Marynell. "Flowing images: Barbara Kulicke continues to draw inspiration from Delaware Water Gap." *The Express-Times* (May 28, 1999): 8–9.

Levine, Jeffrey S. "Slate Pretenders." *The Old House Journal* (November/December 1998): 58–59.

"Northern Archives: Celeste Roberge's Earthy Humanism." *AM: Artists in Maine* (Portland, Winter 1987–88): 14–18.

Orem, Maria. "Old Line Museum timepiece hand-carved in Gothic style." *Aegis* (Harford County, Maryland; November 15, 1995).

Power, Susan. "Pre-Contact Southeast Shell Gorgets." *Ornament: The Art of Personal Adornment* (Mount Morris, Illinois, Winter 2000, Vol. 24, No. 2): 24–29.

"Queen of the Quarry." *Liverpool Daily Post* (March 6, 1995).

Roy, Pierrette. "Enrichie et inspiree." *La Tribune* (24 mai, 1997; Sherbrooke, Canada): F. 2, 3.

Schiff, Gert. "Museum Visit: Contemplation in Queens." *Contemporanea.* (New York): 83–86.

"Sculptor (Ivor Richards) carves powerful and poetic images into slate." *The Western Mail* (October 20, 1998).

Skidmore, Ian. "Slate with imagination." *Daily Post* (October 9, 1998).

Starrett, Peter. "Slate Carvers: Quarry Workers Show Rare Skill." *Portland Telegram* (Maine; May 9, 1954)

Tracy, Robert. "Artist's Dialogue: Isamu Noguchi: Metaphors for the World." *Architectural Digest.* (October 1987): 72, 76, 81, 83, 86.

Tuchman, Phyllis. "Noguchi's Nirvana." *Daily News* (New York: April 18, 1999).

Updike, Robin. "Sharon Boardway: Moments in Time." *The Art of Personal Adornment: Ornament*, Vol. 23 No. 3 (Spring 2000): 52–55.

Westfall, Stephen. "Merrill Wagner/Peter Brown." *Arts Magazine*, (March 1983): 37.

Index

Titles of art works and black and white images are in *italic type*. Color plates are ***bolded italic***.

2719 Pacific (Oshidari), 42

A

Abbot Hall, 93
Aberllefeni, 18
Aberystwyth, v, xv, 59
Absence (Ritz), 129
Abstract brooch (Desrochers), 49
Acton Vale, 19
Albers, Joseph, 63
Alms box, 11
Alphabet (Kindersley), 41
Alphabet box (Cardozo Kindersley), 44
Altarnun, 38
American Antiquarian Society, 35, 36
Angel blowing horn, xiii
Angers, xv, 50
Appalachian, xv, 10
Arch (Goldsworthy), 92
Arkansas, 19
Arlington National Cemetery, 27
Arvonia, 30, 31
Association for Gravestone Studies, xv, 37, 156
Australia, 10, 31, 94

B

Bain, George, 70
Balanced Slate (Goldsworthy), 93
Ball, Michael, 20
Banas, Norma, 68
Bangor Museum and Art Gallery, 14
Bangor, Penn. 28, 32, 141, 155
Bangor, Wales 13, 14, 117, 119, 141
Barbara Hepworth Museum & Sculpture Garden, 82
Barrow, 94, 134, 141
Bas-relief, 6, 15, 67-69, 73, 74, 141
Bauhaus School, 63
Beach, Reg, 69-71, 73, 145
Beeswax, 10, 18, 53, 67, 70, 71, 72
Belize, 67
Benson, Esther Fisher, 45
Benson, John "Fud," 27, 44-46, 145
Benson, John Howard, 44-45, 145
Benson, Nicholas, 45, 145
Berkeley, 131
Bethesda, 13, 18, 53, 76, 122, 123, 124, 125, 141, 143
Bezel, 51, 52, 141
Bhutan, 67
Bidgood, Ruth, 138-139
Biomorphic, 83, 141
Bird Flight (Hepworth), 80, 81
Bizley, Alice C., 38
Blackboard, 1, 6, 9, 19, 28, 55, 64, 65, 66, 67, 73, 134, 136, 140, 143
Blaenau Ffestiniog, 5, 13, 16, 18, 92, 101, 102, 119, 121, 125, 138, 141, 153
Blairstown, 62
Blanchard, 25
Blue Boy comb-rack (Ealey), 29
Blue Mountains, 28
Boardway, Sharon, 54-56, 136, 145
Bogg Farm, 94
Borrowdale, 93, 153
Boston, xv, 33, 34, 35, 36, 37, 42, 44
Botsford, Don, 21-24, 27
Bowcott, Howard, 101-104, 123, 133, 134, 135, 136, 145
Bowness, Alan, 79
Braintree, 35
Brancusi, Constantin, 83
Brazil, 10, 131
Bridge, Ebenezer (gravestone), 36
Bristol, 113, 118, 147, 149, 156
Brooch (Koons), plate 7, 50
Brooch of Cumbrian slate (Fletcher), 49
Brooch with rutilated quartz (Koons), 51
Brooches (Desrochers), 50

Brown, Guy, 25
Brownville, 25
Brussels, 94, 107, 108
Buckingham, 31, 45, 94
Bunyard, Frances "Frankie," 42, 43
Burgess, Frederick, 38, 40, 42
Burlington Quarry, 48
Burnard, Neville Northey, 38

C
Caernarfon, 14, 20, 59
Caersalem (Williams), 43
Caffell, Gwenno, 14
Cairn, 89, 93, 94, 99, 101, 134, 141
Caldicot Cross (Bowcott), 102
California, 32, 69, 130, 131
Calligraphy, xi, 39, 40, 45, 46, 141, 145, 150
Cambrian, 2, 13, 18, 141
Cambridge Rock (Roberge), 99
Can Y Graig – Slate Voices (Menter), 119, 120
Canada, xiv, xv, 5, 10, 19, 25, 31, 47, 71, 105, 152
Capel Rhiw, 18
Capozzolo Brothers, 32
Carborundum, 24, 141
Cardiff, 10, 14
Cardozo Kindersley Workshop, 41, 42, 44, 82, 147
Carlson, Emil, 6, 26-27
Carving (Mylor) (Hepworth), 80
Casson, Lucy, 119
Cat's Cradle (Wagner), 66
Caulfield, Ernest, 37
Celtic crosses (Humphreys), 54
Celtic cross, 43, 70
Celtic design, 43, 54, 70
Centre de development culturel, 92
Ceredigion Museum, 59, 152
Chapel of Art, 128
Chapman, 10, 30
Chapman house, 10
Charlestown Carver, 34
Chelmsford, xv, 4, 43
Chess tabletop (Martins), 74

Chief Justice John Marshall (Eliscu), 69
China, 76, 121, 131
Chisel, xvi, 9, 13, 16, 30, 34, 40, 41, 42, 43, 44, 45, 58, 68, 69, 70, 71, 73, 74, 77, 81, 111
Choeur de Chene (Menter), 120
Church, Frederic, 50
Circular brooch (Koons), 52
Cistercian Abbey, xvi
City Museum and Art Gallery, 113
Cleavage, 1, 4, 9, 16, 17, 67, 141
Cobalt 10 (Wagner), 64
Concentric circles, 13, 14, 17, 32, 47, 113, 135
Conceptual Art, 112, 141
Conical form (Goldsworthy), 94
Continuance (Levesque), 97
Conwy Castle, 4
Coping saw, 23, 27, 141
Core, 82, 94, 97, 99
Cores, 7, 17, 60, 61, 66, 141
Cornish hedgerow, 12
Cornwall, xv, 10, 11, 12, 38, 39, 73, 79, 80, 83, 90, 107, 113, 114
Corris, 59, 69, 70, 111
Craft Centre Cymru, 16
Criccieth, 102, 128
Crossley, Harold, 40
Cumbria, 45, 48, 49, 91, 92, 93, 94, 103, 133, 141
Cup-and-ring marks, 13, 32, 141
Curtis, Christopher, 106-107, 110, 112, 136, 145
Curtis, Penelope, 81
Cutler, Timothy (gravestone), (Lamson), 35
Cwlhwch & Twrch Trwyth (Cwlhwch & The Wild Boar (Beach), 69

D
Dally Quarry, 29
Daniel and the Lion (Eliscu), 68
Danville Quarry, 105
Davies, Paul, 76

De Cacqueray, Janine, 32
Del Piombo, Sabastiano, xv, 66
Delabole Quarry, 11, 12, 27, 73, 74, 80, 81, 82, 83, 109, 110, 113, 115, 141
Delabole Quarry, 12
Delabole Slate Circle (Long), 113
Delaware Water Gap, Four Variations (Kulicke), 63, 64, 136
Delta, 28, 30, 134
Derelict Liverpool Warehouses (Monti), 59
Desrochers, Louise, 49, 50, 52, 56, 105, 107, 110, 111, 136, 146
Devon, 73
Devonian, 2, 12, 31, 141
Diamond saw, 5, 16, 22, 48, 53, 55, 60, 71, 72, 84, 86
Dinosaur (Roberts), 15, 16, 21
Direct carving, 41, 43, 141
Disney, Barbara, 119
Divergence III (Winholtz), 85, 86
Dolmen, 100, 134, 142
Doney Quarry, 28, 62
Doorstop (Rice), 13
Doorway view of abandoned quarry buildings (Napier), 121
Dove of Peace (Beach), 70
Drill, 2, 9, 23, 24, 51, 70, 74, 98, 108, 111, 128
Dry wall, 89, 90, 104, 142
Dublin, 108, 109
Dumfriesshire, 93, 94
Dumps, 3, 6, 22, 28, 49, 52, 62, 142
Dyffryn Nantlle, 17, 18

E
Eagle Man: Welsh Legend (Beach), 70
Ealey, Roy and Robert, 29
Earrings, 29, 48, 49, 53, 54, 55
Earth Art, 142, 146
Eastern Townships, 31, 50, 71
Ecce Homo (Titian), xv, 57
Effigy, 35, 36, 69, 84

Eisteddfod, 59, 142
Elevated Bowl (Rice), color plate 4, 17
Eliscu, Frank, 67-69, 71, 73, 75, 146
Emergence (Swann), 128
Emery, 24, 42, 68, 142
Enameled slate, xi, 59, 142
Enamelled Slate Chimney-pieces, 59
England, 4, 11, 19, 31, 33, 38, 40, 41, 48, 101, 113, 115
Engraving, 19, 24, 58, 59, 73, 107, 108, 109, 110, 116, 142
Epoque/In olden days (Laliberté), 72
Epoxy, 31, 48, 49, 52, 90, 97, 104, 142
Espoir de quartz/The hope of quartz (Laliberté), 72
Essence (Winholtz), 85
Etched items (George), 31
Etched slate, 25, 30, 31, 60, 80, 129, 136, 142
Etifeddiaeth I/Legacy I (Richards), 77
Evans, John Benjamin, 15, 20, 21

F
Fair Haven, 20
Falling Water Resonating Device (Menter), 121
Fan, 14, 15, 21, 72, 119
Farber, Daniel, 36-38, 137, 145, 146
Farber, Jessie Lie, 36, 37, 38
Farmyard scene (Martins), 74, 75
Fausett, Dean, 21
Ffestiniog, 2, 14, 17, 18, 92, 101
Firewood Woman (Gordon), color plate 9, 58
Fisherman at his nets (Martins), 73
Flagstone, 1, 6, 9, 19, 25, 65, 89, 92, 94, 112
Fletcher, John, 48-49, 52, 134
Flourish ABC (Cardozo

Kindersley), 42
Flower Sellers (Gordon), 58
Folded Wing Puzzle (Wagner), 65
Folk art, xi, 6, 7, 10, 14, 17, 33, 37, 38
Forbes, Esther, 34
Forbes, Harriet Merrifield, 33, 34, 35, 37, 38
Forefathers Burying Ground, xv
Fossil, 31, 54, 81, 82, 99, 100, 101, 103, 131, 137
Found material (object), 49, 50, 105, 107, 111, 142
Four-Square (Four Circles) (Hepworth), 80, 81
Four-Square (Walk Through) (Hepworth), 81
France, 4, 5, 31, 50, 92, 120, 121
Fretsaw, 54, 142

G
Gabel, Laurel, 34, 35, 37
Genius is... (Oshidari), 44
Geological Periods, 2
George, Joe, 30, 31, 73
Germany, 31, 63
Getty Museum, xv
Gilbert, H.C., 80
Gilbert, John F., 29
Gill, Eric, 41, 45, 147
Gloddfa Ganol Slate Mine, 5, 153
Goldsworthy, Andy, 53, 89, 91-95, 99, 101, 103, 134, 136, 138, 146
Goldthwaite, Elizabeth (gravestone), (New), 36
Good Day (Swenson), 39
Gordon, Brian, 57-59, 66, 136, 147
Gorget, 47-48, 142
Gorget (Native American), 47
Granville, 11, 19, 20, 21, 24, 50, 99, 100, 142
Gravestone, xi, xv, 1, 4, 25, 33, 34, 35, 36, 37, 38, 40, 44, 67, 76, 77, 82, 83, 101, 122, 123, 136, 137, 139, 156 (see also Tombstone)
Gray Squirrel (Taylor), 61
Graywacke, xv
Green Mountain College, 15, 20
Gregory (Effigy) (Noguchi), 68, 84
Gregory, Murray R., 82
Griffiths, Bob, 102
Groton, xv
Growing Wisdom Plaque Four Seasons (Swenson), 40
Guardians (Desrochers), 105
Guggenheim Museum, Solomon R., xv, 113

H
Hacksaw, 30, 68, 82, 142
Hampton, 19
Hanger, Ryland, 19
Harvard University, 9
Hawkins, Henry, 13, 117
Hayward Gallery, 116
Hazell, Andy, 119
Hearth (Roberge), 101, 137
Hebron, 19
Hebron Pond, Monson (Steward), 57
Hebron Pond Quarry, 25
Hedgehog with Berries (Taylor), 61
Hedgerows, 12
Hepworth gravestone (Kindersley), 82
Hepworth, Barbara, 79-83, 84, 85, 89, 97, 99, 111, 134, 147
Heron, Susanna, 107-110, 135, 147
Herring Island Cairn (Goldsworthy), 93
Highgrove, 90
Homage to a Square from the Slate Belt (Kulicke), color plate 11, 62, 63
Homage to the Square (Albers), 63
Horses (Eliscu), 68, 69
Hound dogs (Botsford), 22
Houston, Lurene Carlson, 26, 27
Humphreys, Sara, 1, 52-54, 56, 134
Humpty Dumpty (Noguchi), 67, 82, 84
Hunsrück, 31

I

Ikon (Black Ikon) (Noguchi), 84
Inigo Jones Company, 59, 70, 153
Inkstand (Evans), 20
Into the Mountain (Bowcott), 103, 104
Ireland, 31, 50, 108
Island (detail) (Heron), color plate 14, 109
Italy, 10, 31, 45, 79, 153

J

James, Gordon, 25
Jeweler's saw, 54, 142
Johnston, Edward, 41
Jones, R. Merfyn, 124
Jones, Sianed, 119
Jones, William Griffith, 25
Jumping Jack (Carlson), 6, 26

K

Kansas, 50, 51, 52, 85
Kennedy, John F., 27, 145
Kindersley, David, 41, 42, 43, 82, 83, 147
Kindersley, Lida Lopes Cardozo, 41, 44, 45, 147
Kindersley, Richard, 41, 42, 147
King, Phillip, 110-112, 114, 136, 148
Kingsey Quarry, 105
Koons, Susan Ringer, 50-52, 148
Kulicke, Barbara, 62-64, 65, 66, 136, 148

L

La descente aux enfers/The fall into hell (Laliberté), 71
Lake District, 30, 48, 90, 153
Laliberté, Edmond, 71-72, 73, 76, 77, 82, 135
Lamp (Brown & James), 25
Lamson, Joseph (Caleb, Nathaniel), 34, 35, 36
Land Art, 77, 78, 94, 95, 112-114, 138, 141, 143, 144

Land Readings (Bowcott), 103, 133
Laval, 71
Leaf bracelet (Boardway), color plate 8, 54
Lehigh-Northampton Counties, 27
Letterforms, 41, 44, 45, 142
Lettering Arts Guild of Boston, 42
Levesque, Julie, 95-99, 103, 136, 148
Levy, Martha, 21
Lewis, David, 16
Library of Congress, 37, 131
Lie, Henry, 37
Little Slate (Noguchi), 84
Liverpool, 57, 58, 59
Llainfadyn, 10
Llanalenchyd, 52
Llanbadarn Church (Worthington), color plate 10, 59
Llanberis, 4, 13, 15, 18, 52, 77, 102, 117, 118, 119, 123, 125, 135, 142, 155
Llanrug, 52
Llechen, 119, 142
Llechiphone, 118, 119, 120
Llechwedd Slate Mine, 3, 119, 153
London, 38, 81, 82, 93, 108, 110, 116, 135
Long Island City, 68, 84
Long, Richard, 100, 101, 102, 112-116, 136, 138, 148
Lowell, xv
Ludwig, Allan I., 34, 35, 36
Lyric (Winholtz), 85, 151

M

Madrid, xv, 64
Maine, xii, xiv, xv, 6, 22, 25-27, 45, 57, 95, 99, 101, 106. 143
Mallet, xvi, 9, 34, 40, 42, 43, 74, 81, 142
Manchester, 57, 101
Mantel, 9, 14, 19, 27, 28, 59, 135
Map of UK, 11
Map of US & Canada, xiv
Maquette, 80, 81, 97, 142

Marbleize, xi, 9, 19, 20, 21, 27, 59, 143
Marbleized pulpit, 19
Marbleized tiles (Ball), 20
Mare and Foal (Eliscu), 68
Mariposa quarry, 32
Martins, Jim, 73-74, 75
Martins, Pam, 73-74, 149
Maryland, 28
Massachusetts, xiv, xvi, 4, 21, 25, 33, 34, 35, 36, 37, 43, 97, 128, 129
Melbourne, 93
Melbourne Quarry, 71
Memorial Hall, color plate 2, 9
Men working in Slate Quarry (Levy), color plate 6, 21
Menhir, 80, 81, 82, 89, 100, 134, 143
Menter, Annie, 119
Menter, Will, 118-121, 138, 149
Metamorphic, 1, 2, 89, 94, 133, 137
Metamorphosis (Koons), 51
Middle Granville, 19, 22, 113, 114
Mid-Wales (Bidgood), 138
Milford Haven, 69
Mill (milled product), 3, 5, 6, 19, 22, 26, 27, 67, 86, 89, 107, 111, 112, 116, 130, 134, 136, 143
Mind's Eye (Richards), 77
Miniatures, 60-62, 66
Minimal art, 141, 143
Missouri, 85, 86, 129
Mitchell, Denis, 80
Moelwyn Mountains, 121
Monmouth County, 102
Monoprint, 64
Monson, xiii, 6, 25, 26, 27, 45, 57, 101, 106, 143
Monson 1 (Curtis), 106
Monti, Rebecca, 59
Montreal, xv, 32, 71, 72
Moore, Henry, 80
Moss slate, 4
Moule, Ros, 124
Mt. Bethel, 29
Mudstone, 1, 16

Mumford, William, 34, 44
Museum of American Folk Art, 37
Museum of Fine Arts, xv, 37
Museum of Scotland, 136
Museum of Welsh Life, 10, 11, 14
Mycerinus and His Queen, xv
Mythical Bird (Beach), 70

N
Naïve art, 57, 143
Nant Dwr-oer, Blaenau Ffestiniog (Tiley), 125
Nantlle Valley, 17, 18, 35, 125
Nantucket Whalers (Beach), 69
Napier, Jean, 3, 121-123, 124, 137, 138, 149
Nash, David, 18, 92, 146
National Gallery of Art, xv, 13, 94, 113
National Library of Wales, xv
National Museum of Wales, 14, 60, 117
National Sculpture Society, 67
Native American on horseback (Botsford), 24
Native Americans plaque (Shuval), 131
Negative space, 44, 70, 87, 143
Nepal, 121
Nesting Canadian geese (Botsford), 23
New England, 34, 36, 37, 38, 45, 86, 100
New Jersey, 27, 62, 63
New Rockland Slate Company, 71, 105
New York, xv, 9, 11, 18, 19, 21, 22, 27, 37, 39, 50, 63, 64, 68, 69, 79, 82, 83, 84, 99, 101, 107, 113
New York City, 37, 63, 64, 69, 82, 113
New York School, 83
New, James, 36
Newfoundland, 31, 99
Newlyn Art Gallery, 107
Newport, Pembrokeshire, 69

Newport, Rhode Island, 27, 44
Noguchi, Isamu, 67, 68, 79, 82-84, 85, 87, 105, 111, 112, 120, 134, 135, 140, 149
Nolay, 120, 121
North Wales, xv, 1, 3, 4, 5, 11, 13, 15, 18, 20, 52, 59, 60, 70, 76, 91, 101, 102, 117, 118, 119, 121, 124, 127, 136
Nova Scotia, 34, 36

O

Octagon Bowl (Rice), 16
Off-cuts, 6, 54, 70, 89, 111, 113, 114, 136, 143
Ogwen Valley, 13
Olana, 50
Old Boys of Rhosydd (Owen), 121, 123
Old Line Museum, 30, 134, 154
Old 'megryn' wheels underground (Napier), 122
Old Stone Cutter, 34
Onassis, Jacqueline Kennedy, 27, 145
Open Place (King), 111, 112
Opposing leaf necklace (Boardway), 56
Ordovician, 2, 18, 103, 143
Ordovician Pyramid (Bowcott), 103
Ordovician Spiral (Bowcott), 103
Ornamental slate fish, 10
Ornamental shelf (Carlson), 27
Oshidari, Houmann, 42, 43, 44
Out of the Woods (Levesque), 97
Owen, Richard, 122, 123
Ozark Mountain characters (Botsford), 22, 23

P

Padstow, 39
Park family, xiv
Passage II (Winholtz), 86, 87
Pasty board, 12
Peach Bottom, 28, 30, 143
Pembrokeshire, 69
Pen Argyl, 28, 29, 143
Pendant (Native American), 47
Pennsylvania, xv, 10, 12, 22, 27-29, 30, 32, 47, 62, 86, 134
Penrhyn Quarry, 13, 76, 117, 124, 125, 143
Penrhyn Quarry in 1832 (Hawkins), color plate 3, 13, 17
Penrhyn Quarry, Bethesda (Tiley), 124
Performance Art, 121
Petroglyphs, 89, 99, 134, 143
Photography, 34, 36-38, 93, 94, 95, 101, 108, 116, 120, 121-126, 129-131, 132, 137, 138, 146, 169, 151
Pictish, 32, 136
Piercy, Rob, 117, 149
Pin and feathering, 82
Pin Hill Quarry, 33
Pine Tree (Smith), 90, 91
Piscataquis County, 25
Pistyll Rhaeadr (Taylor), 60
Pit, 11, 25, 27, 28, 62, 63
Polygram, 11
Pondering (Curtis), plate 13, 106, 107
Pont Cyfyng, near Capel Curig (Tiley), 126, 127
Porthmadog, 13, 127
Portland Museum of Art, 99
Portrait, xv, 36, 67, 69, 83
Poultney, 9, 19, 20, 21, 22
Poultney Church, 9
Pouncing, 43
Prado Museum, xv, 64
Preseli Hills, 13
Pritchard, Humphrey, 30, 134
Pwllheli, 15, 16, 21

Q

Quarry, xii-xv, 2-6, 9-14, 16-19, 21, 22, 25, 25, 28-33, 40, 45, 47-50, 52, 62, 63, 67, 70, 71, 73, 76, 80, 85, 86, 90-92, 94, 100-102, 105-107, 111, 114, 117-119, 121-127,

134, 136-138
Quarry cottages, 5
Quebec, xv, 49, 71, 153

R
Railroad, 5, 13, 50, 101, 127
Rain songs (Menter), 120
Rappaport, Suzanne, xv, 20
Rasp, 42, 68, 69, 70, 71,143
Ratuszniak, Annette, 135
Real Time (Richards), 134
Reclining Nude (Eliscu), 68
Recycle, 5, 6, 57, 66, 95, 114, 116, 136, 137
Red slate quarry, color plate 5, 19
Red Slate Ring (Long), 112
Relief, xi, 6, 15, 31, 39, 67-78, 79, 141, 143
Resist, 40, 103, 143
Rhosydd Quarry, 121-123
Rhwng y Llyaid/Between the eyes (Richards), 76
Rhyd-du, north of Beddgelert (Tiley), 126
Rice, William J., 13, 16-18, 27, 134, 149
Richards, Alun John, xi-xii, 13, 38, 155
Richards, Ivor, 75-78, 82, 91, 134, 150
Riffler, 16, 143
Ritz, M.C., 128, 129
Riven, 41, 76, 106, 108, 143
Riven Welsh Slate Standing Stone (Kindersley), 41
Roberge, Celeste, 99-101, 134, 137, 150
Roberts, Gwilym R., 19
Roberts, Morris, 15, 20
Roberts, William "Gwilym," 15-16, 21
Robins, John (gravestone), 4
Rockmen, William Owen Gallery (Thompson), 117
Ruotolo, Onorio, 83
Rutherford, Maurice, 138

Rutland County, 19
Rychlak, Bonnie, 83, 84

S
Sailing Ship, 14
Saint-Camille, 49
Salcombe, 73, 74
Sandblast, 15, 32, 39, 40, 41, 45, 55, 56, 103, 129, 133, 134, 143
Savannah, 37
Scaur Glen, 93
Schist, 1, 107
Scotland, 10, 31, 32, 89, 90, 93, 94, 99, 136
Seahorse (Martins), 73
Seahorse earrings and pendant (Humphreys), 53
Sedimentary material, 2, 99
Segmented Dish (Rice), color plate 4, 17
Serif, 41, 42, 143
Shakespeare, William, 139
Shale, 1, 33, 99, 100
Sheepfold Project (Goldsworthy), 93
Sheldon Slate Products, 19, 22, 25
Shingle, xiii-xv, 1, 2, 4-6, 9-11,19, 32, 52, 57, 58, 60, 62-67, 71, 73, 89, 92, 93, 95, 97, 98, 101, 127, 134, 136, 143
Shiva's Rings (King), 111
Shuval, Shlomo, 129-131, 137, 150
Sight Unseen (Richards), 75
Silhouettes (Carlson), 26
Silicosis, 2, 27, 54, 143
Silurian, 2, 143
Silver embellished earrings (Fletcher), 48
Slag, 143
Slate (Rutherford), 138
Slate and glass sculptures (Swann), 128
Slate Belt, 10, 18, 19, 22, 25, 28, 50, 62, 63, 71, 154
Slate Belt Museum, 29, 154
Slate Cairn (Goldsworthy), 93
Slate chain (Carlson), 26

Slate clock (Pritchard), 29
Slate fan, 15, 21, 119
Slate fan (Evans), 15
Slate fence (Napier), 3
Slate Frieze (Heron), 107, 108, 109
Slate gravestones at St. Anne's, Bethesda (Napier), 122
Slate Island, 33
Slate Islands in Scotland, 31, 154
Slate marimba (Llechiphone) (Menter), 118-120
Slate Sea (Bowcott), 102, 135, 136
Slate Stack (Roberge), 99, 100, 101, 137
Slate tabletops (Shuval), 130
Slate Valley Museum, xv, 11, 19, 20, 21, 24, 155
Slate Wedge (Bowcott), 103, 134
Slate Wing (Desrocher), 105
Sleeper (Richards), 77
Slim Forms (Hepworth), 80
Smith, Joe, 89-91, 101, 102
Smithsonian Institute, 37
Snowdonia, 52, 121, 127
Sol Owen, Mike, 16
Sonnet 55 (Shakespeare), 139
Sound of slate, xii, 77, 81, 113, 118, 119, 120, 121, 123
Sounding the Edge of the World (Menter), 121
Spaulding, Benjamin (gravestone), 43
Spiral of life, 139
Spiral Plate (Rice), 18
Splash pendant and earrings (Humphreys), 53
Spring Ellipse (Long), 115, 135
Square of slate, 62, 63, 136
Square of the Gap, Fall (Kulicke), 63
Square of the Gap, Fog (Kulicke), 63
St David's, 42
St Enodoc, 39
St Fagans, 10, 11, 14
St Ives, xv, 79, 80, 81, 82
St Kew, 39
Stack #1 (Roberge), 100
Stack #2 (Roberge), 100

Stacked Deck (Levesque), 98
Stacks (Roberge), 99, 100
Stacks for Home and Office (Roberge), 101
Standing Figures (Wagner), color plate 12, 66
Stele, 41, 129, 144
Stevens, John, 27, 44, 45
Steward, Walter L., 57, 150
Still Waiting (Levesque), 96
Stilp, David, 47
Stone (Bidgood), 139
Stone Cutter of Boston, 34
Stone Sky (Goldsworthy), 94
Strange Bird (To the Sunflower) (Unknown Bird) (Noguchi), 83, 84
Strata Florida, xvi
Struco, 129, 130
Structures at Bogg Farm (Goldsworthy), 92
Sun Pendant (Humphreys), 52
Sunburst (Humphreys), color plate 1, 1
Sunken Courtyard (Heron), 110
Swann, Bill, 87, 127-129, 150
Swenson, Tari, 39, 40, 150
Synthetic (reconstituted) slate, 5, 11

T
Tanzania, 119, 121
Tate Gallery London, xv, 81, 82, 112
Tate Gallery St Ives, xv
Tatko, Peter & John, 22, 23, 25
Taylor, Ken, 60-62, 65, 66
Terril, 71, 144
That was something in the rain woods (Boardway), 55
Thomas, Gwyn, 119, 120
Thompson, James, 32, 56, 99, 135, 136
Thompson, M.E., 117
Three Pictish designs (Thompson), 32
Three Romantic Urns (Bowcott), 102
Three Standing Forms (Hepworth), 80
Three Women Watching a Wedding (Gordon), 57
Tile, 6, 9, 11, 20, 25, 59, 60, 63, 65, 133, 144

Tiley, Roger, 124-126, 127, 137, 138, 151
Time, xiii, 2, 6, 23, 24, 31, 33, 39, 44, 60, 62, 65, 66, 89, 92, 99, 103, 104, 114, 116, 125-127, 133-139
Tips, xii, 5, 25, 52, 76, 77, 91, 102, 123, 125, 134, 136-138, 144
Tirlun Cymraeg/Welsh landscape (Swann), color plate 15, 127
Titian, Tiziano Vecellio, xv, 57, 64, 66
Tombstone, xv, 1, 6, 15, 28, 36, 37, 123, 129, 135 (see also gravestone)
Tooby, Michael, xv, 82, 113
Transportation of slate, 4, 5, 13, 33, 34, 66, 84, 111, 127, 130
Trevone Bay, 12
Trinity (Noguchi), 84
Trompe l'oeil, 75-78, 144
Tudor Slate Works, 59
Tungsten, 16, 42, 43, 45, 74, 77
Turn About (Levesque), 95
Two Figures (Menhirs) (Hepworth), 79, 81, 82
Two Forms (Apolima) (Hepworth), 80, 81
Two Urns (Smith), 90
Two-toned cufflinks and earrings (Fletcher), 48
Tympanum, 38, 44, 144
Tyrrell, Myles, 72

U
Un jardin d'ardoise (A Slate Garden) (Desrochers), 105
Untitled (Swann), 129

V
V-cut, 40, 41, 42, 43, 108
Vermont, xv, 9, 18-20, 21, 22, 30, 40, 45, 50, 86, 106
Victorian era, xv, 4, 13, 16, 19, 20, 38, 58, 83, 100, 127
Virginia, xv, 2, 30, 31, 45, 94
Vivian, John, 89
Volcano (Roberge), 101, 137

W
Wagner, Merrill, 64-66, 100, 134, 136, 151
Wales, xv, xvi, 1, 3-5, 10, 11, 13-18, 20, 35, 38, 42, 52, 59, 60, 69, 70, 76, 90, 91, 92, 94, 101, 102, 103, 111, 115, 117, 118, 119, 121, 122, 124, 127, 136, 138
Washington County, 19
Watts, Meic, 128
Wayland, 97
We Three Loggerheads (Wilson), 60
We Two, Oui Tout (Curtis), 106
Weber, Honour (gravestone), 39
Welsh Room (Green Mt. College), 20, 21
Welsh Slate Museum, 4, 15, 77, 102, 117, 118, 119, 155
White Stack (Roberge), 100
Whitechapel Slate Circle (Long), 113
Whitehaven, 103
Whitney Museum of American Art, 822, 84
Wild rose necklace, series #2 (Boardway), 55
William Traver Gallery, 66
Williams, John, 43, 62, 151
Williams, Kyffin, 117
Wilson, Richard, 60
Winholtz, Mack, 85-87, 129, 151
Winterthur Museum, 36
Worcester, 35, 36
Worthington, Alfred, 59
WPA Project, 21

X

Y
Yale University Art Gallery, 36
Yellow Stack (Roberge), 100
Yorkshire Dales, 89
Yosemite Valley, 32

Z
Zen, 85, 86
Zimbabwe, 102, 121

Photography Credits

The authors and publisher wish to thank the artists, museums, and galleries for permitting the reproduction of their works and for supplying the necessary images.

Chapter 1: Jean Napier, 1.1

Chapter 2: Penrhyn Castle, the Douglas Pennant Collection: Plate 3, courtesy of the National Trust NPTL John Hammond; Martin Roberts: 2.10; Harry Fearn A.R.P.S.: 2.9 and 2.13–2.15; Neil Rappaport: Plate 6, courtesy of Susanne Rappaport; Salli Bo Andrews: 2.28, courtesy of Barbara Kulicke; Lindsay Mitchell: 2.33.

Chapter 3: Daniel and Jessie Lie Farber: 3.1 and 3.3, courtesy of Jessie Lie Farber.

Chapter 4: David E. Stilp: 4.1 and 4.2; Sylvain Laroche: 4.6; Dan Koons: Plate 7 and 4.8–4.10; Frank Ross: Plate 8 and 4.15; Doug Yaple: 4.16 and 4.17.

Chapter 5: Hargreaves Photography: 5.3 and Plate 9, copyright The Boydell Galleries; Photo by Taylor: Plate 10; Sara English: 5.12; Eduardo Calderón: Plate 11.

Chapter 6: David Rosenfeld: 6.1–6.4.

Chapter 7: 7.1–7.4 courtesy of Sir Alan Bowness; 7.5 courtesy of Lida Lopes Cardozo Kindersley; Jerry L. Thompson: 7.6, copyright © 2001, Whitney Museum of American Art; Kevin Noble: 7.7 and Akira Takahashi: 7.8 both courtesy of the Isamu Noguchi Garden Museum; Al Surratt: 7.9–7.12.

Chapter 8: Stanley Barker: 8.4, courtesy of Friends of Herring Island; Dean Powell: 8.6–8.9; Jon Bonjour: 8.10; Jay York: 8.11; John Knaub: 8.12.

Chapter 9: Sylvain Laroche: 9.1 and 9.2; Mary Ball: 9.3 and 9.4; David Ward: 9.6 and 9.7; National Gallery of Art, Washington: 9.11.

Chapter 10: M.E. Thompson 10.1, courtesy of the National Museums & Galleries of Wales; Jane Norbury: 10.5; Jean Napier: 10.6–10.8; Roger Tiley: 10.9–10.12; Lizzie Slatter: Plate 14, 10.13, and 10.15.

Photographs, maps, table, and diagram by Judy Buswick: Figures i.1, i.2, 1.2–1.5, 2.1–2.8; 2.11, 2.12, 2.16–2.19, 2.21–2.27, 2.29, 2.31, 2.32, 3.2, 3.4, 3.7, 3.11, 3.13, 4.7, 5.1, 5.6–5.9, 6.6–6.13, 10.2, 10.14, 11.6; Table 1; Plates 1, 2, 4.

All other photographs were provided courtesy of the artists.

The authors have made their best efforts to give accurate credit for photographs. If there are any errors or omissions, please contact the authors so corrections can be made in subsequent printings.

ISBN 142510082-1